PAWEŁ ALTHAMER

ROMAN KURZMEYER
ADAM SZYMCZYK
SUZANNE COTTER

Φ

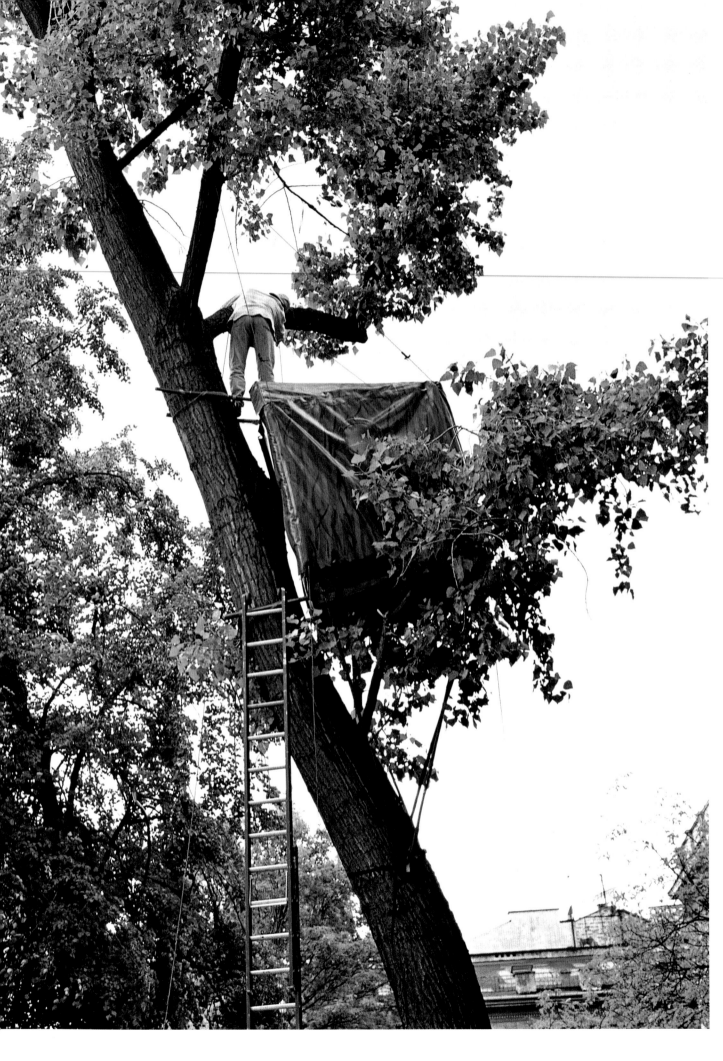

HOUSE ON A TREE, 2001
PHOTOGRAPHIC DOCUMENTATION
OF AN ACTION
FOKSAL GALLERY FOUNDATION,
WARSAW

A bamboo house with a plastic roof
was installed in a tree in downtown
Warsaw, facing the window of the
Foksal Gallery Foundation exhibition
space. Hidden at the tree house,
Althamer was absent from the
vernissage in the gallery, where the
audience had gathered. His illegally
installed private 'flat' had the basic
facilities – a bed, a heater, electricity
– and the artist spent several
nights there during the winter. The
temporary architecture remained in
place for six months before the city
authorities ordered it to be removed.

CONTENTS

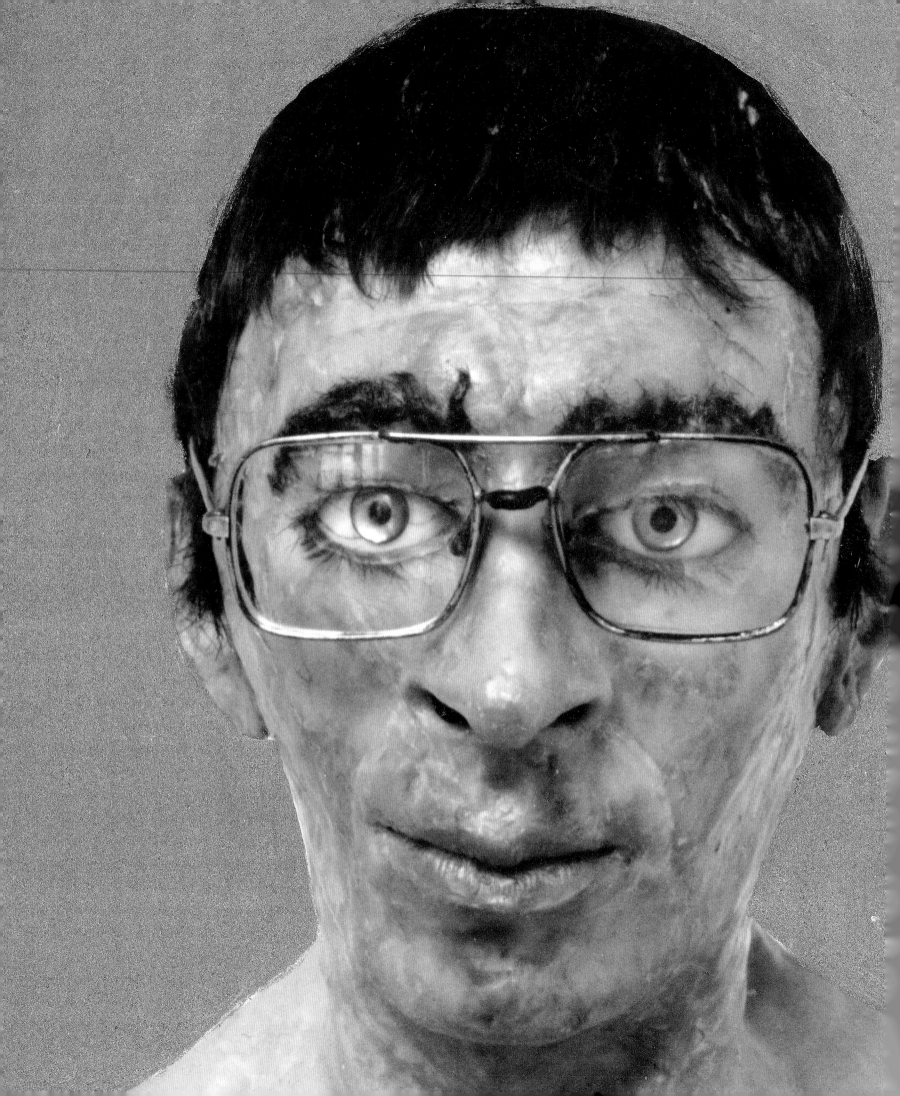

ADAM SZYMCZYK: *I'd like to look back to one of your earliest pieces, which you made at Jacek Markiewicz's a.r.t. gallery in Płock (Untitled, 1991). In this work you tried to wipe out the gallery and bring back the domestic appearance that the apartment had had before Jacek Markiewicz turned it into a white space for the gallery, which opened just two months before your exhibition. You performed and recorded on video several operations as a sort of 'renovation in reverse' to restore the sense of age, history and use to the space. In the a.r.t. gallery retrospective catalogue,[1] the following components of this action, as you refer to it, are listed: video (recording your stay at the gallery), warm tiled stove, the smell of freshly waxed floor, traces of author's presence. Remember that?*

PAWEŁ ALTHAMER: Yes. Actually, the room was already cleaned and ready. I just dirtied it a bit to strip it of that readiness. Before the Second World War the flat had belonged to the Jewish owner of a barge company operating on the Vistula River. Jacek Markiewicz from the a.r.t. gallery, located by the Vistula in Płock, wanted to turn the place into a gallery. The first step was to transform the interior into a white cube, which was a fairly brutal move, or so it seemed at the time. Some sensitivity was suppressed or lost when the beautiful tiled stove was painted white. It was interesting in a painterly way but still sordid somehow.

SZYMCZYK: *But that didn't make the stove entirely disappear.*

ALTHAMER: Not only did it not disappear – it became even more intriguing. It became an emblem of violation, of failure to recognize the character of a place, while I thought galleries ought to do precisely the opposite.

SZYMCZYK: *Then you restored the space to its original condition.*

ALTHAMER: I did. I decided to leave the walls white. I didn't strip the paint – that would have made me a mad restorer – but I strove to restore all that was human to the space, everything that could either encourage me or anyone else to stay around for a moment or that could repel people.

SZYMCZYK: *Was that it? Didn't you put anything there?*

ALTHAMER: Well, I did bring some things.

SZYMCZYK: *Like what?*

ALTHAMER: I brought a cot. You see, I kind of knew what I didn't want to do, but I also wanted to listen to what was there. It still works that way – someone invites you for a project and shows you around the space, the museum, in the hope you'll come up with something cool. But in fact you carry the actual space with you – wherever you go, your space is with you. Sometimes you need an encounter like that, sometimes you don't. In that particular case, I was thrilled with the space but not so much with the gallery or what its manager was doing. But I treated the project as a move forward. Remember that this was after I participated as a student in *Obszarz wspólny, obszar własny* (Common and Private Space), the extremely significant task that Grzegorz Kowalski has been assigning to his students since 1981 in his class in the sculpture department at the Academy of Fine Arts in Warsaw. In other words, I wondered what my next move should be, how I should respond to what the place did, and that's what I made the exhibition about.

SZYMCZYK: *This was around the time you made* Self-Portrait *(1993)?*

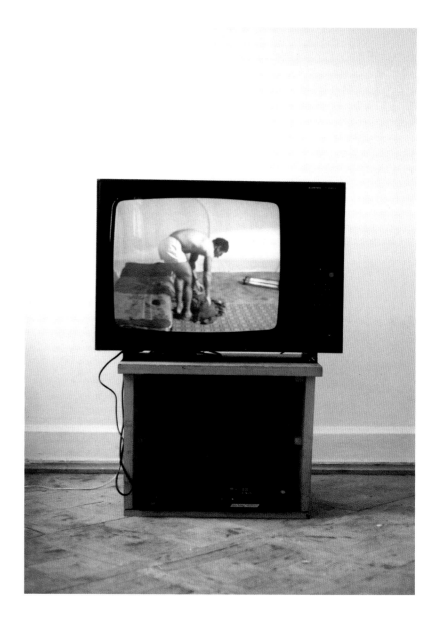

UNTITLED, 1991
PHOTOGRAPHIC AND VIDEO DOCUMENTATION
OF AN ACTION, A.R.T. GALLERY, PŁOCK, POLAND

The artist redesigned the gallery to look like the
apartment it used to be.

previous pages,
SELF-PORTRAIT, 1993
COLLAGE ON PAPER
11 X 15 CM

Postcard made by the artist from a
close-up photograph of his sculpture
Self-Portrait (1993).

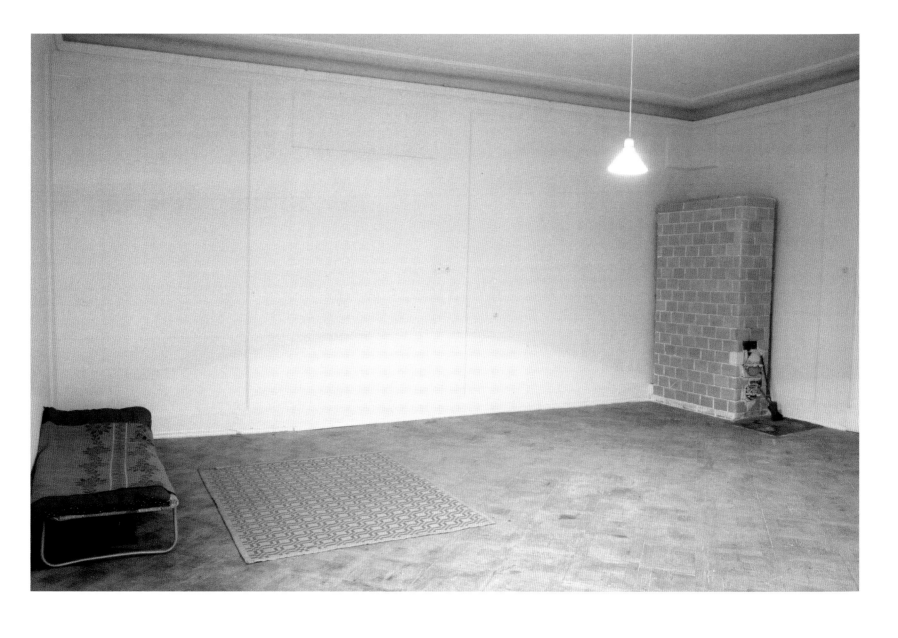

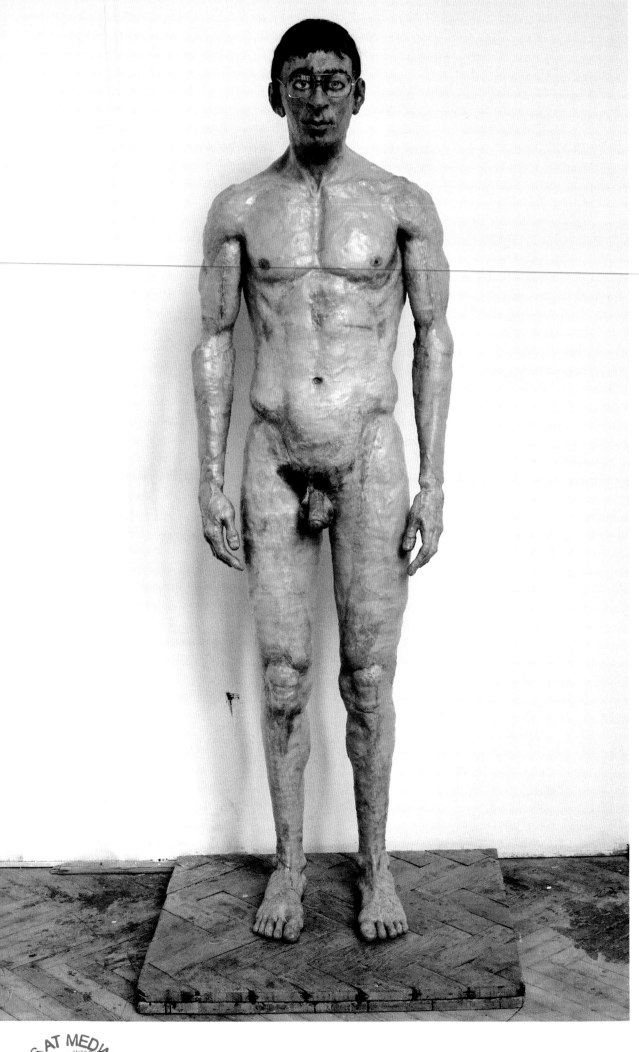

SELF-PORTRAIT, 1993
GRASS, HEMP FIBRE, ANIMAL INTESTINE,
WAX, HAIR
189 X 76 X 70 CM

This lifelike figurative sculpture, which involves
an element of psychological awe inspired by
the figure, was part of the artist's work for his
master's degree project.

opposite,
the artist at work on Self-Portrait (1993) at his
studio in Warsaw.

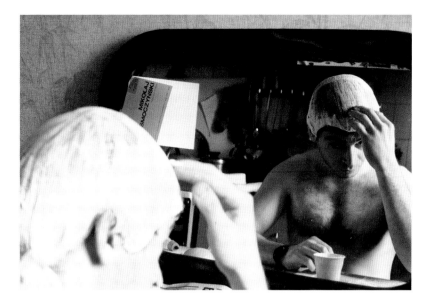

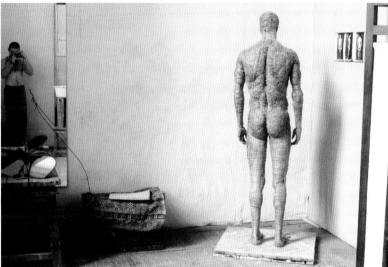

ALTHAMER: Yes, I think I was already out of the Academy by then.

SZYMCZYK: *How did you make the shift from works that were quite traditional in terms of technique – though one could argue about whether they were indeed traditionally executed – to the process of reverting places to their original character, to re-infusing spaces with the real?*

ALTHAMER: My sculptures had more to do with performance art than with figurative sculpture. Crudely put, I felt comfortable with two means of expression: I either made sculptures or extracted them – teased them out, covered them up, lost or buried them.

SZYMCZYK: *Yet most of your sculptures have an extremely forceful presence. They thrust themselves upon the viewer and require a lot of looking. On the other hand, you've made a great number of works in which you blend individuals or situations into the background.*

ALTHAMER: It's about a kind of helplessness affecting artists, when they try to experience and represent what it's like to be an artist, the relishing of sensations. Artists can use tried and tested techniques and manifest themselves as sculpture or pseudo-sculpture – self-portraits, usually. Or they can go out into the world in person to show they were there, to leave a trace of their existence. This can be done through film, performance or interventions into their immediate surroundings. An artist can, for example, wash the floor to anoint it somehow. An artist can leave an imprint of his or her hand, or meet the local people and leave a trace in their memory. This is one of the threads I explore with my works, though reflection usually comes later. The actions themselves are most often spontaneous.

SZYMCZYK: *When, in what circumstances, did you stumble upon the idea that someone could stand in for you when you were supposed to make a work? How did you start delegating work?*

ALTHAMER: It happened once I saw that my gestures were being misread, that viewers were focusing on the surface instead of what was truly interesting. Artists aren't identified with what infuses them, what drives them to action or makes them distinct. They're treated as specimens, curios.

SZYMCZYK: *So you wanted authorship to be …*

ALTHAMER: Distorted. Yes, I wanted to distort it. To show that being jolted from the habits of perception, deprived of certain expectations, is something I can relate to personally – it stimulates my ceaseless curiosity. When I go to a sculpture exhibition and see that there are no sculptures, I find that very interesting. If I were to go to a Paweł Althamer exhibition – I'm projecting here – and find no Paweł Althamer, it would set the right processes in motion.

What was it that attracted me to the exhibition in the first place? The artist's name? His or her persona? Who is that artist? And who am I in the face of what I'm witnessing? Who am I in general? That seems to be the most interesting question you could ask. Also: what am I doing here?

SZYMCZYK: *You've often sent your children to participate in projects for you. Is that because there's a difference between involving strangers, professional actors, and people who are important, not to say vital, to you? Where did you first get that idea? Was it at the Migros Museum, when you sent your daughter to guard the exhibition?*

ALTHAMER: It would be dishonest to claim I knew when and where I got the idea.

SZYMCZYK: *So let's focus on the event itself.*

ALTHAMER: I was spending a lot of time with Weronika back then. I found her

FRÜHLING, 2009
DRAWING
40 X 30 CM
PHOTOGRAPHIC DOCUMENTATION
OF AN ACTION, KUNSTHALLE FRIDERICIANUM,
KASSEL, GERMANY

During 'Frühling' (spring) the artist invited 312 children from Kassel to occupy over 1,000 square metres of exhibition space in the Fridericianum Museum. His main aim was to create a children's version of Documenta, enlivening and transforming the venue with the help of the their youthful, bold and above all free creativity. The children were the main actors, while the artist played the role of their guest and assistant. Frühling continued to develop as a process-based artwork until it closed, with the official end of spring, on 21 June 2009.

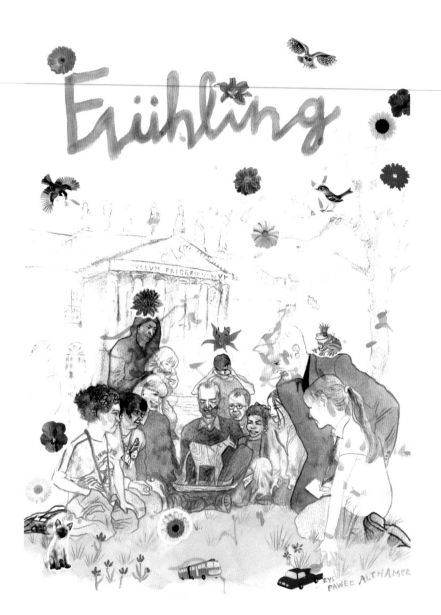

FAIRY TALE, 1994–2004
METAL, MESH, USED CLOTHING AND
ACCESSORIES, HAIR
5 SCULPTURES, EACH APPROX. 190 X 60 X 60
BONNEFANTENMUSEUM, MAASTRICHT

In 1994 the artist made a sculpture showing
parents dancing in a circle while waiting for their
children to finish their art class. The original piece
was destroyed and eventually recreated in 2001
on the occasion of the exhibition 'War in Man' at
the Centre of Polish Sculpture in Orońsko, Poland.

DANCERS, 1997
VIDEO ON 5 MONITORS
3 MIN. 34 SEC
PRODUCTION PHOTOGRAPH

Shot in a film studio and featuring men and
women the artist met at a homeless shelter, the
video shows a group of naked people dancing
in a circle. Made for the artist's exhibition
at Kunsthalle Basel, it is presented on five
suspended monitors in such a way that the figures
appear to jump from one monitor to the next.

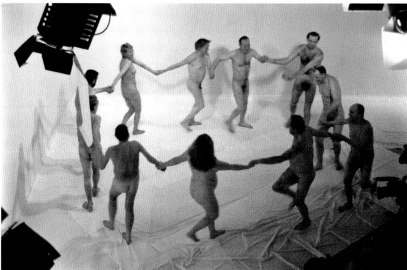

personality and the way she saw things extremely inspiring and familiar. Because she was my daughter, I knew her pretty well, but she was still a child like many others: estranged and alienated somehow, with this freedom and self-confidence bordering on insolence. Children can behave in barbaric ways, not that it bothers me much. Children tend to touch everything, they don't know how to lie, they often take things too far, driven by an energy that – as I discovered – was beyond my reach. I'd get too caught up in the game. So I made use of that energy. I could safely rely on Weronika, and I knew I could count on the other children as well. In any new place, they exhibit the traits I value most: curiosity and a readiness to explore. There were awkward moments, but there was also pride and joy at just being there. Such experiences were much stronger and emotionally gratifying for me than simply mounting my work, pleasant though that is.

SZYMCZYK: *Agreed, but there's also a visual aspect involved when you employ the expressiveness of a child. For instance, when a child is simply too small in relation to the surrounding space, when he doesn't …*

ALTHAMER: … fit in.

SZYMCZYK: *If you sit a child on a stool, and his feet don't reach the floor, you affect the form, even if you do it through contrast.*

ALTHAMER: Well, yes. You can find precedents in tradition, such as depictions of putti or little angels.

SZYMCZYK: *The Migros piece was called* Król Maciuś I *(King Maciuś I).[2] I remember the classic illustrations to that Janusz Korczak book, of King Maciuś sitting on a throne too big for him.*

ALTHAMER: I'd say it was about substitution or maybe changing a system that failed, one that was worn out, burnt out – or simply not interesting enough. Quite a risky change. Though I don't think I felt the risk, it was rather a child-like joy when I recognized myself in the children. But I wouldn't have looked convincing swinging my legs out there, though that's exactly how I felt. I was happy to be pulling a prank on the adults, with their habits and routines.

SZYMCZYK: *Do you still think that way? Do you still feel like pulling pranks, as you put it – overthrowing or distorting the order of things?*

ALTHAMER: A lot of time has passed since then. My context has changed. All of a sudden I found myself functioning in the art world, adapting to it. I take part in too many exhibitions to enjoy each of them. I admit I do some of them half-heartedly. But it still turns me on when I'm given the right conditions and invited to take an active part in the process.

SZYMCZYK: *You've done a lot of figurative sculptures lately. What makes you sculpt so much? What do you want to sculpt?*

ALTHAMER: It might have to do with the art of camouflage. A game of mimicry.

An urge to blend in with the surroundings, bringing in all the wealth of your own individuality and finding that you fit in well with others. It's an escape, a need to stand aside, to distance oneself from a situation, or to act against it.

SZYMCZYK: *Does that make sculpture a form of mimicry? Is executing sculptures a way of conforming to others?*

ALTHAMER: I treat it like a game I'm invited to play, one I either initiate or enter as it progresses. The game takes the form of an exhibition where I'm offered the freedom to act. I don't feel my expression as an artist has been fully channelled. I haven't opted for a single style of expression, though everything I do fits together – at least that's the impression I get reading various texts. I enjoy doing different things, and that includes boycotting my previous approaches, as well as attempts to imitate older artists. It's a bit like when younger kids are chasing the older ones and wanting to catch up. I have a similar approach to fellow artists who've attained interesting positions in art history.

SZYMCZYK: *Let's talk about a work of yours I saw in Berlin, a group sculpture depicting a sort of a sculptor's studio, in which the absent sculptor was represented by a self-portrait in the form of a bust.*

ALTHAMER: *The Three Graces.* That's how I'd interpret it. The work offers an analogy to the sculpture of *The Three Graces.*

SZYMCZYK: *Right, there are three figures. One exists merely through its absence, the other is the bust, and the third is a female figure that looks as if it were unfinished or falling apart.*

ALTHAMER: You could say it was 'let slip' sculpturally.

SZYMCZYK: *Or frozen in the process of becoming or of falling apart.*

ALTHAMER: I like it when actions seemingly designed to preserve something actually record its decomposition. It's as if something weren't hardened, as if the material record failed to give a sense of durability. I'm interested in this boundary, the possibility that we're dealing with a reject, a failed product.

SZYMCZYK: *It's a bit like photography – you freeze fleeting situations.*

ALTHAMER: Yes, technology preserving a fragment of reality.

SZYMCZYK: *While metal …*

ALTHAMER: … doesn't preserve that, doesn't show it.

SZYMCZYK: *As with your other works, I see a trace of the Baroque here.*

ALTHAMER: Mannerism, even.

SZYMCZYK: *A sculpture brilliantly illustrating the decay and disintegration of matter.*

ALTHAMER: That brings to mind Igor Mitoraj, a sculptor I don't admire much, but since I keep bumping into his works, I think about him now and then. Perhaps that's the key to understanding my sculptures, at least the enduring ones done in metal. I never thought I'd be making sculptures you could associate with Mitoraj. I don't know about the ideas behind his works, but to me they resemble fragments of ancient sacred statues salvaged from the sea.

SZYMCZYK: *But there's a difference between his work and antique shards, fragmented sculptures.*

MATEA, 2006–08
CLAY AND ALUMINIUM
STANDING FIGURE 175 X 75 X 46 CM
BUST 25 X 55 X 40 CM
BASE ∅ 340 CM

THE ARTIST AND HIS WIFE AT WORK ON
MATEA, 2006
NATIONAL MUSEUM OF CONTEMPORARY ART,
ATHENS

As his contribution to the 'Grand Promenade'
exhibition at the National Museum of
Contemporary Art in Athens, Althamer set up a
traditional sculptor's studio, in which he and his
wife Matejka also lived, along the footpath to the
Acropolis. They posed for each other, modelling
a classical standing female figure and a bust.

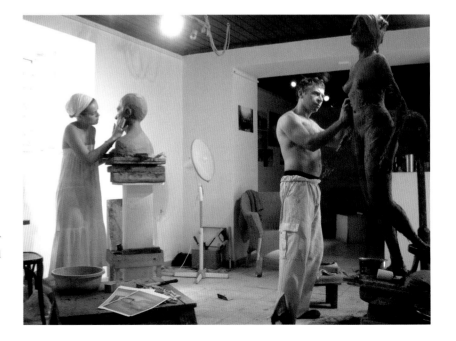

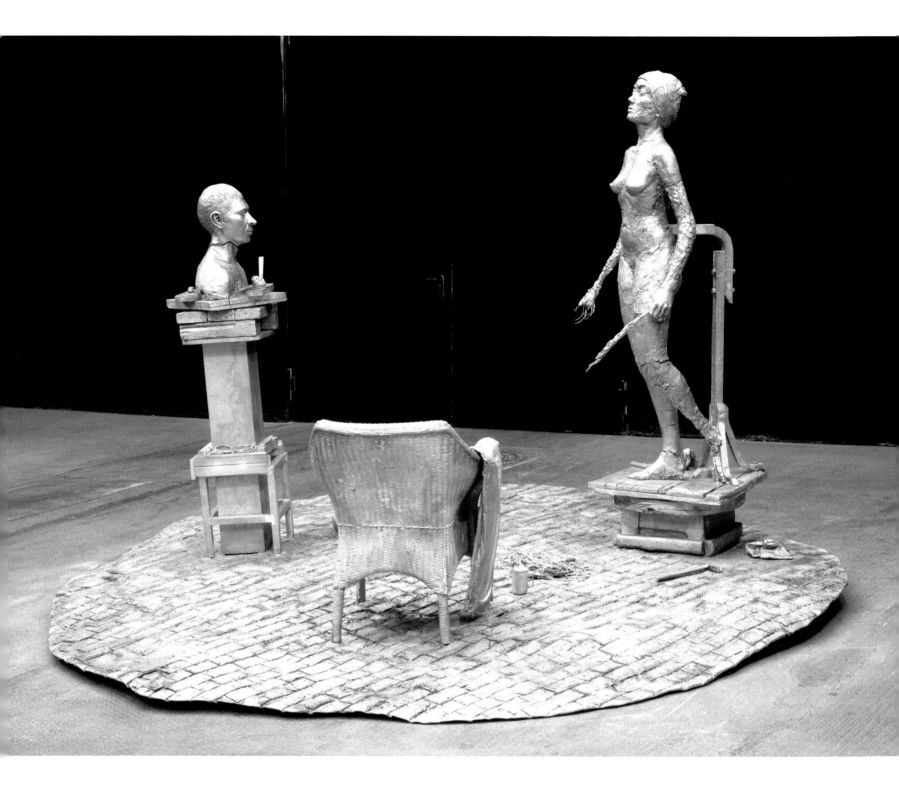

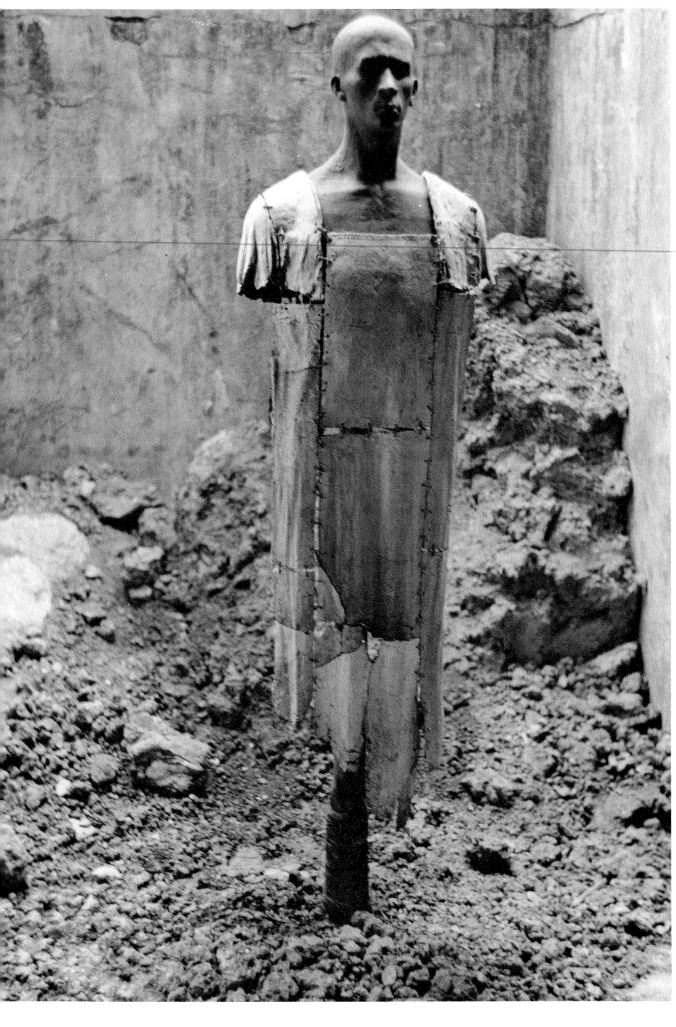

SELF-PORTRAIT (UNFINISHED), 1989
CERAMIC

A sculpture made at the beginning of the artist's
study in Gustaw Zemła's studio at the Academy of
Fine Arts in Warsaw. The work no longer exists.

MATEJKA WITH SON, 2006
TERRACOTTA, METAL, TEXTILES, PARAFFIN
WAX, FOAM
217 X 64 X 49 CM

A portrait of the artist's wife Matejka when she
was expecting their first son – Kosma. The face,
hands and feet are made of ceramic, while the
body is a metal construction covered with a dress
that the artist brought back from Africa

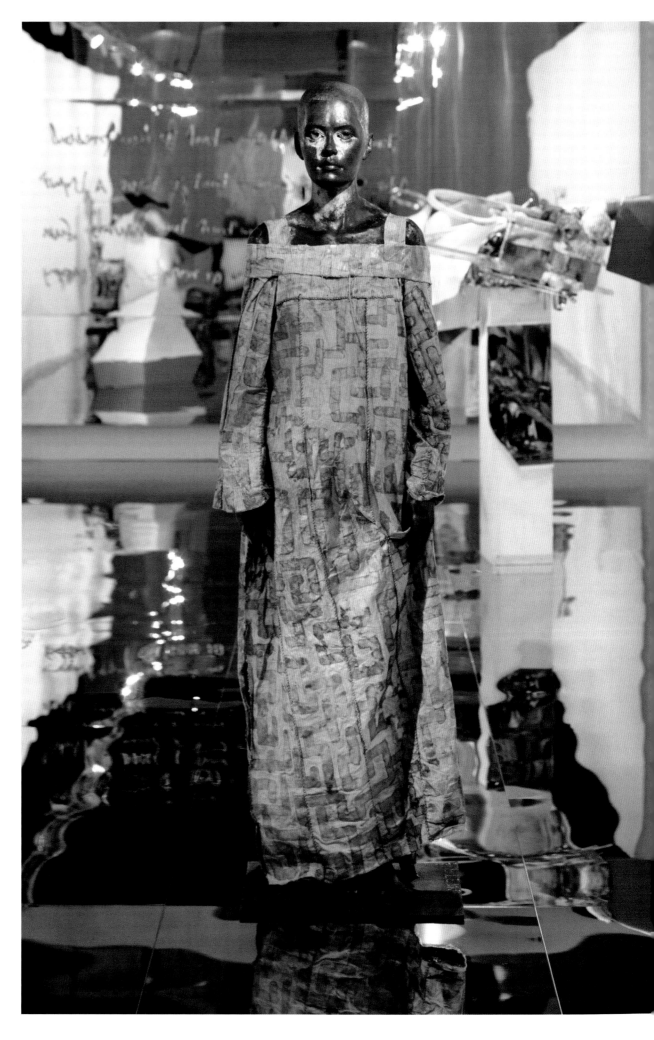

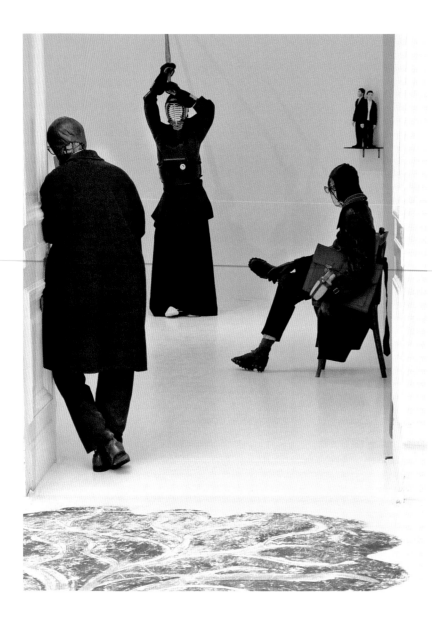

ALTHAMER: Those fragments are a part of collective memory.

SZYMCZYK: *Exactly. Part of history, part of memory. But in your case, decay is not aestheticized, not in the classical sense. It's an everyday fact of biology, depicted in a brutally lifelike way. Take this leg for example – is it unfinished or rotten? It's hard to tell.*

ALTHAMER: But that's also great. When sculpting the piece, I was admiring [my wife] Matejka's leg. I wanted to preserve her beauty and that of her leg. In this sense I wasn't satisfied with the finished sculpture. What makes such sculptural experiments marvellous is that they never satisfy and never cease to surprise me. Failure can be inspiring, too – when I feel that something's failed and should be done from scratch. Maybe I'm unconsciously seeking out failure, self-destruction. I think that depicting these two processes, the building of decay and the construction of destruction, is an extremely momentous experience.

SZYMCZYK: *Your sculptures also convey a striking sense of abandonment.*

ALTHAMER: Abandonment. As in pointlessness or doubt.

SZYMCZYK: *Let's take two exhibitions of your figurative sculptures: the one in Cieszyn and the one in Milan in which you populated the space with a variety of characters.*

ALTHAMER: A kind of *Kunstkammer*.

SZYMCZYK: *In your show at Galeria Miejsce in Cieszyn in 1995, you set up a waiting*

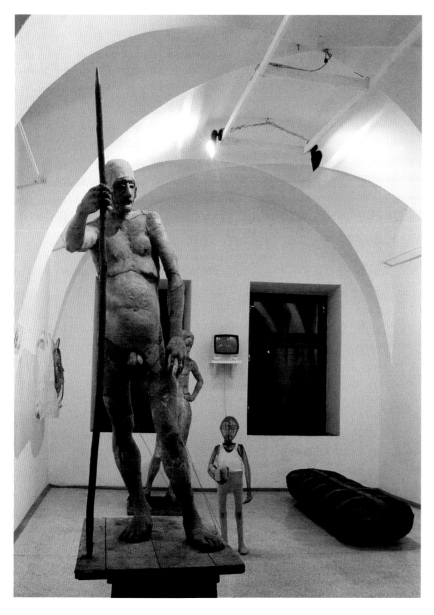

room or left-luggage office for a group of your sculptures, where figures performed different functions – including a warrior (Study from Nature, 1991), a self-portrait as a child with a toy dog (Self-Portrait as a Child, 1995), the life-size nude Self-Portrait (1993) that you made for your diploma at the Academy of Fine Arts, and a self-portrait in the form of a collection of your personal belongings sealed flat in plastic (Self-Portrait, 1994), while, at your 'One of Many' exhibition at Fondazione Nicola Trussardi in Milan in 2007, you had a new group of sculptures: heroic, or rather mythical and symbolic life-size portraits. These included an ebony figure (Matejka with Son, 2006).

ALTHAMER: Ceramic, actually. It showed Matejka as a monumental goddess, a kind of fetish or totem. A totemic sculpture.

SZYMCZYK: Right. That show didn't look like a salon of rejected sculpture, compared to the one in Cieszyn. The figures were all finished, extremely vivid, with a strong presence.

ALTHAMER: The sculpture of Matejka as a goddess was a replica or actually a second go at a self-portrait I did at the academy. That one was also monumental and idolatrous in form – I wanted to achieve the effect conveyed by statues of royalty. It no longer exists, but it was a ceramic bust I sewed or stuck a robe to, bound with straps cut from ceramic slabs. The whole thing was covered in hand-etched patterns. The location was also important. I put it in this niche at the bottom of a shaft down which sculpting clay is delivered and which made me think of a chapel. I keep having religious associations – I don't know why. Some of my things are sacred sculptures, but their sacred nature isn't always legible to someone raised in the European tradition. At times they seem closer to so-called primitive cultures – African ones, for example.

SZYMCZYK: It's been over a dozen years since your first visit to Mali, in Africa. What was special about that journey? I have the feeling you amassed a wealth of experience, but you never invoked it again until you went back there in 2009 as part of your Common Task project.

ALTHAMER: I'd call it an awakening of consciousness. As a one-off experience it was so strong that for many years there was no need to go back. I could dream about returning to Africa without having to go. I had to make that first journey, though. It took place on at least two planes: geographical and internal – away from the place I was and into myself. In fact, I soon felt alienated in relation to the representatives of my own tribe. My companions regarded me as a freak.

SZYMCZYK: Who were those companions?

ALTHAMER: Ordinary people, one could say: travellers, scholars, a journalist, a soldier. As it turned out, the soldier was the one I could best relate to. The whole thing was torture for him – he hated Africa and the blacks – but at least he had nothing against me. He came along as a driver – we were renting a Star, a military truck. He was in it only for the money.

SZYMCZYK: I was struck by the way you described the roles of the travellers. It seems you have the ability, or need, to create dramatis personae in various situations, that you like clearly defined characters: a scholar, a soldier, a tourist. Sounds like a list of the roles you took on in your scenarios.

ALTHAMER: It would make a good short play. I could stage my trip to the Dogon tribe as a three-act play. It would have eight actors, the journey would take place in the conventional setting of a dimly-lit playhouse. All the expressions, problems and challenges would come out in the course of a shared dinner around a bonfire.

SZYMCZYK: A journey as a pretext for dramatic form.

ALTHAMER: I had a strong relation with my inner self then, and I sensed the tension between myself and the others – not so much tension as a lack of understanding, a lack

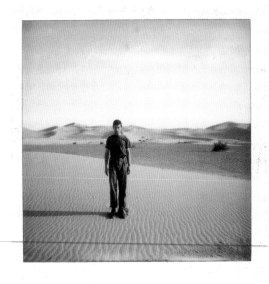

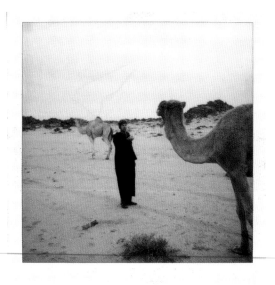

BRUNKA SZYMONKA

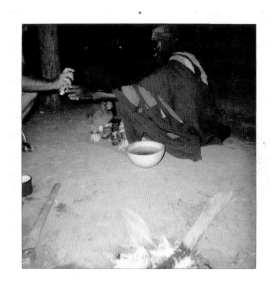

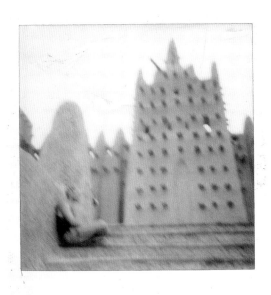

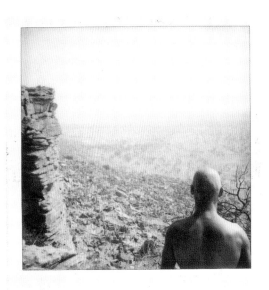

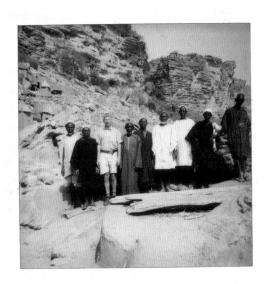

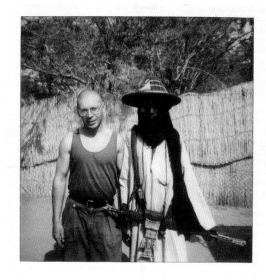

JOURNEY TO THE DRAGON'S TRIBE, 1991
PHOTOGRAPHIC DOCUMENTATION OF A
JOURNEY, MALI
15 POLAROID PHOTOGRAPHS
EACH 11 X 9 CM

A series of photographs the artist shot to
document his first trip to meet the Dogon tribe
in the town of Djenne, Mali.

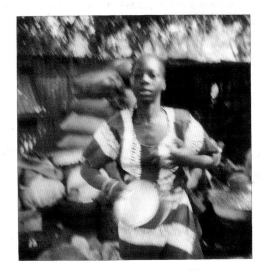

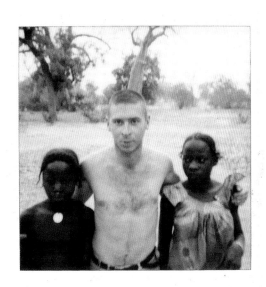

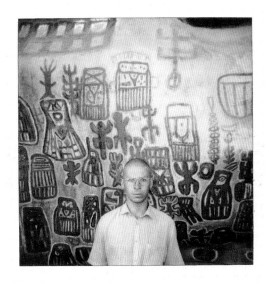

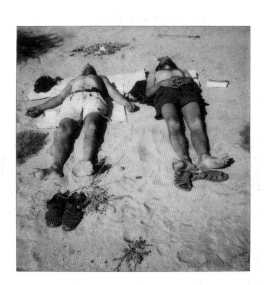

PILGRIMAGE (WITH ARTUR ZMIJEWSKI), 2003
VIDEO DOCUMENTATION OF AN ACTION
29 MIN. 30 SEC
opposite, POSTCARD
20 X 15 CM

A souvenir postcard printed to document a film
by Artur Zmijewski about a traditional pilgrimage
to the Holy Land in which the artist participated.
The project was commissioned from Zmijewski for
Art Focus 4, the Biennial of Contemporary Art in
Jersulalem

of connection. Their fear was amplified by my willingness to abandon fear. Whenever I tried to free myself from fear it triggered their fear, made it manifest.

SZYMCZYK: *I can't help thinking about another journey you made, when Artur Żmijewski filmed you in the Holy Land for the video* Pielgrzymka *(Pilgrimage, 2003). There your behaviour defined the personalities of various individuals you met along the way. The journey itself was an organized pilgrimage. Its aim was for each participant to experience something important.*

ALTHAMER: But it also belonged to a tradition more deeply ingrained than journeys to Africa. For Poles, continental Africa has no place that could compare to the Holy Land. A pilgrimage to Jerusalem has specifically religious roots and references, though for me both journeys led towards the sacred. In fact, every journey eventually turns out to be a journey towards the sacred. The Holy Land stretches as far as the eye can see.

SZYMCZYK: *But you met people who believed that particular places – a lake or a stream – were the only places, that a certain wall or a building embodied the sacred. Your presence interfered with that.*

ALTHAMER: I tried to be true to my feelings and distrustful of the codes instilled in me, and I could not accept that this land was holier than others. Moreover, I had the impression that the concentration of fear in the area was greater than in any other place I visited. When I looked at my companions, I had the impression they were actually unfit to travel. They weren't able to gain anything from the experience, they were so strongly programmed – and were being programmed even more by the tour guide. They didn't experience anything. They weren't able to experience their own selves.

SZYMCZYK: *Because they knew from the start what they should experience in any given place. They could just as well not have left the country.*

ALTHAMER: Perhaps if they hadn't, the trip would've been more effective. The pilgrimage would have made a lot more sense then.

SZYMCZYK: *They would've been intensely recollecting a potential pilgrimage.*

ALTHAMER: Even touching things doesn't help, touching what would appear to be living holy soil, the living sacred in the flesh. Vasanta Ejma gave a very beautiful account of her experience of a journey on which she gave up all rational motives, surrendered and opened up to a place. She let the stones speak.[3] She listened to her emotions and discovered that self-fulfilment was beyond her reach, that she wasn't happy and couldn't find peace. So she left everything – family and work – and, after spending several months in India, she started moving towards a fuller, more complete way of experiencing. In her book there's a nice description of the moment she sensed that the stones of a pyramid were a living organism, a living record, living energy – a record you can read and, with some effort, translate.[4] Everything you encounter strives to speak about its extraordinariness and greatness. There's also a story about how, during a trip to Egypt, the author realized she was a queen. It's beautiful. She was

Queen Nefertiti, and everyone bowed down to her. She fled a rational system – her friends probably thought she'd gone mad. Recently, during a trip to Egypt with my daughter, I had the occasion to retrace her footsteps. I tried to create similar conditions for myself, to follow my emotions and feelings before reason stepped in, before scepticism appeared.

SZYMCZYK: *We know from films and stories that you've gone on many other journeys – to Mexico, for example. Your aim was not to get new experience or skills. You didn't want to learn indigenous customs, technologies or ways of thinking, or to understand local artists, like in Africa. The real reason you went to Mexico was peyote.*

ALTHAMER: That trip was related to another sacred tradition that predates Christianity – a journey in pursuit of wisdom.

SZYMCZYK: *But not the wisdom that comes with experience, or stems from contact with other people. You sought wisdom by reaching down into the deeper layers of your self.*

ALTHAMER: You can have both. That's what wisdom boils down to – you can always set out on a journey without physically going anywhere, merely by sitting on a chair, just like I am right now. I've been making more of these journeys lately. Moreover, you meet many other travellers, because you're not the only person travelling that way. There are scores of travellers going in just one direction – inwards, towards the within. The expression is actually misleading, as the inside has no end. In fact it is the outside.

SZYMCZYK: *In what sense?*

ALTHAMER: In the sense of openness. It's like when a character in a film is banging on a door wanting to go out, and then you get a bird's-eye view that shows he's actually in an open space trying to get into a small room.

SZYMCZYK: *I'd like to change the subject a bit. On the way to our meeting, I saw several dozen street-cleaners in Day-Glo vests next to a Second World War monument in the Praga district of Warsaw. I think they were unemployed – the marginalized cleaning the margins of public space.*

ALTHAMER: Nobody would invite them home. Somebody owning a villa with a swimming pool would rather hire professionals, experts, virtuosos of the mop.

SZYMCZYK: *That distinction between professional and non-professional cleaners is symptomatic. You seem to see the position of an artist in a similar way – as someone who's both authorized and unauthorized.*

ALTHAMER: Or at times excluded.

SZYMCZYK: *For me, that street scene recalled your operations on a number of levels. First there's the aspect of cleaning. Then there's the fact that your projects often involve poor people unaccustomed to public performances, or people from the margins – prisoners,*

the homeless and so-called 'problem kids'. Those guys were like prisoners. They were barely moving. It was horrible and made me think of concentration camps.

ALTHAMER: When I think of my motivations today, it's not in terms of social awareness, fighting for equal rights, or community-building. What intrigues me is what would happen if I offered someone a new social role. I seek out such experiences myself. Acting in a larger group just makes it more exciting. You get a broader range of experience, more possible interpretations, as well as exchange between participants. This was what drove me. Another aspect is the exceptional availability of people who have merely a handful of life roles to choose from, who let others decide for them. That's why I invite them.

SZYMCZYK: *That means you don't consider it a form of social protest?*

ALTHAMER: I see it differently now. I know that assuming alternative roles is very effective, that giving people a choice is the only way for them to make that choice. Many people live the way they do because they don't realize they have a choice. They think it's the only way. It never occurs to them that they have a right to choose. They never ask the basic question: 'What do I choose? What occupation, what position?'

SZYMCZYK: *Do you think the profession, or occupation, of an artist involves responsibility? Like that of teachers or educators?*

ALTHAMER: Whatever I do, I feel accountable to myself. But I've also been held accountable for abusing my position, though I don't see it that way.

SZYMCZYK: *Namely?*

ALTHAMER: I asked the Nowolipie Group, the handicapped people I'm working with, to become an art group, which required going beyond the limits imposed by therapeutic classes. I suggested they try acting like other artists, that they try out various forms of expression. This was frowned upon by my superiors, who expected me to develop and follow a certain programme. I preferred improvised activities, involving the group in various projects without defining the result beforehand. This meant participating in public events, working on sculptures and other projects they thought they weren't up to. And they weren't, precisely because they'd never done such things before. I was criticized for being irresponsible and insubordinate, for refusing to conform to the standards expected of a teacher in a state institution. I was drawn into a bitter conflict with my superior, which continues until today.

SZYMCZYK: *Your superior was unhappy that you'd thrown the Nowolipie Group in at the deep end?*

ALTHAMER: She was. We're back to the issue of responsibility. I feel responsible for my trainees. I want them to have all the choices they can. Pompously speaking, I care about our common good, about giving everyone interesting and wonderful perspectives. But the director is guided by fear, the 'what if?' approach. When these radically different attitudes meet, it can lead to an immediate communication breakdown.

PEYOTE (WITH ARTUR ZMIJEWSKI), 2003
FROM THE SERIES SO-CALLED WAVES AND OTHER
PHENOMENA OF THE MIND, 2003-04
VIDEO
14 MIN. 50 SEC
MEXICO
below, PRODUCTION PHOTOGRAPH

So Called Waves and Other Phenomena of the Mind is a
series of eight videos in which the artist systematically
tries out the psychological effects of several illegal
drugs, prescription medications and treatments.
Shot while Althamer was under the influence of LSD,
hashish, mushrooms, peyote, truth serum and hypnosis,
the videos are a candid documentation of the artist's
journey into the world of altered perception

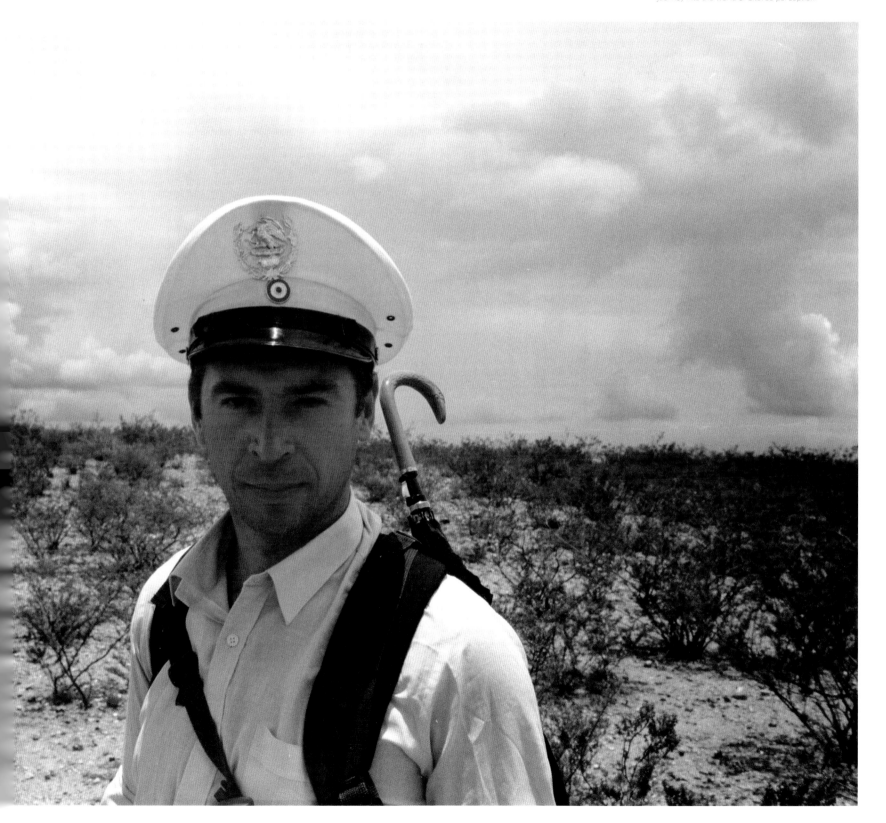

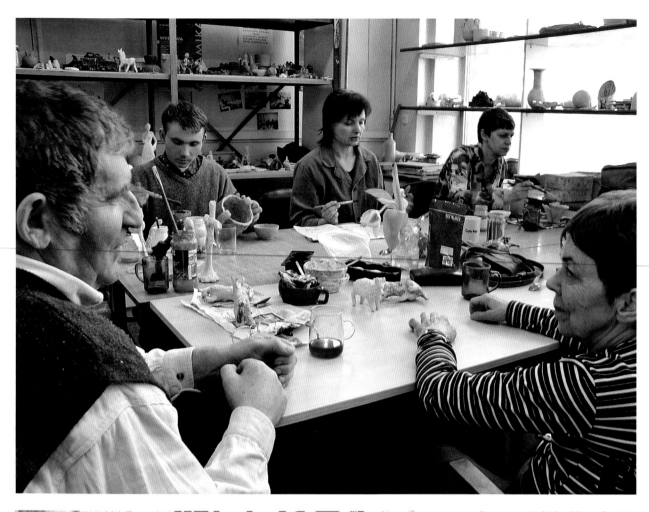

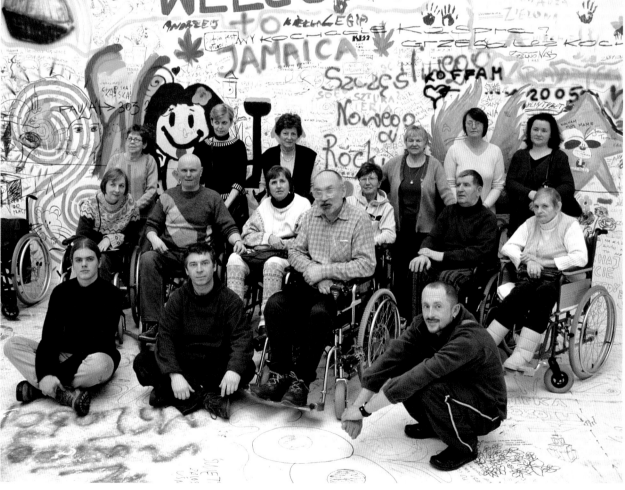

Since 1994 the artist has been working at a small
Warsaw arts centre, teaching ceramics to people
suffering from multiple sclerosis and other forms
of paralysis. Some of the resulting sculptures
have been exhibited as collaborations between
the artist and his students under the name Paweł
Althamer & the Nowolipie Group.

SZYMCZYK: *And what did your trainees think?*

ALTHAMER: They trust me. They don't always understand my point, but they don't feel threatened. They can always say no, and they know I won't take them anywhere they don't want to go, or have them do things they don't want to do. At times they may feel lost, as they often admit, but the level on which we communicate allows for unrestrained jumps into the unknown without ever losing touch.

SZYMCZYK: *Before that they were…*

ALTHAMER: They were typecast as a group of sick people coming in for therapy. This was their role. Before that, they were victims of an illness, multiple sclerosis, or just generally victims. This means they'd come to terms with the fact that little could be done. We can do this much but no more.

SZYMCZYK: *Were they aware that the ideal of health was beyond their reach? That such an ideal exists but they don't belong to it?*

ALTHAMER: Yes. I suppose you'd find a couple of doctors who'd say it was irresponsible of me to offer the group something beyond their capabilities, something exposing them to frustration. And there was some frustration. Some people – not many – resigned. A few simply died. I don't think I'm to blame. It's a disease that develops in the most surprising way – no one is able to gauge its full extent. When starting an activity I'm often uncertain where it'll lead me. That can make me feel uneasy.

SZYMCZYK: *In what public situations did your trainees find themselves?*

ALTHAMER: The whole group never participated in the same activity. Some of them usually represented the rest. Perhaps the most daring idea was getting two people with cerebral palsy – grown men with the minds of boys, you could say – to conduct classes for people with multiple sclerosis in Newcastle, England. They went there as instructors with me as their assistant. They were great. People normally seen as freaks became leaders, opening people up, showing them that anything was possible. When the rest of the group saw how bravely they were coping and the crazy ways they found to realize their own needs and ideas, they realized they could do the same. This created a stimulating atmosphere that helped people get rid of fear and individual prejudices. That, I feel, is the way to win people over.

SZYMCZYK: *Yes, but it might never go beyond the Nowolipie Group.*

ALTHAMER: I'll do what I can. But the workshops are open. They're being run.

SZYMCZYK: *Being an artist, how do you see the public significance of similar events over the last ten or fifteen years? Do you think the situation in Poland is improving?*

ALTHAMER: It is. Things once kept secret are now coming to the surface. It might seem bad at first glance, but that's merely because so many things had remained out of sight. Now is a time for cleansing. Clear-cut situations are mixing with 'dirty' ones that should be cleaned up. But this is a process, and it's moving in the right direction. Ten or twenty years ago, I would've been fired. But now the group wanted me to stay, and they protested. I could have taken the story to the papers – that would have provided a starting point for a discussion. Instead I ventured a public protest during a staff meeting. I criticized my superior and refuted her accusations. The faculty reaction was disheartening – the majority thought I was a careerist trying to make it in an institution at the expense of hard-working people who toe the line. I was made out to be someone trying to assert his individuality, trying to be different – that is, better. But at least there was some sort of exchange – I could learn what's what. People can work for years, all their lives, enduring in strained relationships, unable or afraid to take any steps. I now know that my person, my point of view and my working methods are not accepted, but at least I stated my case and so did they. I think that's a positive thing.

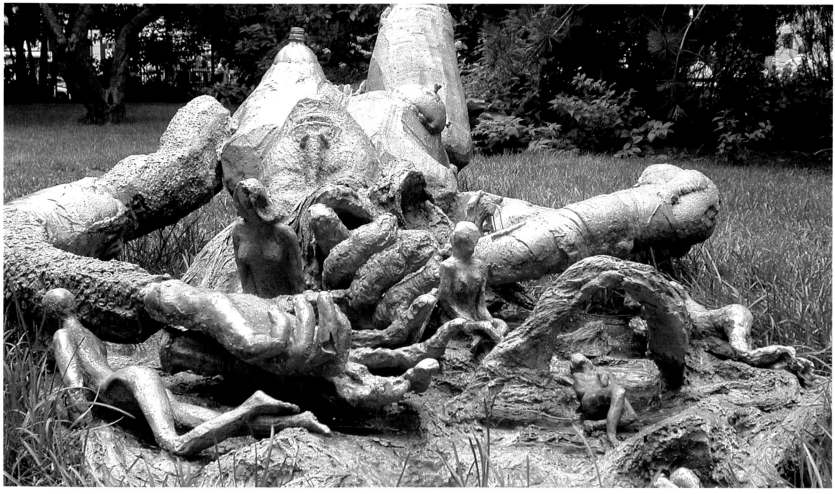

SYLWIA (WITH NOWOLIPIE GROUP), 2010
ALUMINIUM
83 X 320 X 117 CM
NEW YORK

Sylwia is the product of a series of workshops
with the Nowolipie Group sculpting from a live
model. Initially made in styrofoam, with each
member of the group sculpting a different part
of the body, it was later put together by the artist
and cast in aluminium. The project was realized
for the Public Art Fund USA and presented in
New York City. Sylwia has since been transformed
into a fountain and placed in the Bródno Sculpture
Park in Warsaw.

PERSONA (WITH NOWOLIPIE GROUP), 2007
PAINTED CERAMIC, PLYWOOD
205 X 120 X 100 CM

The ceramic figures made by the group were
placed on a wooden construction designed by the
artist in the shape of a female silhouette.

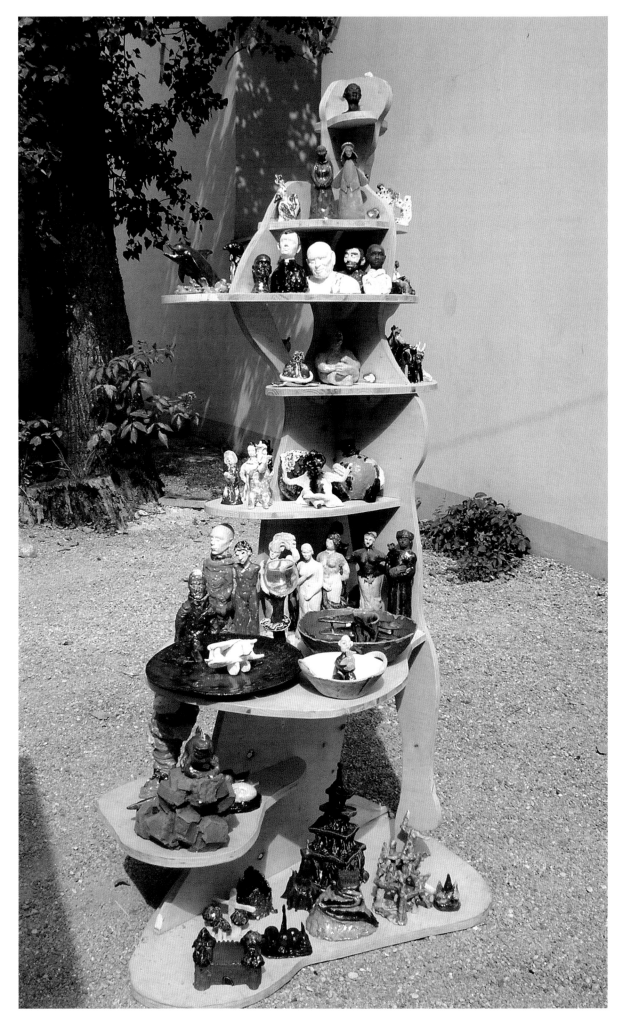

SZYMCZYK: *What about the piece you did with homeless people in 1992, in which you had them sit in the street wearing badges that said 'Obserwator' [Observer]? This piece was your response to the commission you got from the new Warsaw daily* Obserwator, *to create a street advertising campaign for the newspaper. Do you think the social context around the excluded was more repressive at the time?*

ALTHAMER: They were excluded because they had excluded themselves in the first place. Offering them another chance to join the game on different rules can't hurt anyone – them or the system. I'm convinced that, whatever my motives, I'm fulfilling a useful role. What I'm driving at is that sometimes you don't need to do anything except recognize your own choice and validate it. The homeless can stay homeless, the ill can stay ill, as long as they accept that. But if they want to change, they need to do whatever it takes. I went so far as to ask people in the Nowolipie Group whether they thought they'd caused their illness themselves, whether they'd wanted to become ill.

SZYMCZYK: *That's an extremely problematic statement, Paweł.*

ALTHAMER: I was quoting a book. But that quote somehow reflects what I think and feel. I trod softly. The group knows me, and I know them. We can be extremely frank with one another. I asked how they felt about such a statement. And one of the women said that she wanted to be ill. At that point, she was unable to do anything else with her life except suffer. Others were downright enthusiastic. They consider the time when they discovered their illness, when they were diagnosed, to be the decisive moment when they could finally take matters in their own hands and do something with a complete sense of purpose – which doesn't mean they want to stop taking medication and listening to their doctors.

SZYMCZYK: *Perhaps that's what you get when roles are clearly defined.*

ALTHAMER: Yes. They take all their roles and add one more – that of an ill person. But if an actor were to get such a role it would be neither good nor bad, right? A difficult and interesting role is an exceptional challenge. Think of it this way: so far you've been an employee, now you're an ill employee. So many challenges!

SZYMCZYK: *You said you could take your story to the papers if necessary.*

ALTHAMER: Yes, I meant the public space. I think that's a good path.

SZYMCZYK: *As an artist, you have a complex approach to mass media. On the one hand, your works address the motif of 'odd jobs' and their status. On the other, you often enter into serious relationships with magazines or TV stations. You've designed the award given by* Machina *magazine, designed sets for music videos, and you've also benefited from the strong media presence at projects like* Bródno 2000 *(2000) or* Plac zabaw *(The Playground) projects (Warsaw, 2003, and Zurich, 2006). You employed the media in order to channel information to people in a straightforward and accessible way.*

ALTHAMER: I want to send the message that my works are meant for everyone. For instance, I treat newspapers as partners even when I think their journalists are ignorant or unwilling to listen. I think I should give the press, TV or other media a chance, even at the risk of them misreading my work. Otherwise I'd just grow entrenched in my position as an artist, the one who knows better. What could I gain by that?

SZYMCZYK: *That sets you apart from many other artists whose strategy is to strictly control all information about their work, their artistic stances or views.*

ALTHAMER: But did anyone ever really manage to do that? I think it's just a terrible waste of energy.

SZYMCZYK: *You believe that handing over the initiative can yield measurable results.*

OBSERVER, 1992
PHOTOGRAPHIC DOCUMENTATION OF AN
ACTION, WARSAW

The artist was invited to prepare the advertising
campaign for a popular daily newspaper. He
invited homeless people, who spend a lot of their
day watching the world go by, to sit for some
time on a downtown pavement while wearing a
badge with the name of the paper, Obserwator
(Observer)

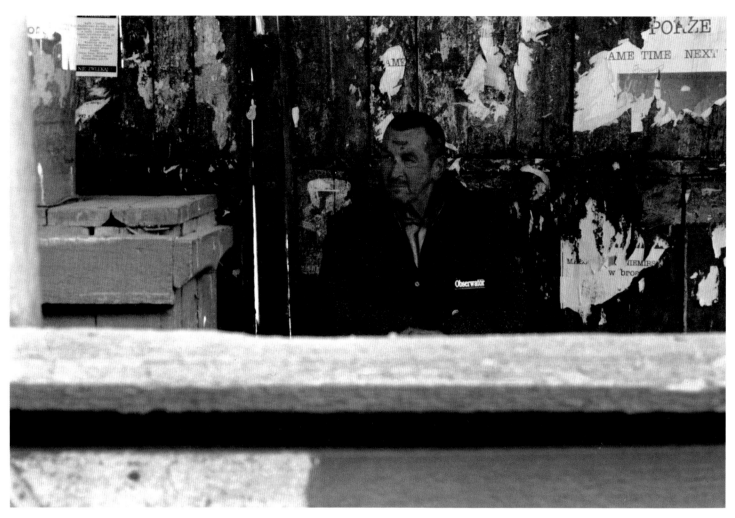

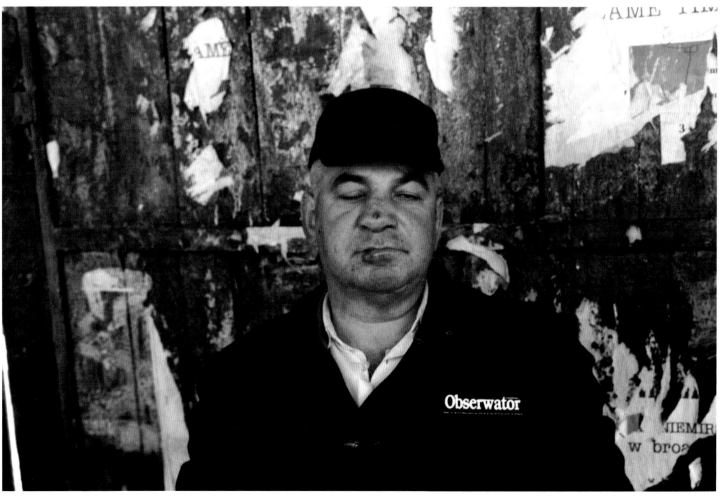

PARADISE, 2009
PHOTOGRAPHIC DOCUMENTATION OF AN
ACTION
BRÓDNO SCULPTURE PARK AND MUSEUM OF
MODERN ART, WARSAW

Paradise is part of the Bródno Sculpture Park,
a project the artist created with the Museum
of Modern Art in Warsaw as a coordinator and
artistic supervisor. He proposed Olafur Eliasson,
Monika Sosnowska and Rirkrit Tiravanija as the
first artists to participate in the Sculpture Park,

which is planned to expand in the coming years.
The artist himself organized a paradise garden
designed after drawings made by children from
the neighbouring elementary schools. During the
opening he asked his neighbours from Bródno
to pose for a group photograph, which, the very
next year, was carried in a procession to the
local church alongside women dressed as the
the Virgin Mary. The following year he installed a
fountain sculpture, Sylwia Fountain, created by
the Nowolipie Group.

SYLWIA FOUNTAIN (WITH NOWOLIPIE GROUP),
2010
BRONZE
83 X 320 X 117 CM
BRÓDNO DISTRICT, WARSAW

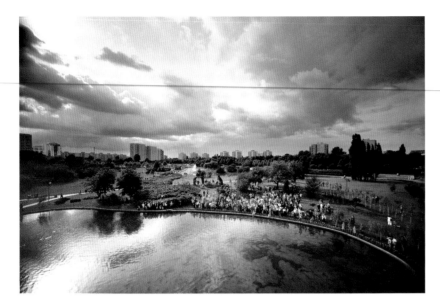

ALTHAMER: It's just as interesting when initiative is complemented by interpretation, even if it diverges entirely from the author's original intentions. That's precisely the reason I'm doing it.

SZYMCZYK: *Doesn't it bother you when the media calls you an artist who specializes in co-operation with excluded individuals, a kind of medic for difficult cases?*

ALTHAMER: That's one of the interpretations, yes.

SZYMCZYK: *But that draws you into a pre-existing social divide – there are the excluded and the people who look after them. Reading about* The Playground *(2003) or your other operations, one could get the impression that the picture is more rosy.*

ALTHAMER: It's like with books. You find something new each time you read them. When I read [Hans Christian] Andersen as a child, I thought it was just simple stories. Only later did I find room for interpretation and begin to recognize myself in his tales. No matter what you write, people will always read whatever they want into it. I can only try to express myself precisely. Why should I deprive others of the fun of exposing this precision or its lack? I don't want the game to start off with exclusion. When children are playing The Miller Takes a Wife, holding hands, dancing in a circle and so on, the point is for the fat kid to be given a go, too. All the children should get a chance to hold hands. No one should be left out. You can't say someone can't play because he'll trip or drool and spread germs, or that the miller should have a beautiful wife, so the ugly boy can't join in. In my case this seems to stem from a natural need to avoid excluding people. Besides, those who want to will eventually exclude themselves.

SZYMCZYK: *You're often approached by people doing therapeutic work with problem kids, prisoners or similar groups. How do they respond to your ideas for joint projects in prison, for example?*

ALTHAMER: That's an interesting story. When I went to the prison in Münster [for *Prisoners*, 2002], I felt prejudice at first. The curator was stressed. She thought I was flirting with danger, though she understood why. For my part, I was simply attracted to the place. I acted on that and, before long, I established a very good rapport with the prisoners, not even knowing the language.

SZYMCZYK: *There exist precedents. I immediately thought of other artists entering prisons and other institutions to confront and liven up the situation. The Cramps played in a mental asylum in the United States in 1978, and the inmates joined them on stage.*

ALTHAMER: You can be scared, but fear is not a barrier as long as you don't let it drive you. The people you meet sense this, and you tune in with them, regardless of their situation. I experienced such tuning-in when I visited the prison in Lubliniec [in southern Poland]. I was told I might find female convicts willing to participate in a project there. I was specifically looking to work with women. By being excluded from society and by virtue of their gender, they were at two removes from me. There was an appeal in establishing contact with unknown women in prison – there were the factors of femininity and sexual tension. The governor had her doubts about the project. She called me into her office to hear me out and said I was too enthusiastic, too eager. She said I needed to calm down a bit.

SZYMCZYK: *A sensible woman.*

ALTHAMER: Yes. She said the women would be wary, that they didn't trust strangers. I said I'd like to meet them in person and see what happens. So she organized a meeting in a common room. Seven or so women came. I told them I wanted to do a live TV show and I wanted them to be in it with no mention of the fact that they were convicts. I wanted them to come across as muses, happy and beautiful women who enjoy their lives. Ten minutes later, they came back and said they all wanted in. From

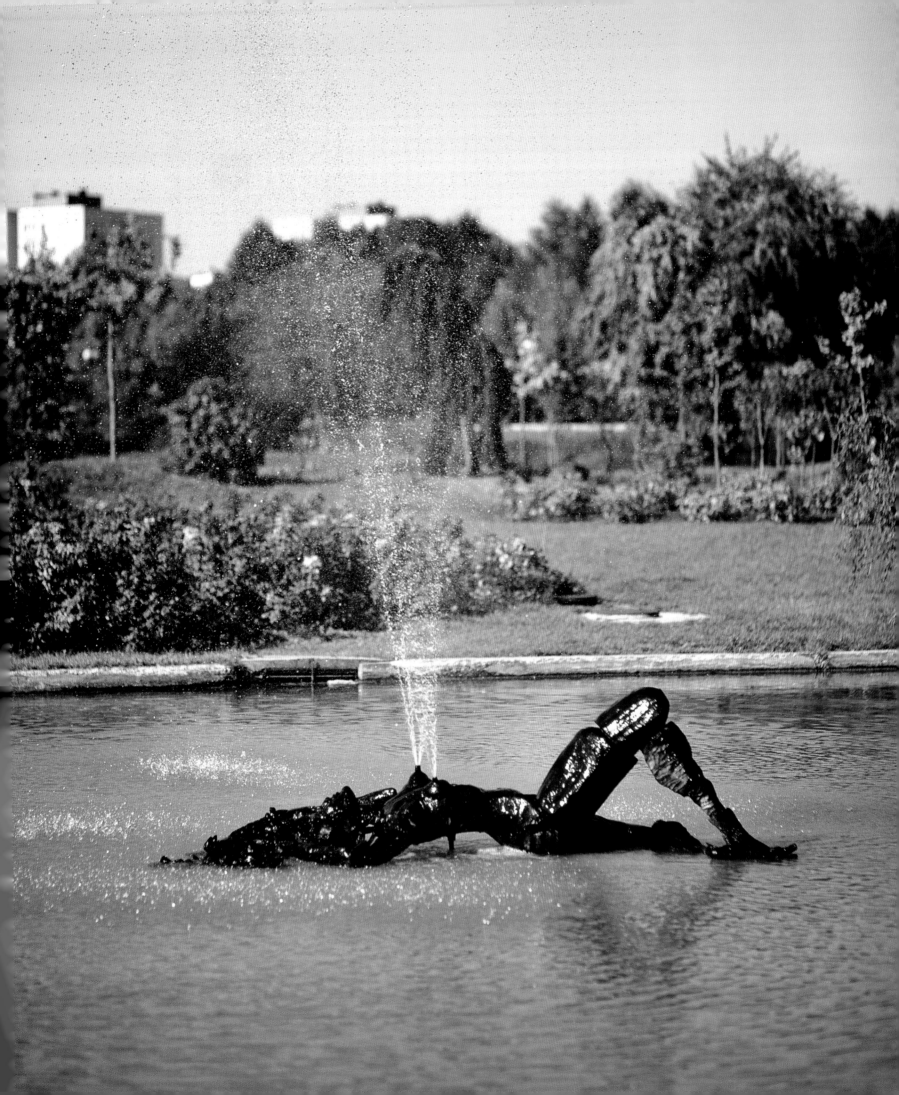

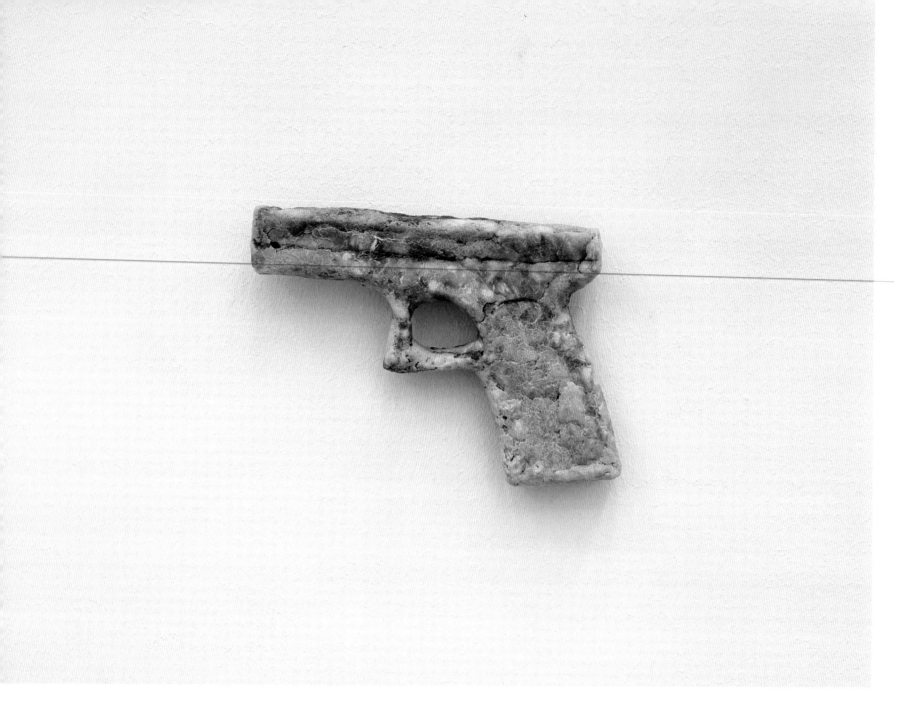

BREAD GUN, 2002
BAKED BREAD
13 X 18 CM
FROM THE PROJECT PRISONERS (WITH THE
PRISONERS OF THE JUSTIZVOLLZUGSANSTALT
MUNSTER), 2002

The concept of imprisonment and conditioning
was the source and inspiration for the artist's
2002 exhibition at the Kunstverein in Munster.
Featuring objects made by the artist himself,
such as a pistol baked out of bread; items found
in the Justizvollzugsanstalt prison, such as a an
abstract wall painting; and drawings on loan
from the prisoners, the installation drew on the
minimalist aesthetics of the white cube in which
it was shown. Several prisoners were asked
to be involved in the project and invited to the
opening without further announcement, and
approximatively ten of them came. A workshop
took place every second week throughout
the project, and the objects fabricated in the
workshop were subsequently integrated in the
exhibition space. The artist's initial installation was
gradually covered by objects expressing the real
needs and hopes of prisoners.

then on we were friends. The question is, why are people willing to trust others, even people who've been wronged by life, or who've hurt others and were punished? How come they still believe it's better to be doing something rather than nothing, that it's worth taking chances?

SZYMCZYK: *Do you think you have some kind of contract with society owing to your position, or do you sense a gap between yourself and your prospective audience?*

ALTHAMER: I can only speak about the society closest to me, and that's the Poles. I suspect I'd find things much easier in non-European societies. People here find it harder to accept propositions from someone like me, someone who's active and creative, who seems irresponsible at times, who's eager to exchange experiences and explore the bounds of communication or expression. That reluctance comes from what people were taught and the associated prejudices, although that's changing now.

SZYMCZYK: *Why is that?*

ALTHAMER: Not to sound like a megalomaniac, but my position has become significant – this interview is a case in point. The more things happen, the more proof of that I have. This, in turn, gives me energy and makes it all worthwhile and interesting.

SZYMCZYK: *You're managing to live in a number of situations that develop in parallel. There's the Nowolipie Group, a therapeutic community that co-signed some work with you. There's the situation in Bródno, where you live and animate the locals to act up. There's your studio in Praga, where our conversation is taking place and where I see a lot of old, new and unfinished works, but which looks extremely small and modest. And there is your growing presence in the international art world. These different conditions of production and reception of your work seem hard to balance, if not totally incompatible.*

ALTHAMER: I've gained a certain harmony recently. I think everything is interrelated – circles representing overlapping sets.

SZYMCZYK: *I'd like to see you draw that.*

ALTHAMER: I'd need to visualize it first. There's the sphere of freedom and self-fulfilment. It would contain co-operation with museums and people who trust me, who give me opportunities to express myself and take advantage of what the world has to offer. The Nowolipie Group and my work with them would intersect with this circle. It would have been inside it if my trainees had started doing individual exhibitions. Family, my role as a father, husband, etc., would form a circle around the first one. That's how I see it. But perhaps you could use other figures instead of circles. Visualizing it would be a sculptural challenge. I could make a work around that. It would probably resemble a planet, and the figures could move freely. I could bring in the circles of my neighbours whenever I form a team with them. The whole thing would resemble Chaplin's *Modern Times*, in which a giant cogwheel meshes with others to form a machine. Perhaps that's the greatest source of energy and force. But this large wheel has considerable inertia. With time, its energy might be transferred to other wheels.

SZYMCZYK: *How did you get to the idea of involving your neighbours in* Common Task?

ALTHAMER: I wanted to invite a group of neighbours from my block of flats to travel with me so that, when I was invited to a project like the one I did in Oxford for Polska! Year (2009), I'd have the group join me, because they're Polish and I'm a Polish artist.

I was invited by virtue of being an artist, so once they became artists they were able to come along. What interesting things did they do once they became artists? Well, our being a team is a performance in itself, so they didn't really need to do anything if they didn't feel like it. They could stay silent and question everything the others are doing. Initially I wasn't sure who'd want to join the group, who'd be willing to embark on a journey. It got more complicated, more saturated, when we decided to make the sci-fi film. Then, besides travelling and being a team, the group was also acting in a film.

SZYMCZYK: *That's a working method you seem to use quite often: organizing a 'landing party', as in your* Bad Boys *project in 2004, when you travelled with the difficult youth from Bródno to Bonnefantenmuseum in Maastricht.*

ALTHAMER: Yes, but it's a two-sided operation. They don't know that. It's a bit deceitful on my part, but it's done with good intentions. They're being air-dropped, but they're air-dropping me along with them.

SZYMCZYK: *You're the instigator.*

ALTHAMER: Generally they'd need to draw their own circles and think what they stood to gain.

SZYMCZYK: *That's an idea that could work as a one-off excercise, but what next?*

ALTHAMER: Things will go down other tracks, slightly altered ones. There's this machine that collides particles, an accelerator.

SZYMCZYK: *Constructed to discover the rules governing the universe.*

ALTHAMER: Of which we ourselves are particles.

TRANSLATED FROM POLISH BY KRZYSZTOF KOŚCIUCZUK

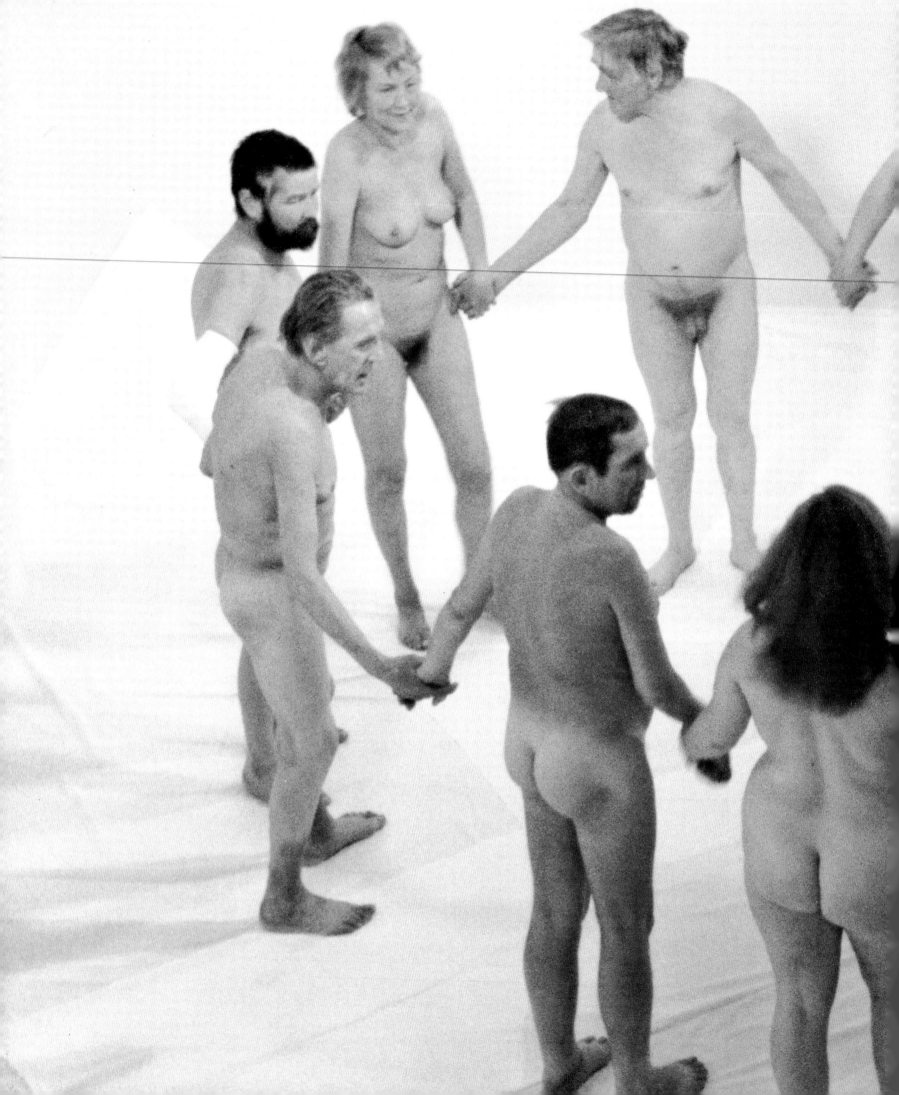

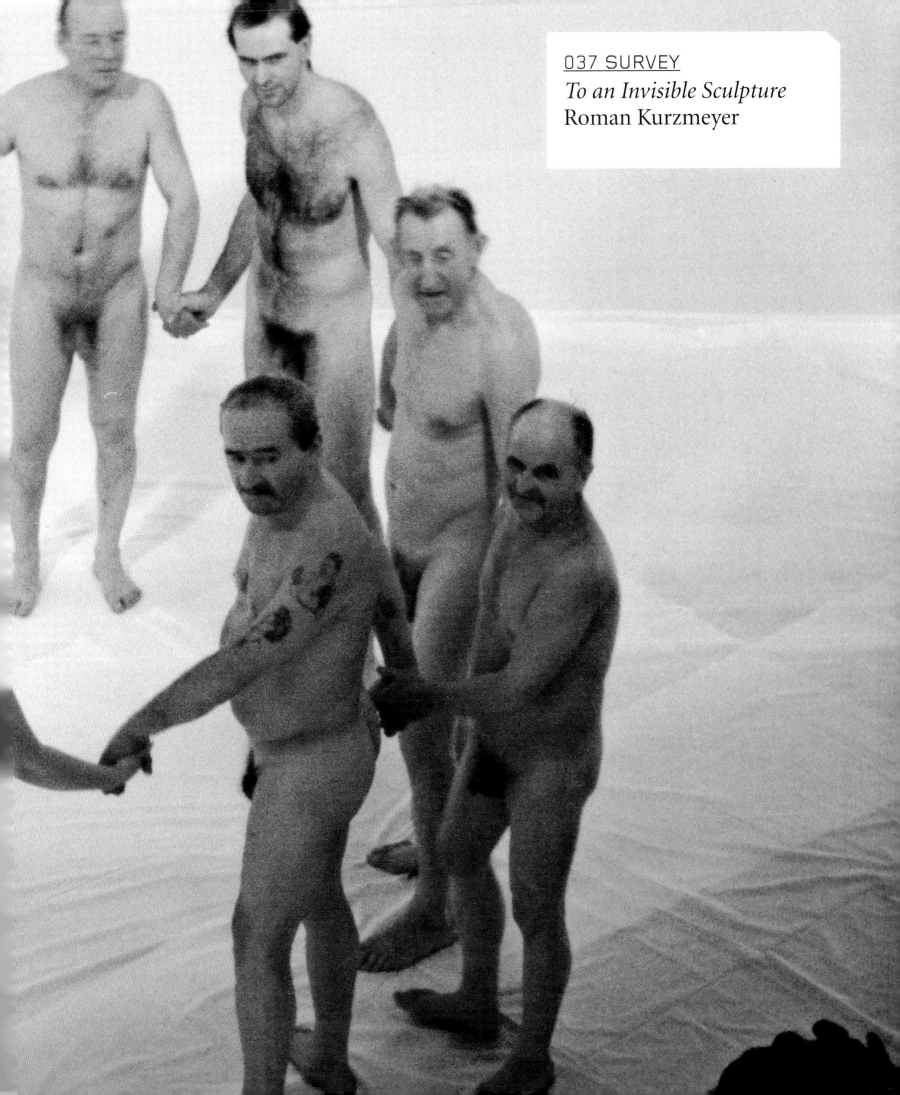

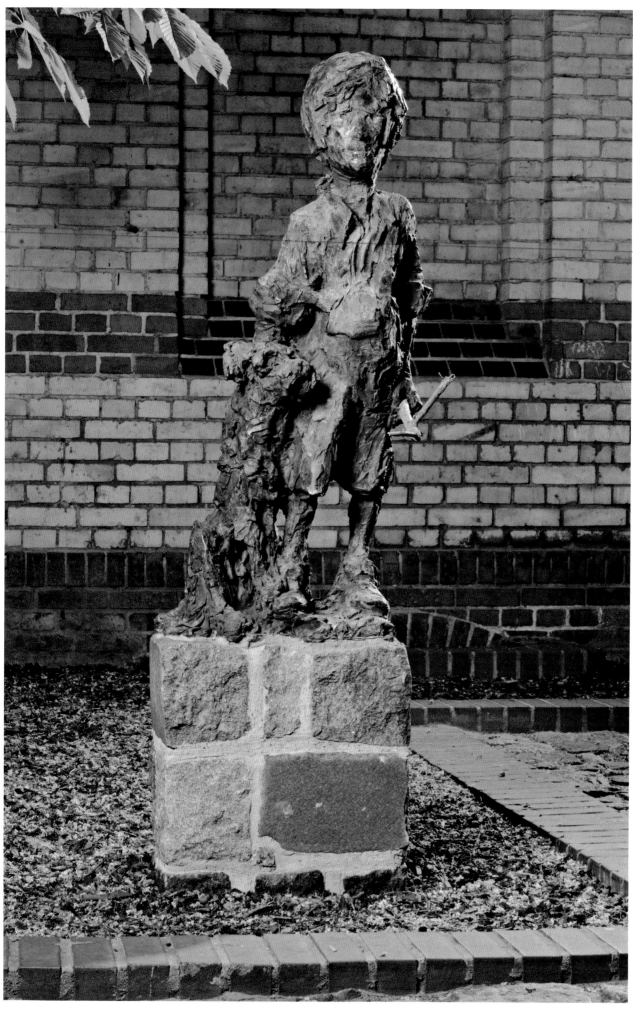

ABRAM AND BURUŚ (DREAM SCULPTURE), 2007
BRONZE, GRANITE COBBLESTONES,
WOODEN STICK
160 X 31 X 48 CM

ABRAM AND BURUŚ (DREAM SCULPTURE), 2003
PENCIL DRAWING
29 X 21 CM

During one of the hypnosis sessions he undertook
for So-Called Waves and Other Phenomena of
the Mind (2003–04), the artist returned to one
of his earlier incarnations: Abram, a small boy
wandering in the ruins of the Warsaw ghetto
with his dog, Buruś. The artist represented this
vision in a drawing he made immediately after the
session and later executed the sculpture Abram
and Buruś. It is cast in bronze, and the boy figure
holds a real wooden stick.

previous pages:
DANCERS, 1997
VIDEO ON 5 MONITORS
3 MIN. 34 SEC
PRODUCTION PHOTOGRAPH

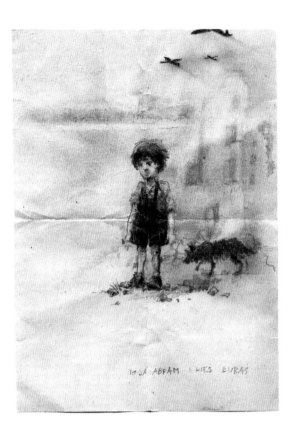

Bródno is a poor, densely populated suburb in the east end of Warsaw, the Polish capital. It is where Paweł Althamer lives with his family, occupying a flat in one of the large blocks in Krasnobrodzk Street. The lifestyle of this quarter is heavily marked by poverty, social conflict and violence, which inevitably affect his daily life. Although he is successful enough on the international art scene to move himself and his family to a better part of the city, or to an art capital abroad, the suburb of Bródno is not just a place to live; his roots are here. His idea of art and his own approach to it, which he calls 'reality-related', have a great deal to do with the lives of underprivileged people, with whom he feels a great affinity and, more importantly, whom he tries to be close to so that he can involve them in his projects. His sense of identity with this place – weighted down as it is by material want, disappointed hopes and neglect – is so strong that he, in a film documentary about the enormous block he lives in, points back at the building and tells the camera that he built it with his father. From his kitchen he can look into the courtyard formed by the flats. In it is a playground he designed to the specifications of the children who live here and then constructed in his father's engineering works. It also contains a little sculpture he created for this location.

The bronze statue, *Abram and Buruś* (2007), is of a dog and a boy whose hand holds a small wooden stick. It stands outside the entrance to the building on a little lawn where the dogs from the block often play with each other and relieve themselves. This site for the figure was carefully chosen, as it is where the occupants of the building meet and swap news while the dogs go about their business. Althamer regularly has to replace the boy's little stick, which can easily be taken from the

hand's metal grasp; people borrow it to play with the dogs as they rampage around, and it gets left lying about. The origins of this sculpture lie in a drawing made after a visit to a Warsaw hypnotist in 2003. Althamer, under hypnosis, saw himself as a Jewish boy at the time of the Second World War. The drawing shows the boy accompanied by a shaggy black dog; there is rubble underfoot and three aircraft overhead. The hypnosis was documented by Artur Żmijewski in a video called *Hypnosis* (2003). Friends since they were students under Grzegorz Kowalski at the Warsaw Academy of Arts, Żmijewski and Althamer have worked together on several occasions. The video, in which Althamer undertakes a journey into the horrors of the war and reports on the destruction of the Warsaw Ghetto from the point of view of a Jewish boy, was made for the exhibition 'So genannte Wellen und andere Phänomene des Geistes' (So-called waves and other phenomena of the mind) at the Kunstverein für die Rheinlande und Westfalen in Düsseldorf. The exhibition documented attempts by the two artists to shift themselves into other dimensions of space and time under the influence of drugs. As the Polish art historian Joanna Mytkowska writes, 'Paweł and Artur made a trip to the Real de Catorce desert in Mexico to check the possibilities of mental transmigration offered by a magic plant, the peyote. Not entirely satisfied with the experience – some substances do not encourage sharing the experience – they visited a hypnotist in Warsaw upon their return. The result was a unique documentary of Paweł's trip to – depending on interpretation – his subconscious, a past life or collective memory.'[1] *Abram and Buruś* is important in many respects because this sculpture, which Althamer calls a memorial, suggests his interest in other dimensions of space and time without detracting from his work's characteristic realism. The

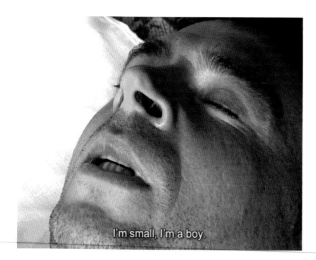

I'm small, I'm a boy.

Yes. 1945.

HYPNOSIS (WITH ARTUR ZMIJEWSKI), 2003
FROM THE SERIES SO-CALLED WAVES AND
OTHER PHENOMENA OF THE MIND, 2003-04
VIDEO
13 MIN 17 SEC
WARSAW

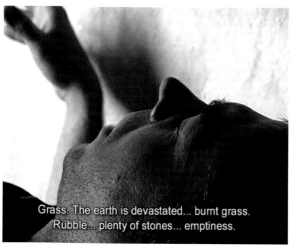

Grass. The earth is devastated... burnt grass.
Rubble... plenty of stones... emptiness.

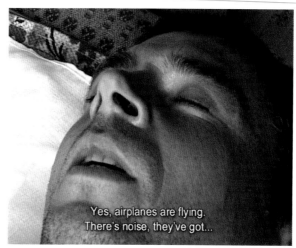

Yes, airplanes are flying.
There's noise, they've got...

That's the end of the town.

There is smoke.
There're some holes instead of houses.

It is Warsaw on the other side.

It scares me...
It scares me to move away from there.

GUMA, 2008
POLYURETHANE ELASTOMER,
POLYURETHANE FOAM, STEEL ARMATURE,
STEEL SPRINGS, PLASTIC
169 X 74 X 47 CM
PRAGA DISTRICT, WARSAW

A portrait of a legendary tramp from the Praga district, who was called 'Guma' (Rubber) as he was always swaying. After Guma died, the artist and the children from the Praga district decided to honour him with a monument placed in front of the bar where he used to stand. The sculpture was executed in rubber and is set on a special base that causes the sculpture to sway back and forth when lightly pushed.

narrative about a Jewish boy in Poland's traumatic war experience still touches on a social taboo in Poland. *Abram and Buruś* is Althamer's response to Jerzy Jarnuszkiewicz's *Little Insurgent* (1983) in Warsaw old town, an area full of monuments and memorial tablets. The statue of a boy with a gun slung round his shoulders and a helmet that is too big for him recalls the numerous child soldiers killed in the Warsaw uprising battles in autumn 1944. Unlike this work, *Abram and Buruś* is a memorial with no monumental quality. Abram is not carrying a weapon, just a little stick in his hand that local people use while playing with their dogs.

The logic of sculpture and that of monuments were closely connected with each other before modernism. At a first glance, *Abram and Buruś* fits in with this pre-modern logic fairly precisely. The American art critic Rosalind Krauss had this to say on the subject: 'By virtue of this logic a sculpture is a commemorative representation. It sits in a particular place and speaks in a symbolical tongue about the meaning or use of that place.'[2] *Abram and Buruś* does not fit in with this memorial logic because of the instrumental concept of the work of art that underlies it. Althamer has worked in this direction in a variety of ways, and in doing so he has tried

to redefine the idea of the memorial. *Guma* (2008), for example, is a life-sized portrait of a drinker created for the spot the man always used to occupy outside a bar. He was remembered in the district because he always stood there silently, his head bowed. The statue was intended to be placed directly on the asphalt and mounted on steel springs so that people could touch it as they passed, setting it in gentle motion.

Althamer built *Guma* with young people who were involved in his *Einstein Class* (2005), a project that Krzysztof Visconti documented in a film of the same name. As part of an exhibition in Berlin for the Einstein Year in 2005, Althamer worked with young people who had learning difficulties. They came from the Warsaw suburb of Praga, where his modest studio had been located for some time. There, in the loft of a large post-war brick building, next door to artists no one mentions outside Poland, is where Althamer's sculptures are created, and it was here that Althamer met with his class to teach them. An additional space was rented with part of the project money, and teachers were paid to train the young people in their own classrooms and on excursions to places outside the city. The aim was to help them to perceive things more precisely through observing physical phenomena and to make them self-confident

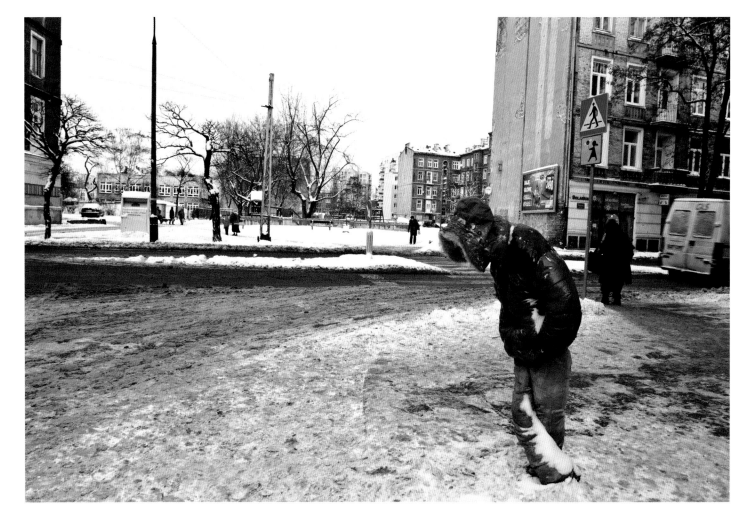

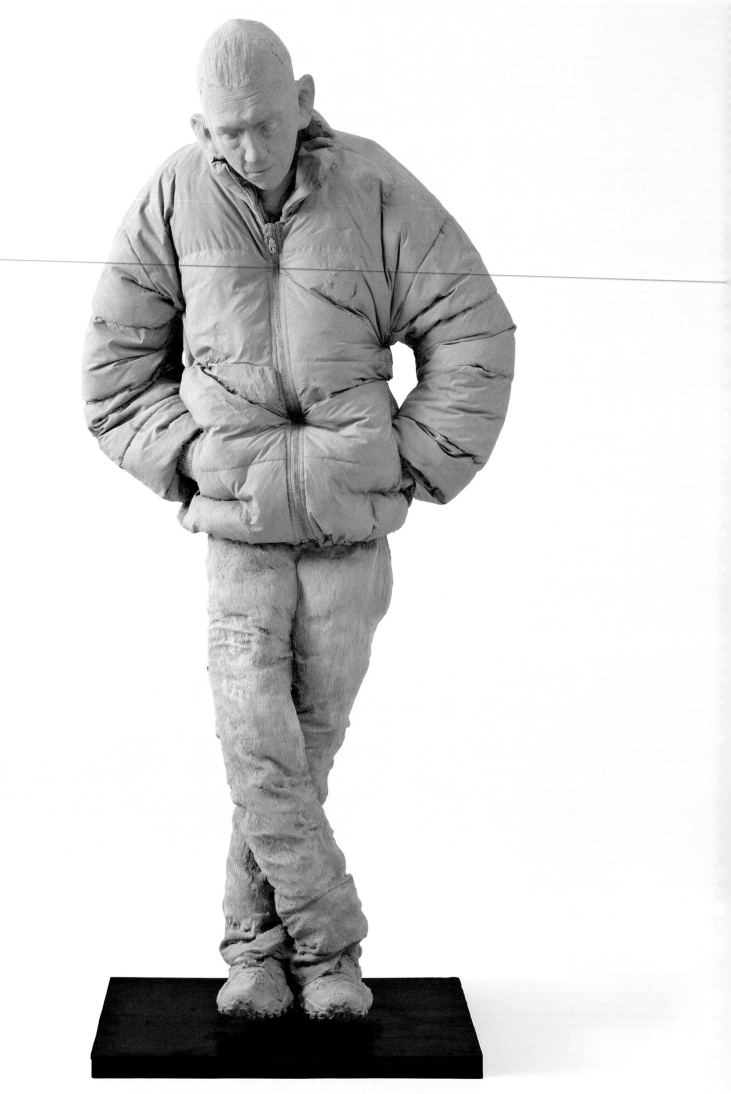

GUMA, 2008
POLYURETHANE ELASTOMER,
POLYURETHANE FOAM, STEEL ARMATURE,
STEEL SPRINGS, PLASTIC
153 X 74 X 47 CM

EINSTEIN CLASS, 2005
PHOTOGRAPHIC DOCUMENTATION OF AN
ACTION, WARSAW AND BERLIN

Commissioned to make a project as part of a
major celebration of Einstein's centenary in
Berlin, the artist used the funds to give physics
classes to a group of troubled teenage boys.
Led by a maverick physics teacher who had
recently been made redundant, the boys learned
about Einstein's discoveries through practical
experimentation in a rented building that served
as their classroom. During the six months the
project lasted, the kids went on trips to the
countryside, had a week's vacation by the sea and
travelled to Berlin for the opening, which for some
was the first time they'd been outside Warsaw.

and self-motivated. Althamer says that the process was intended to give the young people a positive experience of life that would not have been possible for them in the context of their families, schools and personal lives, most of which were difficult.

As an artist, Althamer is primarily interested in processes that he is able to set in motion with projects like the *Einstein Class* and not in the aesthetic quality of the objects created through them. He still shows these objects, but such displays are 'secondary exhibits'.[3] One is reminded of a remark by the German art historian Hans Belting, who identified tendencies in art since the 1960s 'to drive the art out of the work that can be exhibited'.[4] For example, the ceramics created as part of Einstein Class were shown in the 'Einstein Spaces' exhibition in the Archenhold observatory in the Berlin suburb of Treptow alongside other items left over from the lessons. From the outset, Althamer has seen the performative dimension of artistic work, which draws in viewers not just as observers but as active participants, as an essential prerequisite for a successful work of art. As we will see, this process can spread authorship among a number of people.

Open Form and Common Space, Private Space

Althamer studied in Grzegorz Kowalski's sculpture class at the Warsaw Academy of Fine Arts from 1988-93. One of Kowalski's predecessors at the Academy was the architect and artist Oskar Hansen (1922-2005), who directed its Plane and Solid Figure Design Studio[5] until

his retirement, teaching the principles of Open Form there from 1955. Althamer did not meet Hansen until shortly before his death, when Hansen was preparing his last exhibition at the Foksal Gallery Foundation in Warsaw, with Althamer assisting in its technical realization. Hansen said that the artist's duty is 'to shape space with visual structures not only so as to look but also so as to see. To see the most important thing in space – the human being, who is so difficult to make out, to distinguish from the chaos of the object-littered, object-cluttered space of Closed Form that surrounds us today. Here, in this laboratory space, visitors are subjects and at the same time viewers and actors taking active part in a cognitive analysis of the human figure displayed by a formally absorptive, anti-materialistic background – Open Form.'[6]

As art historian Michał Woliński summarizes, Oskar Hansen's most important postulates were

– *diversity (man treated individually and with his whole dissimilarity; an opposition against the modernist striving towards standardization and schematization);*
– *transformability, flexibility, processuality (the human environment should be transformable depending on its users' activity and evolving needs and preferences);*
– *participation (the users 'co-authoring' the spatial arrangement by adapting it to new needs; people in active relation with the space);*
– *communication (spatial composition as the background for interpersonal relations and as an instrument of visual influence, as a medium of ideas that can affect people's consciousness and influence their needs and attitudes);*
– *scalability (the method, as well as its individual*

OSKAR HANSEN
OUTDOOR GAMES SKOKI OPEN AIR, 1972
PHOTOGRAPHIC DOCUMENTATION OF A
WORKSHOP, SKOKI, POLAND

OSKAR HANSEN
DREAM OF WARSAW, 2005
top,
ARCHITECTURAL MODEL OF TV TOWER
MOUNTED IN TREE
250 X 80 CM
bottom,
HANSEN AND ALTHAMER INSTALLING THE
WORK AT FOKSAL GALLERY FOUNDATION,
WARSAW, 2005

As a polemic against the obtrusive form of the
Stalinist Palace of Culture and Science, built in
the 1950s at the very centre of Warsaw, Althamer
assisted Oskar Hansen (1918–2005) in mounting
an architectural model of a nonexistent tower
that, when seen from the gallery, counterbalanced
the palace in the skyline of the city. Exhausted by a
long illness, Hansen passed away soon after

elements, can be applied equally well to a model of reality, for example a sheet of paper, and to space where the Great Number problems are present; Hansen discerned between micro scale (the building interior), mezzo scale (the housing estate) and macro scale (the geographical region);

– integration (of the space elements, disciplines of art, art and science, people with their diversity, and also integration of the human beings with nature, which was to be facilitated by science and new technologies).[7]

Grzegorz Kowalski calls his own educational method, which he still deploys as a sculptor and performer in his class at the Academy, the 'didactics of the partnership'. Over several decades Kowalski developed a curriculum directed at joint processual work in his class. The students do not work on self-imposed tasks but take part in exercises that are a fixed part of the teaching programme. One of these exercises, which was regularly carried out by Althamer even when he was still a student, is called 'Common Space, Private Space'. It is worth quoting Kowalski's 1985 description of the exercise in full, as it makes clear why Althamer and other internationally known Polish artists of the middle generation, such as Artur Żmijewski and Katarzyna Kozyra, look for co-operation, proceed performatively and see the process itself as a work of art:

1. In 'Common Space, Private Space' we are all, students and teachers, on equal terms as participants. We each have our definite private space and access to the space which is a field for our common activities. For example:

a long table, with photographs of participants' faces on it. This structure allows to define characteristics of one's own artistic language (in the photograph) and its involvement in activities in the common space (the table).

2. We assume that the language we will use is not based on words but generally made up of signs, signals, gestures, whose repertoire will depend on the situation. Example: marking one's presence in different parts of the common space with one's 'own' colour.

3. The aim of this task is to actively participate in the process of communication without the use of verbal language.

4. The process itself is unpredictable and depends solely on the creativity of the participants and the 'temperature' of contact between them. We agree to one thing: the participants will not engage in destructive actions. This restriction is necessary, since communicating with the use of an un-codified language is a fragile process and can easily be broken with a reckless gesture. However, experience proves that a destructive action can lead to new experience, therefore we give up destruction only if it would end the process.[8]

In his explanations of the rules of the game, Kowalski makes it clear that these conditions he has formulated mean that each work of art exists on a limited time-scale and only in the given situation. There is no audience, but multiple authorship, as everyone present has to be included in the process. Records of this process have no artistic status, nor does any interpretation of it.

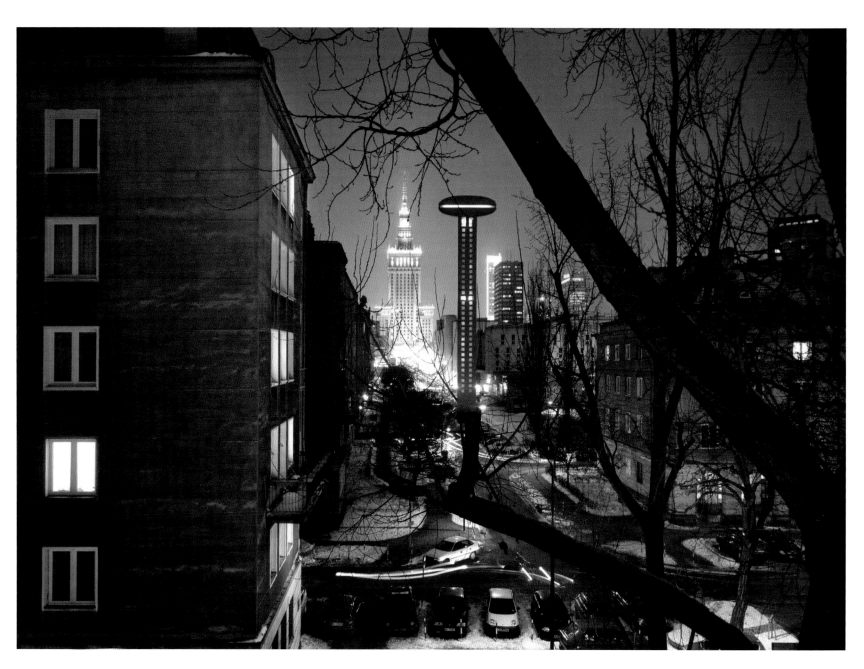

The action, created while the artist was a student at the Academy of Fine Art in Warsaw, was a response to an assignment formulated by professor Grzegorz Kowalski on the subject of a 'junction of two points'. Althamer proposed a chess game played on two boards, with the players (Althamer and Mikołaj Miodowski) sitting with their backs to each other and trying to communicate telepathically.

When I asked Kowalski about Althamer's work with the Nowolipie Group, he was not slow to reply.[9] What interests him about it as an artist are the communicative processes Althamer is able to trigger and the devotion that keeps him there, not the objects that are now on display in an exhibition.

The Nowolipie Group is made up of adults, most of whom are suffering from multiple sclerosis. Althamer meets them every fortnight for a ceramics workshop in Nowolipki, a well-know Warsaw educational institution run by the Arts Council. Under the name Paweł Althamer & Nowolipie Group, creations from this workshop have been shown in recent years at exhibitions such as 'Double Agent' (Institute of Contemporary Arts, London, 2008), where the small ceramic sculptures were shown on tables and in showcases designed by Althamer. Rafał Kalinowski, who has taken part in Althamer's courses for many years, makes models of historic aircraft and explains why he is so passionate about them in Artur Żmijewski's documentary video *Winged* (2008), in which he accompanies the Nowolipie Group on a trip above Warsaw in a historic propeller aeroplane. When Althamer is asked why he is so fascinated by working with the Nowolipie Group and his reasons for taking the chance to exhibit with them, he says, 'We are self-proclaimed. But I like this self-proclamation idea. I think self-proclamation is like self-awareness, self-judgment, self-sufficiency. I like that.' And he goes further: 'I also encounter attitudes I would not normally see with artists.'[10] Relevant in this context is the installation

Prisoners (2002) at the Westfälischer Kunstverein in Münster, in which pieces produced in various workshops Althamer ran with inmates from the Münster Penal Institution were shown alongside his own works.

Some of Althamer's well-known early work was produced while he was still studying at the Academy. The performances *Cardinal* (1991), *Water, Air, Space* (1991), *Boat* (1991) and *Astronaut Suit* (1991) should be mentioned, but so should a performance in the Polish town of Dłużew in the winter of the same year (*Untitled*, 1991). For it, Althamer sat down in the icy cold of a snow-covered field wearing a homemade white garment without any openings for his face and hands. He wore warm clothes under this white shell, which he had additionally stuffed with newspaper. He remained sitting in the field for many hours, moving as little as he possibly could, and listened to the people walking by. He followed their conversations, heard comments about the snowman that the passers-by thought he was, and observed the way his sensory perceptions changed. The sculptures *Okno* (1988) and a *Self-Portrait in Ceramic Material* (1989) were created during his first year as a student. *Okno* is a portrait of a meditating figure whose seated body is wrapped in jute. The arms are held close into the body, and the hands are resting on the figure's thighs. Attention is drawn to the finely detailed face and its closed eyes. Kowalski remembers that Althamer liked to work on his own, outside the group, and quickly showed that he was a talented sculptor who was interested in self-portraiture from the outset.

WINGED (WITH NOWOLIPIE GROUP AND ARTUR ZMIJEWSKI), 2008
VIDEO
8 MIN. 45 SEC.
WARSAW

Documentation of a sightseeing flight of the Nowolipie Group over Warsaw. It was important for the artist to get the members of the group off the ground – a highly symbolic moment as most of them are confined to their wheelchairs.

CARDINAL, 1991
opposite, top, PHOTOGRAPHIC DOCUMENTATION OF AN ACTION, ACADEMY OF FINE ARTS, WARSAW
opposite, bottom, VIDEO INSTALLATION
8 MIN.
228 X 216 X 60 CM
FONDAZIONE NICOLA TRUSSARDI, MILAN

The work was an academic assignment to represent a cardinal's ceremonial garments. The artist built a wooden stage on which he placed a tin bathtub filled with a mixture of water and purple papier-mâché. He sat naked in the bathtub and smoked several joints. High on marijuana, he played taped religious music of different cultures and talked to himself and to the audience. His intention was to reduce the religious experience to its bare rudiments. The hierarchy present in any organized religion was questioned, and the estatic and ritual elements were reclaimed.

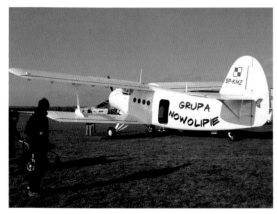

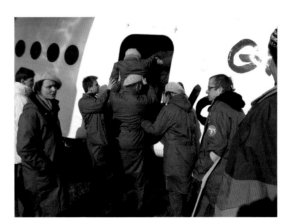

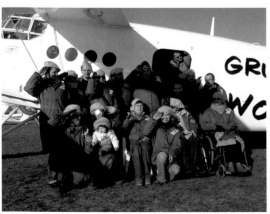

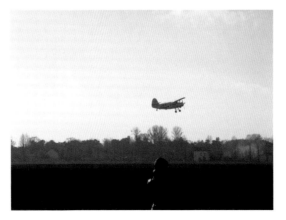

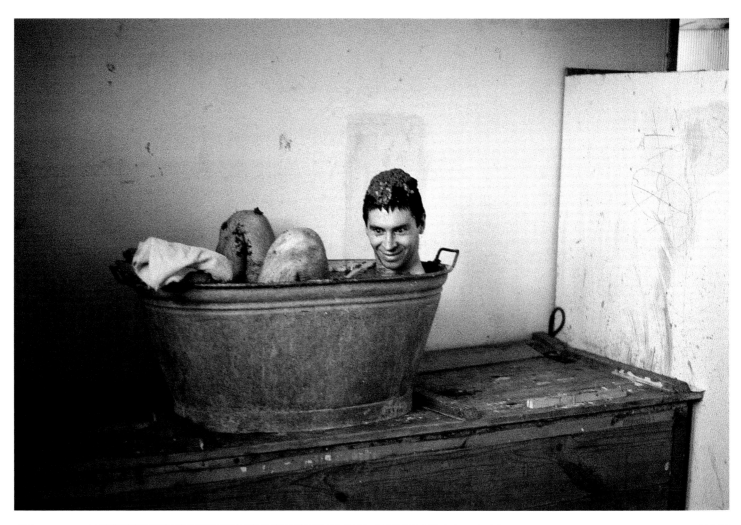

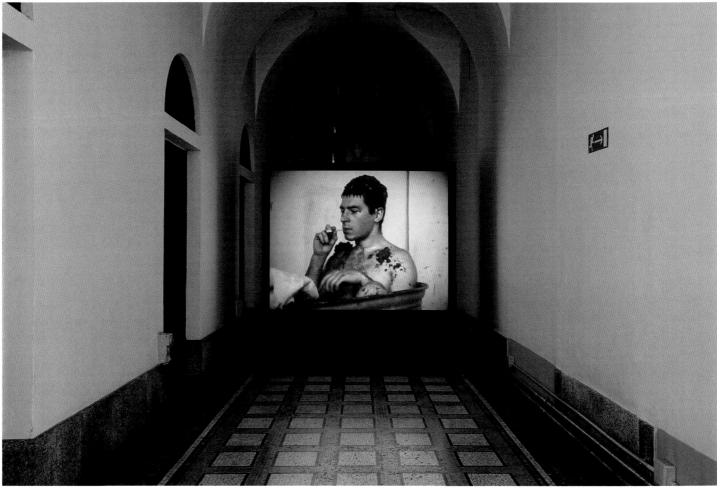

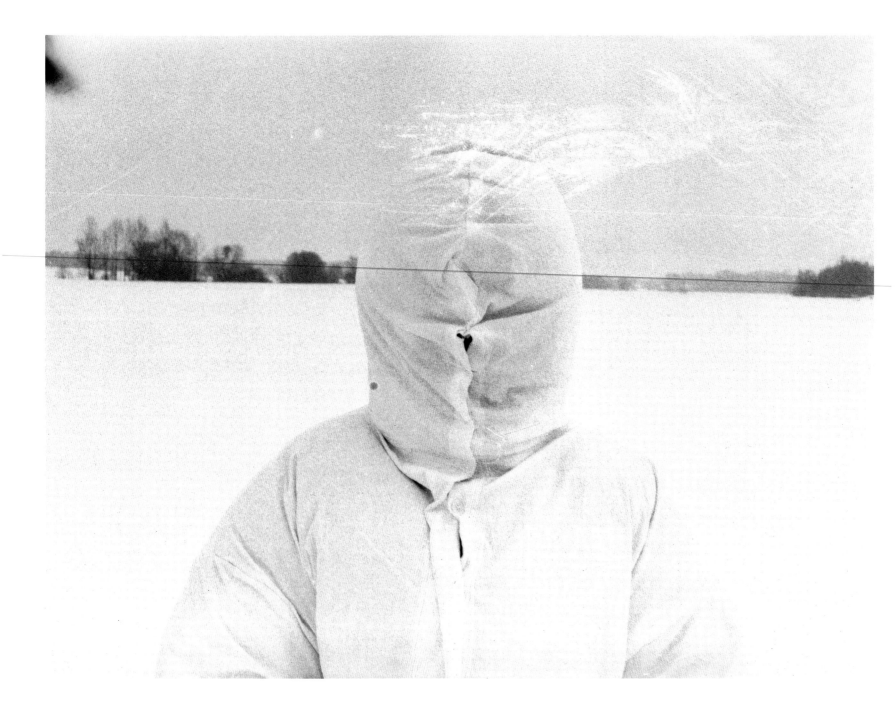

UNTITLED, 1991
PHOTOGRAPHIC DOCUMENTATION OF AN
ACTION, DŁUZEW, POLAND

Early in the morning, the artist sat in the middle of
a snow-covered field dressed in a white costume
he had made, with no openings for the face or
hands. Beneath it he wore a bulky anorak, and
he had stuffed the costume with newspapers for
protection against the cold. While he sat almost
motionless, he could hear passers-by from the
nearby village of Dłuzew making comments about
the 'funny snowman these art students built in
the field'. (The performance took place during a
students' field trip.) Eventually the artist began
to suffer from sensory deprivation. He continued
a few hours more, until his professor asked him
to stop.

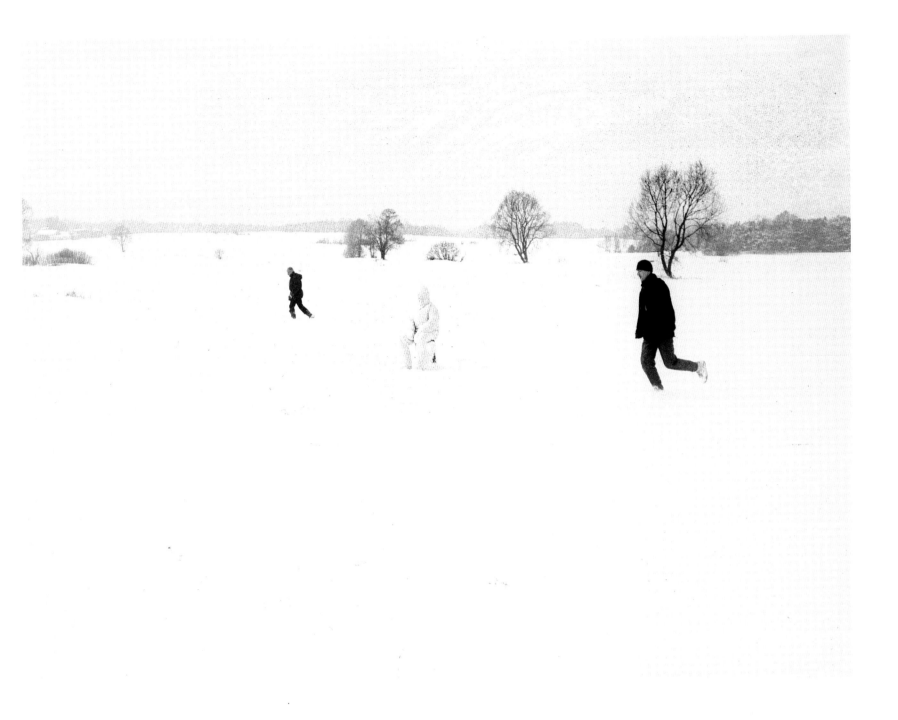

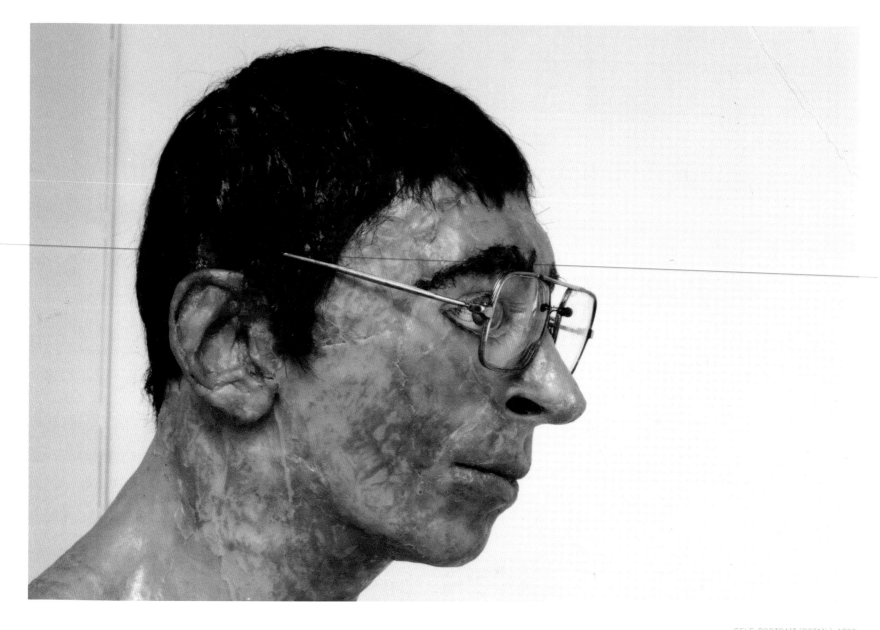

SELF-PORTRAIT (DETAIL), 1993
GRASS, HEMP FIBRE, ANIMAL
INTESTINE, WAX, HAIR
189 X 76 X 70 CM

His final project for the Academy consisted of two parts: the sculpture *Self-Portrait* (1993) and a video called *Master's Project* (1993). He made the life-size, naturalistic, nude portrait of himself from grass, hemp, animal intestine, wax and hair. The video shows the artist leaving the Academy, getting on a bus and travelling to the end of the town. The camera follows him into the woods, where he takes off his clothes and disappears naked into nature. Contrary to regulations, he was not present at the final examination. Instead his then-wife Monika read out an explanation and showed the video. Kowalski writes, 'Plunging into nature was not a symbolic return to human primeval condition. It was the reunion at the level of one's ego freed from corporeality. I knew earlier works of Althamer and his yearning to "become like ether", to fly away to other levels of reality. He was building space isolating him from the world: a water "sarcophagus", a watertight iron boat. He sewed suits zipped up from the feet to the top of the head. He constructed a pitch-black darkroom. He plunged himself into the water, closed and isolated himself in order to experience exteriorization of his ego.'[11] Many years later,

when asked about his course with Kowalski, Althamer said, 'This was also when I discovered I wasn't as lonely as I had thought. To the contrary, after that experience, I have found my friends in the woods, quite literally: I discovered trees as friends, nature and all the creatures around me, so I only remained lonely on the human level, only in one layer of my consciousness, which is not the only one that I have. And then a lot of people appeared along the way, allies you meet that make your load lighter. And these were the guides I had.'[12]

This experience of himself, as well as the visual representation of this experience, is still one of Althamer's central interests. He is concerned not merely with physical and borderline psychological experiences but also with the way he perceives himself in various life situations. Even in the early works, addressing public space and the people who appear in it were no less important. Here what he wanted to debate through his art were not social or political questions but rather individual human beings and their concrete reality, which he always presented respectfully. In 1992 he was asked to

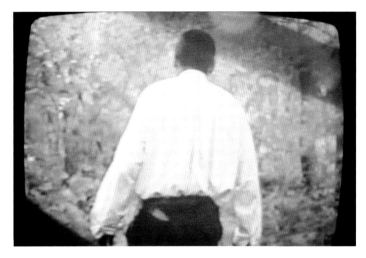

The video, which formed an integral part of
Althamer's work for his master's project, shows
the artist as he walks out of the Academy hall,
through the city and into the forest, where he
takes his clothes off and disappears into the trees
The video was shown alongside Self-Portrait for
his master's exam, at which the artist was not
present His wife read a statement on his behalf
'I build a man sculpture – the figure of Paweł
Althamer, who is the focal points of my interests
It is a desire to record the physical presence of
myself – my confrontation with my work[...] the
ephemerality of a living human being recorded in
the shape of a wax effigy-puppet Does being next
to a dead man-object make me experience my own
animation more strongly? Or is it only a stronger
experience of my physicality?'

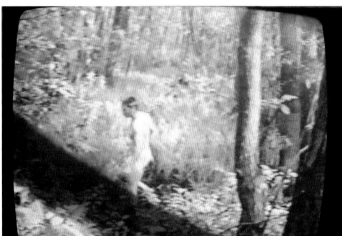

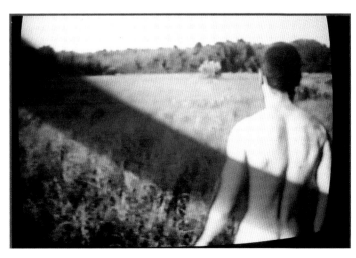

ASTRONAUT 2, 1997
PHOTOGRAPHIC DOCUMENTATION OF AN ACTION,
DOCUMENTA 10, KASSEL, GERMANY

A former military mobile command unit was turned
into a living space for one person for the duration
of Documenta 10. Part of the vehicle was accessible
to the public, accommodating two viewers at a time,
with a tiny LCD monitor installed above the door.
Visitors could watch a video that showed a man
walking around Kassel in a self-made spacesuit – a
suspicious visitor from outer space encountering
random passers-by, wandering through a forest and
a quarry and finally bathing in a swimming pool. The
vehicle stood in a local park like a landing module from
another planet. Its inhabitant, hired by the artist in
Poland to act as his alter-ego, looked like an alien
astronaut who had landed in the extraterritorial
space of a huge international exhibition.

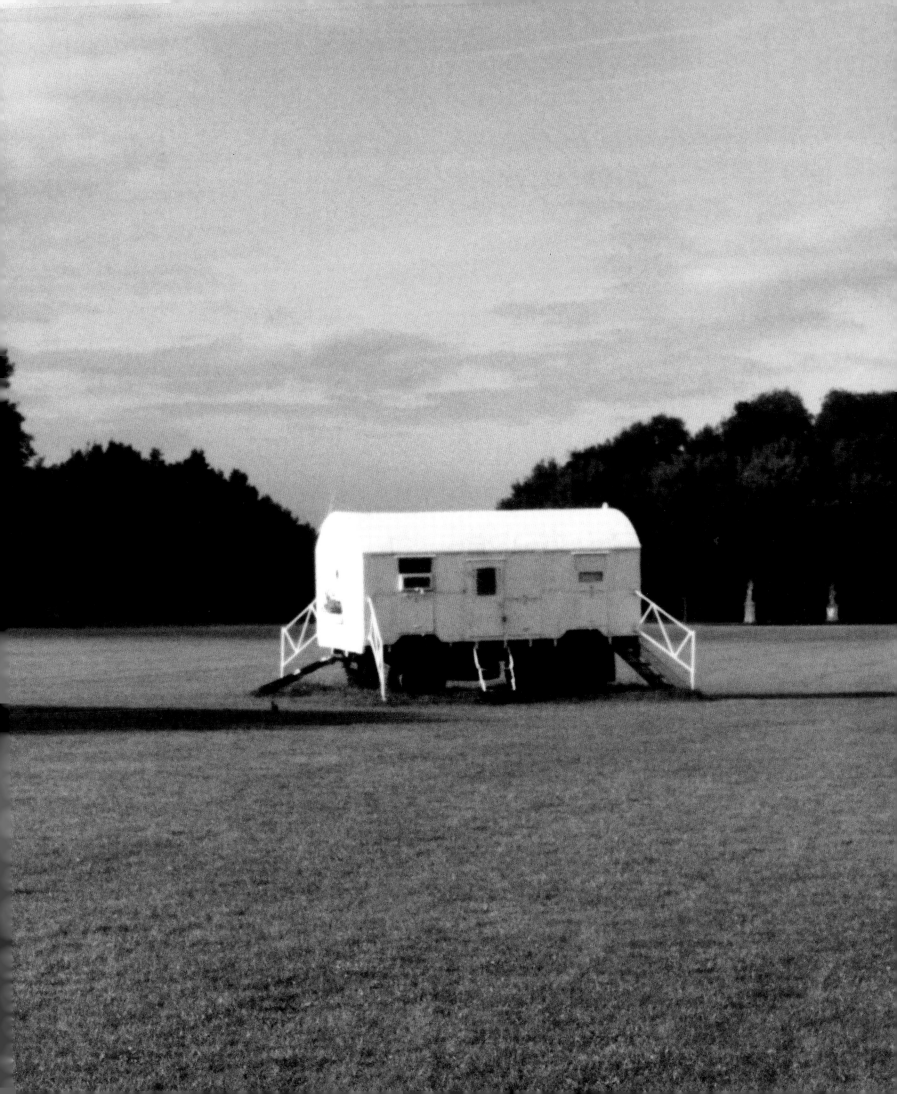

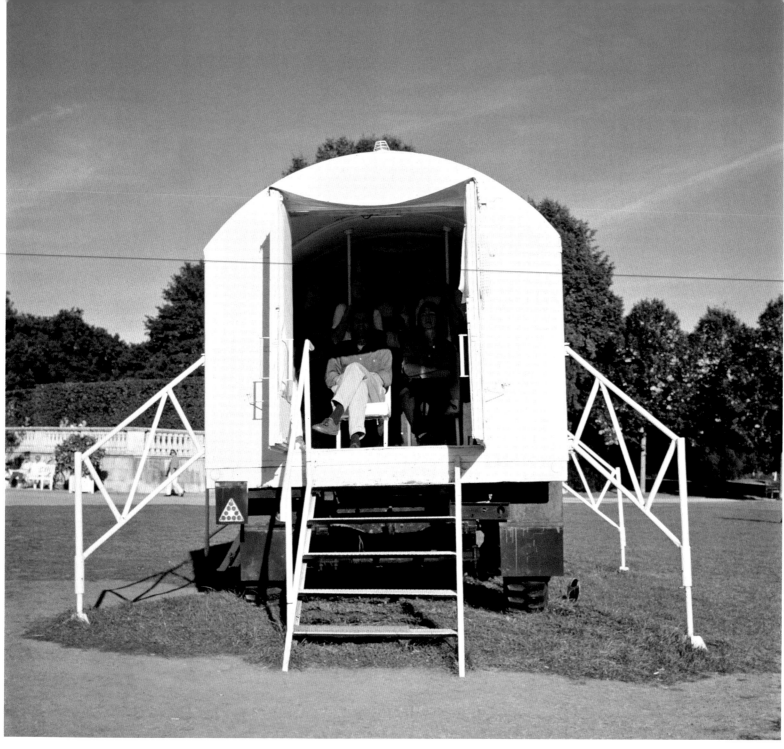

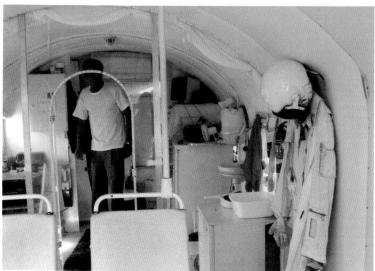

KOSMONAUTA, 1995
PHOTOGRAPHIC DOCUMENTATION OF AN
ACTION, OIKOS, MUZEUM OKRĘGOWE IM. L.
WYCZÓŁKOWSKIEGO, BYDGOSZCZ, POLAND

The artist arrived by train for the opening of the
exhibition, emerging in a handmade astronaut
suit. He walked through the city from the train
station to the gallery, observing the world as if
he were a stranger from another planet and
filming everything around him. The video footage
was transmitted directly to a monitor worn on
his back.

previous page,
ASTRONAUT 2, 1997
PHOTOGRAPHIC DOCUMENTATION OF AN
ACTION, DOCUMENTA 10, KASSEL, GERMANY

design the advertising campaign for the *Obserwator*, a Polish daily. He took the job and set out to find the real observers in the city. And he made rapid headway. He managed to persuade some homeless people to do nothing but sit and watch time pass while wearing a badge with the paper's name on it. At Documenta 10 (1997) a homeless Polish person lived in a white caravan that Althamer had parked on the exhibition site in Kassel. Inside, a monitor showed a video in which the man, dressed in a homemade spacesuit, explored Kassel curiously. *Astronaut* is based on *Kosmanauta* (1995), an action in Bydgoszcz, Poland, in which Althamer walked round the streets in a spacesuit, recording what he saw with a video camera. The footage was displayed on a monitor he carried with him on his back.

In 2001 he invited homeless people in Vienna to spend the day at the Wiener Secession, where they were provided with a free meal. The original intention was to give them secondhand clothes with well-known brand names so that they would look like the homeless people of the future, but they ended up wearing white costumes. Martin Prinzhorn wrote, 'One initial reaction – including my own – is to see in the work a rather cynical exploitation of people who are socially weak or to dismiss the work as another taboo-breaking spectacle. Yet it is difficult to maintain this sense of an exploited victim for long, because the real concern of the work is once again to subvert our usual view of the existing power structures. You cannot ignore the fact that the artwork looks back at you, even if you don't want to see it. What's more, it continues to look back even when you are not in the museum anymore.'[13] In

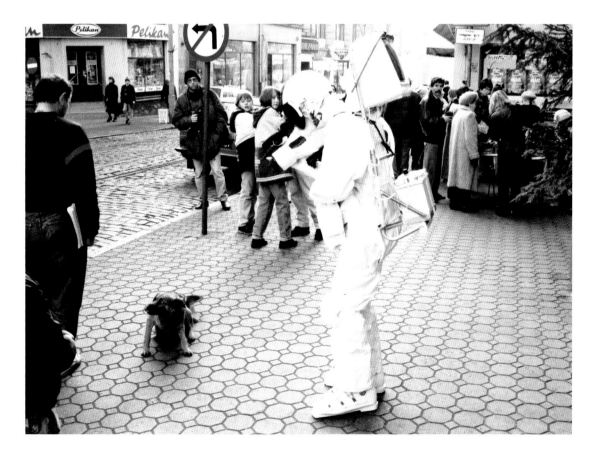

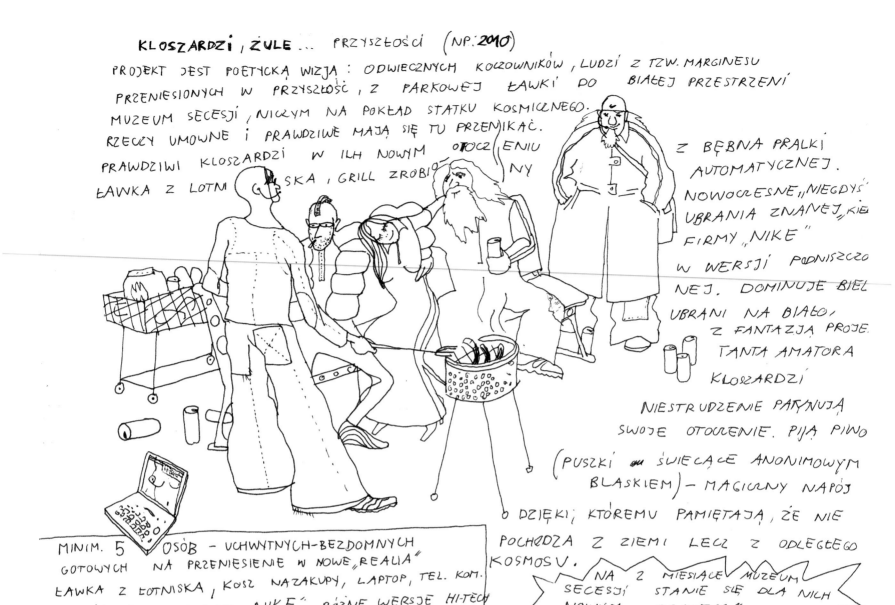

KLOSZARDZI, ŻULE ... PRZYSZŁOŚCI (NP. 2010)

PROJEKT JEST POETYCKĄ WIZJĄ : ODWIECZNYCH KOCZOWNIKÓW, LUDZI Z TZW. MARGINESU PRZENIESIONYCH W PRZYSZŁOŚĆ, Z PARKOWEJ ŁAWKI DO BIAŁEJ PRZESTRZENI MUZEUM SECESJI, NICZYM NA POKŁAD STATKU KOSMICZNEGO. RZECZY UMOWNE I PRAWDZIWE MAJĄ SIĘ TU PRZENIKAĆ. PRAWDZIWI KLOSZARDZI W ICH NOWYM OTOCZENIU ŁAWKA Z LOTNISKA, GRILL ZROBIONY

Z BĘBNA PRALKI AUTOMATYCZNEJ. NOWOCZESNE "NIEGDYŚ" UBRANIA ZNANEJ, KIEI FIRMY "NIKE" W WERSJI PODNISZCZO NEJ. DOMINUJE BIEL UBRANI NA BIAŁO, Z FANTAZJĄ PROJE. TANTA AMATORA KLOSZARDZI NIESTRUDZENIE PARYNUJĄ SWOJE OTOCZENIE. PIJĄ PIWO (PUSZKI ŚWIECĄCE ANONIMOWYM BLASKIEM) - MAGICZNY NAPÓJ DZIĘKI, KTÓREMU PAMIĘTAJĄ, ŻE NIE POCHODZĄ Z ZIEMI LECZ Z ODLEGŁEGO KOSMOSU.

MINIM. 5 OSÓB - UCHWYTNYCH - BEZDOMNYCH GOTOWYCH NA PRZENIESIENIE W NOWE "REALIA" ŁAWKA Z LOTNISKA, KOSZ NA ZAKUPY, LAPTOP, TEL. KOM. UBRANIA - PROPONUJĘ "NIKE" - RÓŻNE WERSJE HI-TECH

NA 2 MIESIĄCE MUZEUM SECESJI STANIE SIĘ DLA NICH NOWYM "DOMEM"

SECESSION

AUSGETRÄUMT...
Pawel Althamer, Jože Barši, Thomas Baumann, Cezary Bodzianowski, Josef Dabernig, Ricarda Denzer, Tomislav Gotovac, Renée Green, Elisabeth Grübl, Florian Hecker, Patrick Jolley, Martin Kaltner, Július Koller, N.I.C.J.O.B, Deimantas Narkevicius, Roman Ondák, George Ovashvili, Mladen Stilinović, Werner Würtinger, Carey Young,...
kuratiert von Kathrin Rhomberg

the same year, Althamer commissioned his school friend Piotr Anczarski to take part in an exhibition in his stead at the Museum of Contemporary Art in Chicago. Anczarski had emigrated to the United States and was working as a house painter rather than as a fine artist. Althamer engaged him to paint the walls in one of the museum's galleries a different colour every day for thirty days. Visitors to the exhibition saw a Polish immigrant painting the walls – in other words, doing his ordinary work, which was now being paid for by a museum.

Working with people who spend their days on the fringes of society, in voluntary or imposed isolation, who are often among the losers as a result of modernization is a clear thread running through the artist's work to date. Althamer is not following any particular socio-political thrust here. From the earliest projects right up to the most recent, his work has addressed the mutual transfer of knowledge and experience between everyday life and art. The consequence of this method is a constant questioning and reformulation of the concept of the work of art.

White Cube

In 1996 Althamer showed his installation *Untitled* at the Foksal Gallery in Warsaw, his first work with the people who later founded the Foksal Gallery Foundation, where he continues to show today. The exhibition involved the gallery space and its courtyard, which, with its trees and untended vegetation, could be seen but not entered from the gallery. Althamer made the courtyard accessible to gallery visitors by replacing a window with an open door and steps out into the garden. Inside the gallery he laid a grey industrial PVC floor and mounted white bus seats and a fan on it. 'I'm attracted to buses, bus seats interest me,' he said at the time. 'I'm convinced that the seats to be used in the gallery should ride in buses first. They should be used, have signs of wear and tear, and only then be used as seats-sculptures. Then they could be seen as things to sit on and, at the same time, as objects bearing traces of human use. In a sense I'm also employing extras now – the passengers in the buses – as sculptors ageing the seats. [...] Walking through the gallery could become an impulse, turning me on

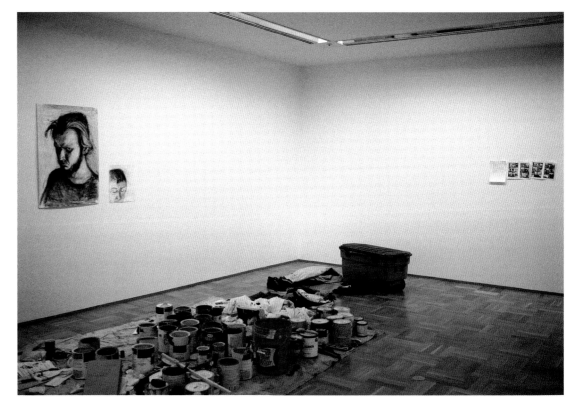

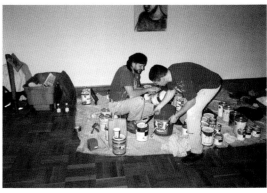

to something seen not during the exhibition itself but beyond or after leaving it. What I did was meant to be a situation stimulating certain mental states, not an object to look at and admire.'[14] With this work, Althamer returned to the motif of travel, which he had first addressed as a student. A visit to the exhibition led out of the city, through the gallery and into a garden that had run wild. Here the gallery takes over the function of a waiting room, a vehicle and an unreal intermediate space, metaphorically speaking. The visit to the exhibition is a journey, extremely condensed in terms of both time and space, leading from individual everyday reality into a space that has been handed over to nature.

The white bus seats were to turn up again the next year in his exhibition at the Kunsthalle Basel. There they were juxtaposed with figurative sculptures. And a few years

later he used them again, this time in a white service bus in Milan – a travelling 'white cube' showing the passengers how reality unfolds outside the window. Althamer further radicalized the idea behind the installation *Untitled* in his work *Untitled (Tent)* (1999), addressing more intensively the idea he had abandoned: the exhibition space as a white cube isolated from its surroundings. This time the gallery remained empty during the exhibition, and the courtyard was covered with a white tent. The exhibition visit now led into a natural space, created and limited by art, in which nature could be experienced only in a manipulated form, since the tent, functioning like a greenhouse, changed the living conditions of the plants and animals beneath it.

A pair of more recent works, the mobile galleries *Foksal Gallery Foundation* (2004) and *FGF Warsaw* (2007),[15]

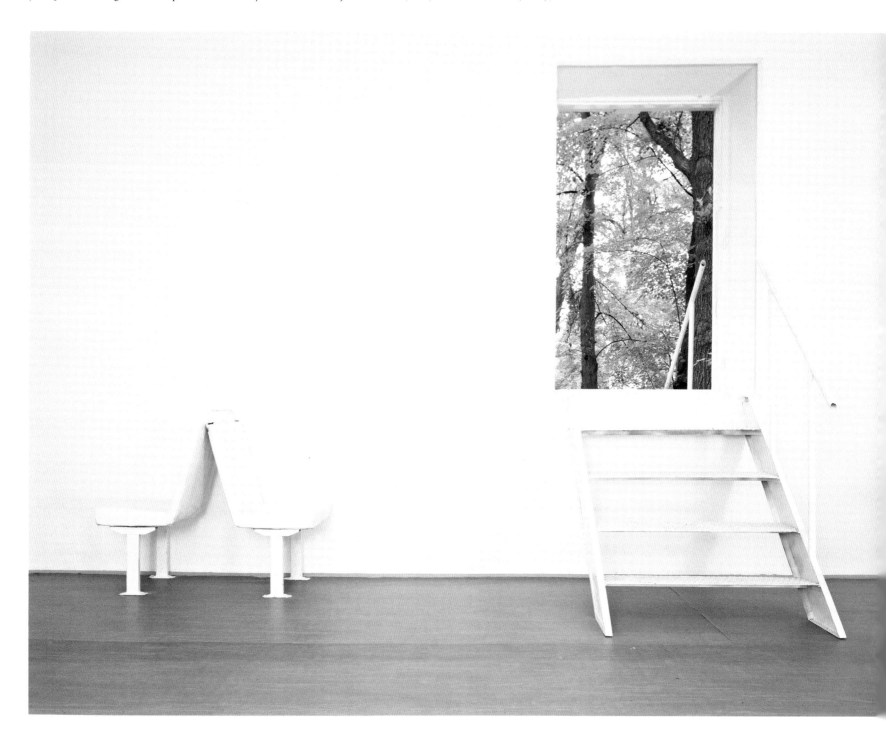

The exhibition consisted of a small gallery room
at the end of a dead-end street. A grey industrial
PVC floor was put down, and attached to it were a
number of bus seats covered with white artificial
leather that had travelled in the Warsaw buses in
the week preceding the show. (Normally bus seats
in Warsaw are red or brown.) On the ceiling a
fan with oversize blades revolved slowly, stirring
the air. A window was transformed into an open
door with the addition of metal steps and a railing
leading to the garden outside. The room became
a purgatory or a decompression chamber that
allowed visitors to take a rest and relax before
leaving for the garden, which was lush with plants
and trees.

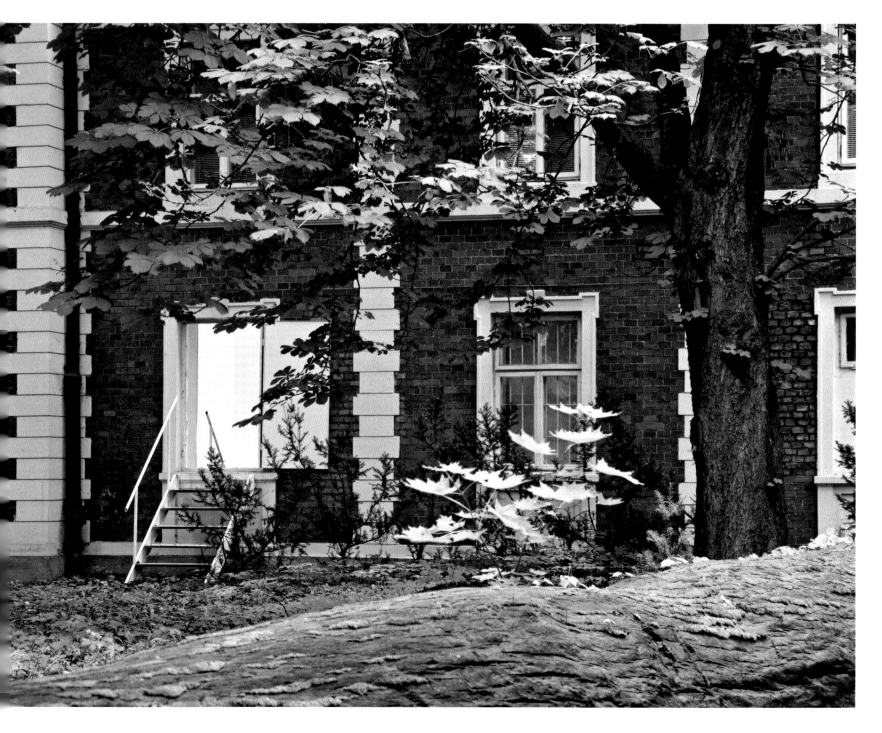

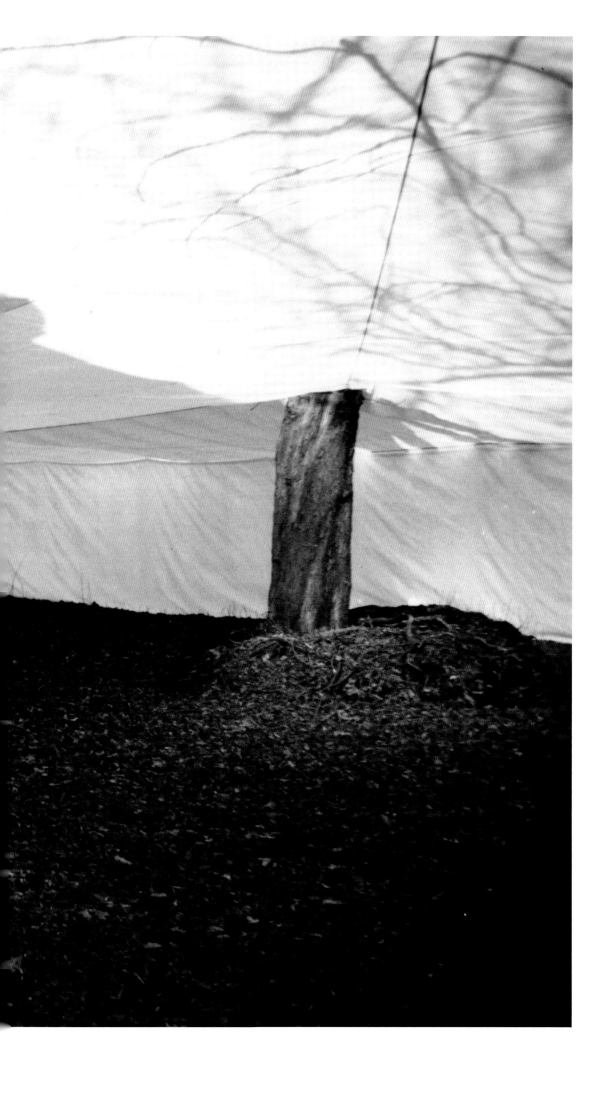

A white tent covered some 600 square meters of garden adjoining the gallery and also a small courtyard in front of the building. The gallery itself was left empty for the duration of the exhibition. The tent, which was set up in late February and taken down early in May, affected all biological activity within it. It functioned as an extension of the white gallery interior, as a frame cut out in the park or as a space that could be accessed without entering the gallery. The full experience of nature was thereby suspended (the growth of the vegetation under the tent being delayed) and reinforced (the tent generated a strange atmosphere of distorted sounds, smells and light).

show how important it has been for Althamer to work with his Warsaw gallery, with the artists it represents and especially with the first directorial team, Andrzej Przywara, Adam Szymczyk and Joanna Mytkowska. The Foundation's name alludes to the Foksal Gallery, jointly founded by art critics and artists in 1966 and an important meeting place for artists in Poland for decades because of its radical, avant-gardist and international exhibition programme. The public 'living archive', in which the activities of the Polish critics and artists connected with the gallery were recorded, also had an important part to play. The Foundation does not restrict itself to exhibitions in its own space in Warsaw but fosters the international presence of the artists it represents.[16]

Of the two works mentioned above, the first is a mobile model of the gallery space at 1:5 scale, set on a chassis. As well as depictions of the exhibition room, library and office, it also includes dolls of the Foundation's employees. Andrzej Przywara is standing at the window and looking into the distance. Adam Szymczyk – who, like Joanna Mytkowska, no longer works for the gallery – is standing at the long table, talking on his mobile phone. Mytkowska is working on the artist archive, and Joanna Diem is sitting at the computer and speaking on the phone.

The second work, produced for the 2007 Frieze Art Fair in London,[17] consists of a large wooden crate whose components can be arranged as a mobile stand. The stall is made up of a mobile stage element that serves as a temporary exhibition space, a covered extension with a washbasin, and a large market trader's tent offering nothing for sale. The work is a joint effort by Althamer and other artists from the gallery, as well as Althamer's son Bruno and the technical workshops of Adam Althamer, the artist's father. The temporary exhibition space has a window that originally came from a tram, and the space is furnished with a tram seat, a small folding table from a train, a bookcase, a standard lamp and a carpet. The bookcase contains catalogues of work by gallery artists, a magazine with a cover designed by Edward Krasiński, and dolls and miniatures by Paweł Althamer. It is possible to get onto the stage, or to go through a door at the side, whose handle was designed by Monika Sosnowska. The door itself comes from an earlier exhibition by Althamer in the Foksal Gallery, where it used to connect the gallery with the adjacent working premises of Wirtualna Polska, at the time Poland's largest Internet portal. The extension is covered with a painting by Wilhelm Sasnal. Next to the washbasin hangs a small painting by Jakub Julian Ziółkowski, and a flat monitor screen shows Artur Żmijewski's record of Oskar Hansen's last exhibition. The irony of the installation of course lies in

FOKSAL GALLERY FOUNDATION, 2004
METAL, RUBBER WHEELS, PLYWOOD, WOOD,
PLEXIGLAS, POLYMER CLAY, TEXTILES, HAIR,
PAPER, CARDBOARD, PAINT, WAX, RUBBER,
MDF BOARD
155 X 213 X 102 CM

A precision-made 1:5 scale model of the Foksal
Gallery Foundation office and staff has been
equipped with a wheeled chassis, enabling the
foundation to travel anywhere.

FGF WARSAW (INCLUDING WORKS BY MONIKA
SOSNOWSKA, WILHELM SASNAL, JAKUB JULIAN
ZIÓŁKOWSKI AND ARTUR ZMIJEWSKI), 2007
WOOD, PLYWOOD, LACQUER, PAINT, METAL,
BRASS SINK, PLASTIC WATER TANK, SOAP,
TV, DVD, TEXTILES, FOAM, OLD TRAM SEAT,
OLD TRAM WINDOW, RUG, MAGAZINES, OLD
WOODEN DOOR, USED FLYSHEET,
PLASTIC WHEELS
DIMENSIONS VARY FROM 200 X 201 X 219 CM
TO 250 X 500 X 1400 CM

A special project prepared by the artist for the
Frieze Art Fair in cooperation with Foksal Gallery
Foundation and a number of the gallery's artists,
the piece is a movable vehicle on wheels that can
be folded up and transported virtually anywhere.
The crate is a work in itself and, once unpacked,
becomes a temporary space for presenting works
by other artists. But above all it is a multi-layered
personal response to the current conditions of the
art market.

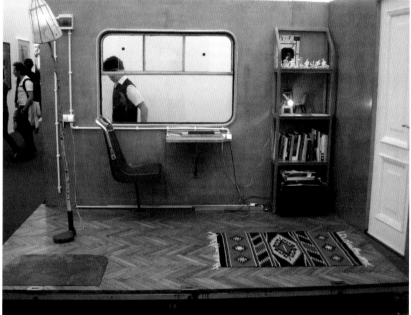
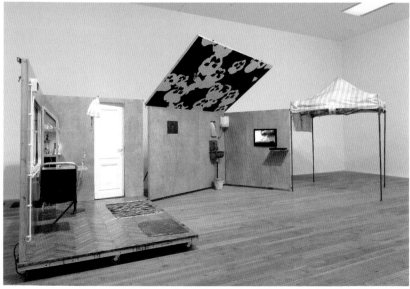
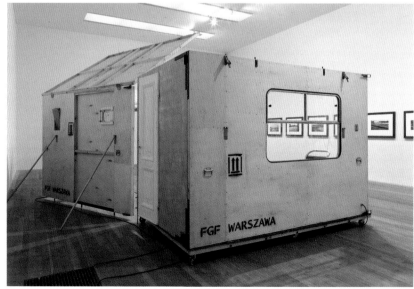

the fact that it was created to be seen at an art fair. *FGF Warsaw* is a work of art and at the same time a platform for the gallery's commercial work at the fair. Various authors are involved in the work, and no distinction is made between art and craft contributions. Once again Althamer is addressing the exhibition context and reflecting on the subject of exhibitions, presenting friendship, artistically expressed, to be considered under commercial conditions.

The photographs Althamer took of *Foksal Gallery Foundation* show the work not in a museum, where it now resides, but in the streets of Warsaw with children in front of it laughing and looking into the model through the window. He pushed it through the streets of the town, like a showman or a travelling salesman, in order to hand it over to the Foundation, which then offered it for sale at the Art Basel fair. But the true nature of the work came to the fore in the Warsaw streets, where it attracted an audience who responded to the doll's house spontaneously, genuinely and directly.

Making and selling dolls was very important to Althamer and his family in the 1990s. Selling them made an essential contribution to the upkeep of the household; for many years their income from the sale of these little fabric and leather figures was greater than the family's art-generated income. The dolls, made at home

with his then wife Monika, point forward in many ways to his later view of art and authorship. At first, Althamer showed some of these dolls outside the art context, in shop window displays such as *Doll's House* (1997), which tells the story of two neighbours. A poor sculptor and his children live on the top floor, which is built around a self-portrait of Althamer as an old man. Below them lives a scruffy, lonely man whose flat is crammed full of consumer goods. *Doll's House* was first shown in a Warsaw toy-shop window, then in Venice in a tailor's window. Althamer never saw the dolls as children's toys but as little exhibits that would interest even a public who were not familiar with art.

None of the exhibitions that Althamer had put on so far with Foksal had actually been mounted in the gallery's exhibition space. *House on a Tree* (2001), for example, was a work in the form of a tree-house installed outside the gallery window. The exhibition included an empty exhibition space and a private enclosure set up illegally in the public space. Althamer doesn't use exhibitions in private galleries just to offer work for sale but also to address the exhibition medium and the exhibition context in every show. In the art of the 1990s there were many parallels with this element of institutional critique, and I shall have more to say about them, but there was also a significant difference. Unlike most of the artists of his generation who criticize institutions, organizing their

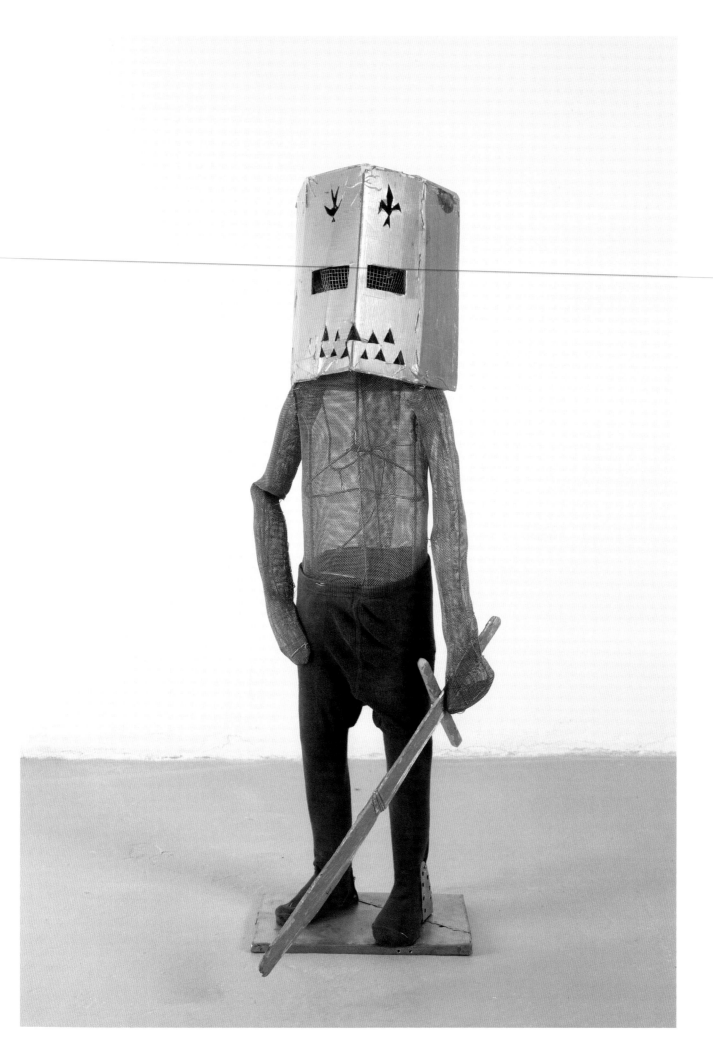

GOLDEN KNIGHT, 2010
METAL MESH, PAINTED
WOODEN SWORD, CARDBOARD
MASK, CHILDREN'S TIGHTS,
BRASS BASE
95 X 40 X 50 CM

DOLL HOUSE, 1997
WOODEN CONSTRUCTION, METAL, WIRE,
PLYWOOD, CARDBOARD, CLAY POLYMER, PAINT,
TEXTILES, WAX, HAIR
160 X 110 X 70 CM

Doll House shows the story of two neighbours: one good and poor, the other rich and bad. The poor one, a sculptor (a self-portrait of the artist at age sixty and his children, who are still small) lives upstairs. Below him lives a lost and lonely man who sits and watches television. His walls are covered with pornography, and the floor is cluttered with unpacked electronics equipment – everything is disordered and temporary. The house was first exhibited in the window of a toy shop in Warsaw, then in the window of a tailor's shop in Venice.

HOUSE ON A TREE, 2001
BAMBOO CONSTRUCTION,
WATERPROOF FABRIC, BED,
CHAIR, LAMP, HEATER, ROPE
LADDER
200 X 200 X 150 CM

work in the form of a meta-discourse and thus deliberately operating within those institutions, Althamer also questions the art system from the outside. This shows in the fact that he uses his status as an artist to open up creative spaces and situations that other people can actually use without finding themselves again in the role of individuals questioning the system.

Kids

The first exhibition by Althamer that I visited and can precisely remember was his 1997 solo show at the Kunsthalle Basel. In the skylit gallery on the top floor, which visitors again entered like a tent, through a white plastic curtain, he'd had a white floor lain, creating a white cube to show two of his early sculptures and eight white bus seats. The adjacent small gallery contained a self-portrait and the video *Dancers* (1997), which showed naked men and women holding hands, humming familiar tunes and dancing in a circle. In one sense the exhibition seemed strangely detached and intangible, in terms of both time and space, but then also refracted, humorous, comical and humane because Althamer had found the performers for the video in a shelter for the homeless.

Three years later I visited him in Warsaw and offered him an exhibition in the Swiss mountain community of Amden, where there had been, around 1912, an artists' colony centred around the painter Otto Meyer-Amden (1885-1933).[18] Meyer-Amden created work in rural seclusion whose meaning to today's mind is to be found precisely in the fact that it was always directed towards process and fundamentals. Althamer was interested in the story of Meyer-Amden and told me, in turn, about the Polish writer and artist Witkacy (1885-1939). Witkacy, whose plays were not acknowledged in his lifetime, is now seen as one of Polish modernism's major playwrights, and in the post-war period he became a central influence on the work of the artist and dramatist Tadeusz Kantor, another artist from the Foksal Gallery circle. Witkacy, a free and eccentric personality, drew portraits to earn money, often under the influence of drugs.[19]

Althamer brought his entire family to Amden in summer 2001, and for the exhibition he realized his *Weronika* installation in a stable that was remote but picturesquely situated in the mountain landscape. The installation featured a life-size sculptural portrait of his daughter Weronika along with a selection of her drawings and

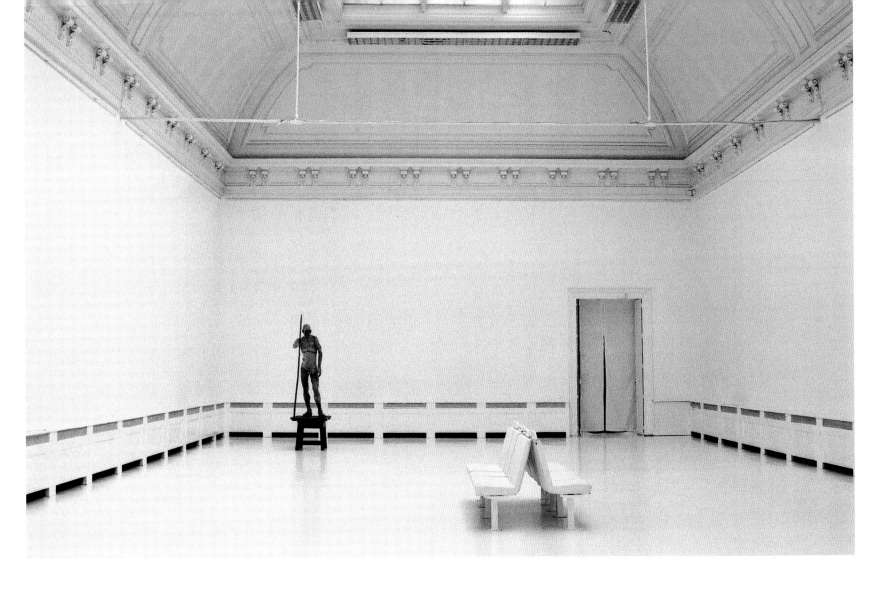

A plastic zip curtain was installed at the entrance
to the exhibition and the floor covered with the
same white anti-slip material used at airports or
railway stations, with eight bus seats placed at the
centre of the space. Two figure sculptures stood
at opposite ends, creating a contrast between the
clinical image of the white space and the realistic
sculptures made with non-durable materials, such
as grass and animal intestine. Two other works,
Dancers (1997) and the artist's Self-Portrait
(1993), were shown in the next two rooms.

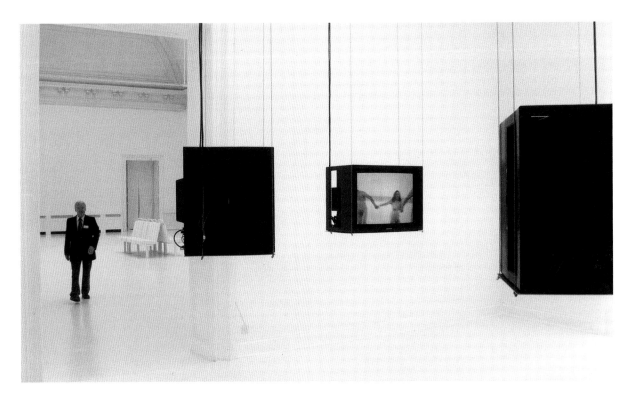

WERONIKA, 2001
HAY, HEMP, ANIMAL INTESTINE, HUMAN SKULL,
WAX, HAIR, GLASS EYES, WOODEN STICK,
FEATHER
110 X 40 X 25 CM
AMDEN, SWITZERLAND

The exhibition was realized in a small barn in a
village in the Swiss Alps. During his stay there,
the artist sculpted a portrait of his five-year-old
daughter, Weronika. It was a fetish object of
grass, string and animal intestines, and the head
was made with a genuine human skull. The work
was exhibited in the barn alongside drawings
made by Weronika, and the work was dedicated
to the place where it was made, intended to be
shown only in the neglected Alpine barn.

silhouettes, also created in Amden. In the week before
the exhibition, he spent the afternoons with his little
daughter in the mountain meadow outside the stable,
working on his image of her while she drew and played
nearby. He used organic materials for the sculpture, as he
had for his degree project at the Academy, some of which
he found on the spot: hay and wire to shape the body,
hemp for the hair. From Warsaw he brought a skull for
the head, mother of pearl for the eyes and cow's intestine
for the skin. Art critic Philipp Kaiser wrote in his review
of the exhibition, 'Paweł Althamer is not quoting Otto
Meyer-Amden's well-known nude drawings of boys and
girls directly, but as a foil they do provide an invisible
reference point that also addresses the latent sexuality of
the pictures of young people. As the little girl's outward
appearance is also androgynous, this level correlates
with a Utopian allegory of the innocence of childhood, a
familiar notion in the early years of the last century. For
this reason, a complex reflection about images of what
is our own and what is alien, whose force is to be sensed
in the sensual and real encounter, condenses in *Weronika*
within a field of tension built up of autonomy, site-speci-
ficity and context.'[20]

In the same year, the artist and his daughter
Weronika were both involved in the exhibition 'The
Collective Unconscious' at the Migros Museum für
Gegenwartskunst in Zurich. Althamer suggested
replacing the museum's staff with small children,
including Weronika, who worked as a gallery atten-
dant at the exhibition opening. The title, *King Maciuś I*
(2001), refers to the 1923 fairytale of the same name by
Janusz Korczak (1878-1942), which tells the story of a

boy who becomes king because his father dies suddenly
and who then forms some negative instincts and has to
learn from his mistakes. Korczak, who came from an
assimilated Jewish family, worked as an educator, doctor
and writer, and founded an orphanage for Jewish chil-
dren in Warsaw in 1911. He created a kind of children's
republic with its own parliament, court and newspaper.
He took up this idea again in 1926, getting children to
produce a newspaper that was issued once a week as a
supplement to the Jewish daily *Nasz Przegląd*. Korczak
was compelled to move his orphanage to the Warsaw
ghetto during the Second World War. The orphanage
was closed by the German occupying forces on 5 August
1942, and the children were deported to the Treblinka
concentration camp. Korczak remained at the children's
side, even though he was told he could leave the ghetto.
King Maciuś I is one of the by now numerous works that
involved members of Althamer's family or that even
featured them in his stead. In 2002 he took part in a
group exhibition in Utrecht as an assistant to his seven-
year-old daughter and helped her to realize the proposed
project. In the following year his sixteen-year-old son
Bruno stood in for his father with his own drawings at
a group exhibition called 'Under the White-Red Flag:
New Art from Poland' in Moscow, Vilnius, Tallinn and
Riga. Althamer won the Vincent Award in Maastricht in
the same year. This award was the first significant public
recognition outside Poland and was accompanied by a
major exhibition in the Bonnefantenmuseum. This exhi-
bition featured *Bad Kids*, performed by a group of young
people from Bródno, including his two sons Bruno and
Szymon. Althamer wanted the teenagers to enjoy a trip
to 'paradise' and spent ten days with them in Maastricht,

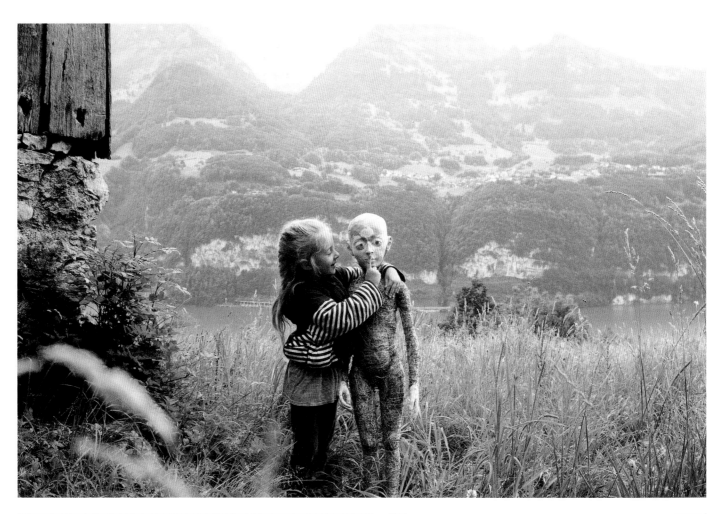

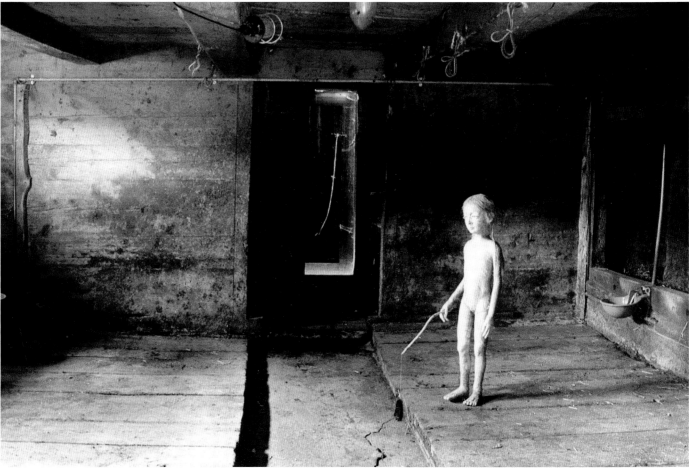

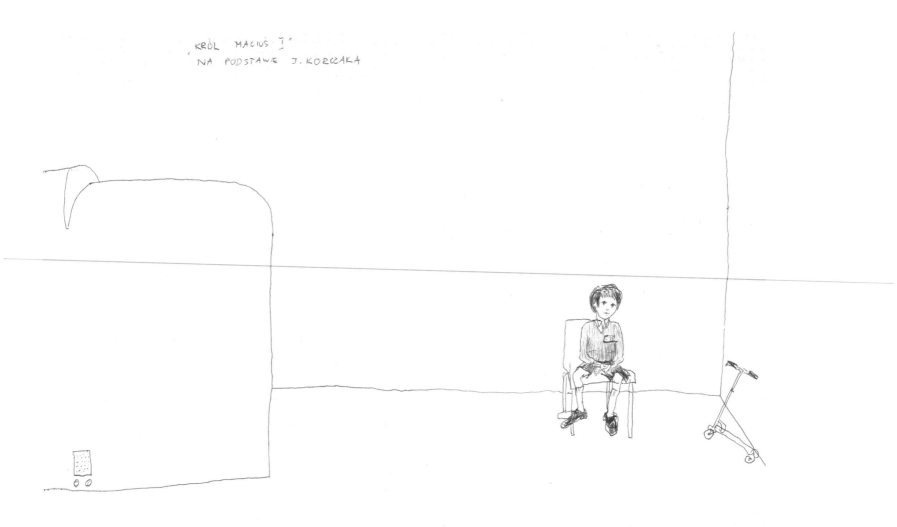

working with them in the museum and giving them the vestibule in the exhibition to show their own work. The result was unsurprising, consisting of countless graffiti sprayed on the walls and floor. The family was now no longer just made up of his children and relatives – with whom he undertook a 'pilgrimage' to Tuscany in 2002 – but also included his sons' friends. As well as these trips, there were also group walks, with Althamer taking over the role of leader. In 1999 he showed the district he lived in to a group of German art collectors *(Walk into Bródno District with German Art Collectors)*. Since 2008, under the name *Common Task*, he has undertaken a series of trips with his family and his Bródno housing block neighbours, travelling to destinations such as Brussels, Brasilia, Oxford and Mali, where they visited the same Dogon tribe he had set out to see as a student in 1991.

Context Art

In 1993 the Odessa-born artist and curator Peter Weibel presented the outlines of 1990s art in an exhibition, which was part of the Styrian Autumn in Graz, as well as in the source volume *Kontext Kunst* (Context Art). Weibel wanted to find out which art concept would define the decade, based on his conviction 'that there probably still are avant-gardes and new artistic movements, and that the confused randomness asserted by many is only an illusion from the observer's point of view serving a conservative ideology.'[21] He consequently disassociated himself from the position then dominating the theoretical debates, according to which the age of the avant-gardes had gone, and postulated a new caesura within modernism: 'The conceptualization of art production is followed by the contextualization of art.'[22] But what precisely is to be understood by 'contextualization'? What are the characteristics of this new movement? According to Weibel, this new art addresses 'the social, formal and ideological conditions under which art is produced, but also the economic, ideological and social contexts within which art is institutionalized. The conditions under which a work comes into being become the starting point for the work or the work itself. [...] This approach delivers work in all media, mainly materials strewn around the space, installations of all shapes and sizes whose appearance can lurch between research lab, coffee house, natural history museum, home, stage, information stand, interior design, expedition camp or refuge for homeless people. Their material form tends towards a network of readymades and products made by the artists

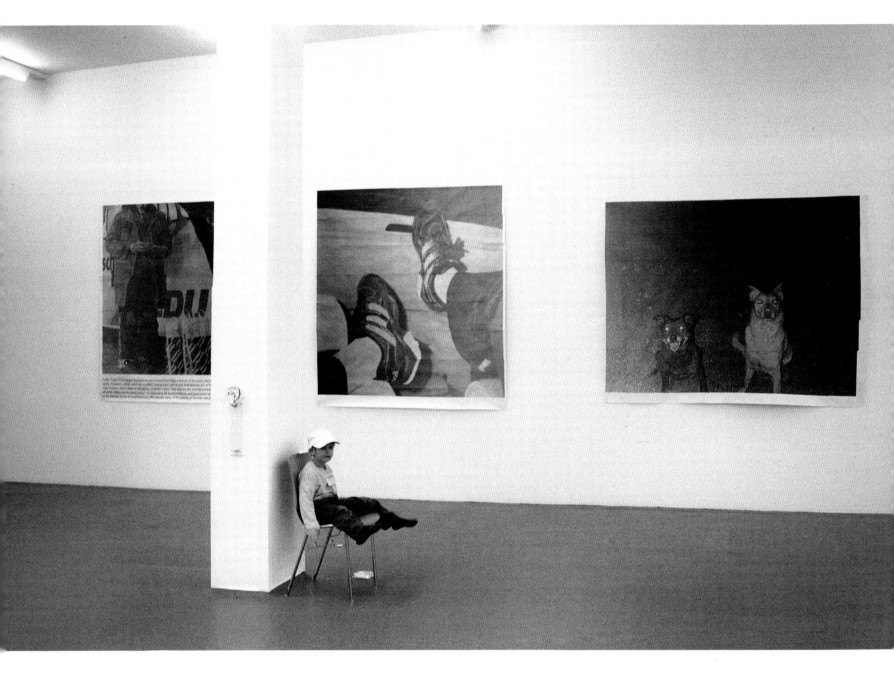

KING MACIUŚ I, 2001
PHOTOGRAPHIC DOCUMENTATION OF
AN ACTION, MIGROS MUSEUM FÜR
GEGENWARTSKUNST, ZURICH
opposite, DRAWING
30 X 21 CM

Inspired by pre-war Polish educator Janusz
Korczak's book King Maciuś I, the artist proposed
replacing the museum staff — ushers, guards and
cafeteria workers — with children. In Korczak's
book, children develop negative instincts upon
taking control of the world, and their kingdom
eventually collapses. They are not small adults,
their world is independent, mysterious, and their
motivations often unclear. (Korczak is remembered
as someone who didn't leave his Jewish pupils
during the Holocaust but rather accompanied them
to the concentration camp.) Althamer is interested
in the child as the other, someone who has his or
her own autonomous world, and he seeks the
hidden entrance to that world.

themselves. The text, the work, is replaced by the context, which becomes the text. The art product becomes almost invisible, by historical standards.'

Boris Groys sees contextual art as an attempt to make up for the disappearance of the 'real' context – in other words, an interested public – by providing a fictitious context in order to get over the agonizing isolation stemming from social indifference to contemporary artistic developments.[23] Althamer would not agree with this view. He was socialized as an artist at a time when the segment of the Polish public interested in contemporary art developments was only just beginning to take shape again. Generally speaking, there was no art-institutional framework to which the artist could have related or for which he could work, as artists in Western Europe did. He was also little concerned with addressing the social context within which works of contemporary art can be acknowledged and institutionalized, because his creative thrust is not directed at turning his works into museum pieces. Althamer applies artistic methods within his own living environment. He wants to experience reality and also to influence it through his artistic processes. Contextualization means putting art in touch with non-artistic methods, formats and media, but it also means treating life as art. This attitude also explains the (slight) kinship with Joseph Beuys's art, which has already been mentioned in literature about Althamer. Francesco Bonami writes, 'If Beuys's ambition was to move through the darkness of life with a full-blown torch, today's artists, such as Althamer, seem to be more interested in looking into the simple but mysterious corners of daily life with the help of just a light bulb.'[24] Andrzej Przywara, who knows Althamer and his methods like no other critic and has written a great deal about him, aptly described him as a 'director (*Regisseur*) of reality'.[25] He explains the closeness to reality of Althamer's artistic processes, and those of other Polish

artists of his generation, in terms of 'the gulf between personal and social experience in an epoch of social transformation'. He goes on to say, 'At this time, actions with the body made it possible to violate conventions and the conventional within activities in the art field and thereby move towards real experience.' Of course, Althamer's oeuvre includes numerous works that rely on a public that is interested in art. But there are also works that he has realized for himself alone, and some that cannot be seen as art by the people involved in them, as these categories are alien to them. There is no doubt that Althamer is an artist for whom the concept of contextualization is centrally important, as it is for many other artists in the 1990s, though his case is different, as many of the works he has produced in recent years, as we shall see below, were not recognizable as works of art by the actual addressees.

Intermedia

When the new millennium was about to begin, Althamer came up with an idea for a spectacular work. He wanted to write the numeral 2000 on the facade of his Bródno apartment block by switching the lights on in certain rooms. About 200 families, carefully briefed in advance by Althamer, were involved in this action, which happened on 27 February 2000 and had to be prepared meticulously over many weeks. The numeral remained legible for about twenty minutes. As the artist had anticipated, a number of public bodies – politicians, the church, cultural institutions, the media – claimed the event for their own purposes. *Bródno 2000* was announced as an event, attracting thousands of visitors and ending up as an exuberant popular festival. An intermedia work, it was many things at the same time: performance, art in a public space, exhibition, happening and political action.

BAD KIDS, 2004
PHOTOGRAPHIC DOCUMENTATION OF AN
ACTION, WARSAW AND MAASTRICHT

A group of 'difficult' young people from Bródno's
housing blocks, including the artist's sons
Bruno and Szymon, were taken on a trip to the
Bonnefantenmuseum in Maastricht.

WALK INTO BRÓDNO WITH
GERMAN ART COLLECTORS, 1999
PHOTOGRAPHIC DOCUMENTATION OF AN
ACTION, WARSAW

The artist invited a group of German collectors
to visit his native neighbourhood of Bródno in
Warsaw.

In his famous 1958 book about Jackson Pollock, Allan Kaprow explained the Happening, then a new art form, as a logical consequence of Pollock's way of painting.[26] A few years after the appearance of this study of Pollock's significance for contemporary art, Kaprow returned to discuss the pre-history of this new art form in his book *Assemblage, Environments and Happening*, maintaining that it had largely removed the distinctions between modes of presentation.[27] Painting now no longer referred exclusively to objects in a space but could become an environment within the environment itself. In his happenings, which he called activities after 1969, Kaprow replaced the viewer with invited participants who were to act as protagonists in certain prescribed actions.

The American art critic Clement Greenberg revealed himself to be a precise observer of the New York art scene in his late essay 'Intermedia' (1981), even though he rejected the new forms.[28] He said that the scene had opened itself up to installation art, sound art, action art, performance, video and dance but also to various forms of the written and spoken word. He explains this openness and readiness to accept inter- and multimedia forms not as a result of the leading role played by fine art in the modernist renewal but as a result of changed quality standards and the receptive behaviours of a growing middle-class public. In fact, he argues, intermedia or multimedia art, with its long history extending back to modernism, has become the dominant art form. Artists brought everyday life into the museum space, with happenings and Fluxus, in order to open the space up from the inside. The 'open museum' was one of the ideas that both the artists and the museum curators of the late 1960s and early 1970s aimed for. The artists were looking for a new public, opening up new locations for art and promoting other forms of perception. Installation art occupied entire galleries, demanding integral perception and turning most artistic movements in that decade against an exclusively retinal understanding of art. Defining as 'intermedia' those works of post-war art that move conceptually between mediums or between the arts dates from Dirk Higgins's 1965 essay of the same name.[29]

Althamer was not familiar with post-war art forms when he put on his first performance while still a student. Kowalski, his teacher at the Warsaw Art Academy, who had spent time in New York in the late 1960s, remembers the isolation in which his and the next generation worked after 1969. But, as we have seen, Althamer

światło zapalone światło zgaszone

WWW.FOKSAL.ART.PL

SCHEMAT ŚWIECENIA

<u>BRÓDNO 2000</u>, 2000
left, INSTRUCTIONAL LEAFLET
opposite, below and following pages, PHOTOGRAPHIC
DOCUMENTATION OF AN ACTION, BRÓDNO DISTRICT,
WARSAW

Bródno is a working-class district in the east of Warsaw.
Althamer lives there in one of the huge blocks of flats
on Krasnobrodzka Street. His idea was to display the
number 2000 on the block's front wall by turning on
the lights in selected apartments. The project required
the participation of some 200 families, who were given
precise instructions on the sequence in which they
should switch lights on and off in particular rooms. The
action itself lasted approximately twenty minutes and
became a large event attended by at least 3000 people,
most of whom came from the neighbourhood to watch
the event. Scouts helped Althamer deliver instructions
to people and distribute posters and flyers, and various
parties tried to appropriate the concept and fill it with
their own meanings. Politicians and Bródno district
officials delivered speeches on the site during the event.
In his daily sermon, the local parish priest referred to
the divine nature of light, including that making up the
luminous display on the building. Local cultural activists
came up with various initiatives, including giving away
free meals to people during the event, inviting a Warsaw
folk music group to play a concert, holding a dance party,
and staging a fireworks display. The event went well
beyond the notion of a happening or performance and
was given enormous and seemingly spontaneous media
publicity. It stirred a debate among the local community
and became a perfect example of what Althamer calls
'reality directed'. Most importantly, the project became an
efficient medium for the articulation of the community's
various needs and interests without being reduced to an
'artistic event'.

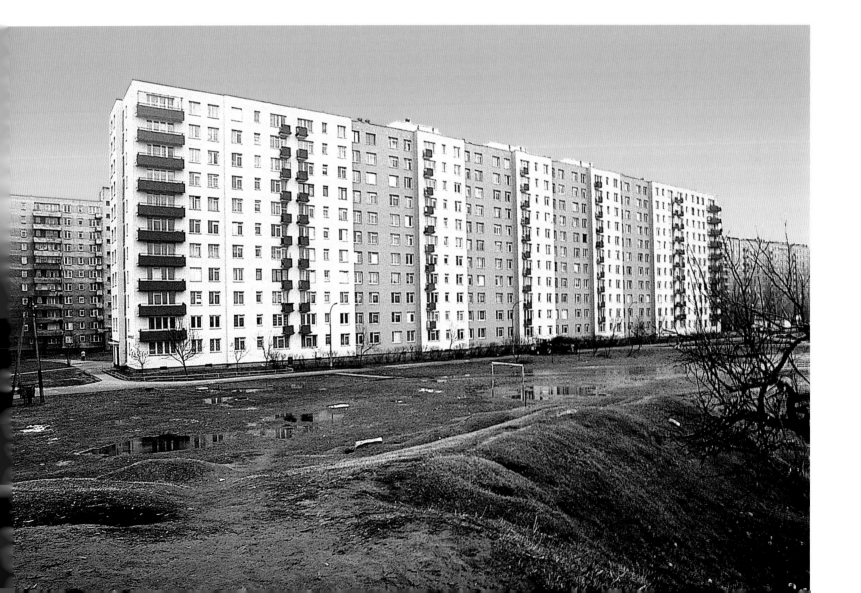

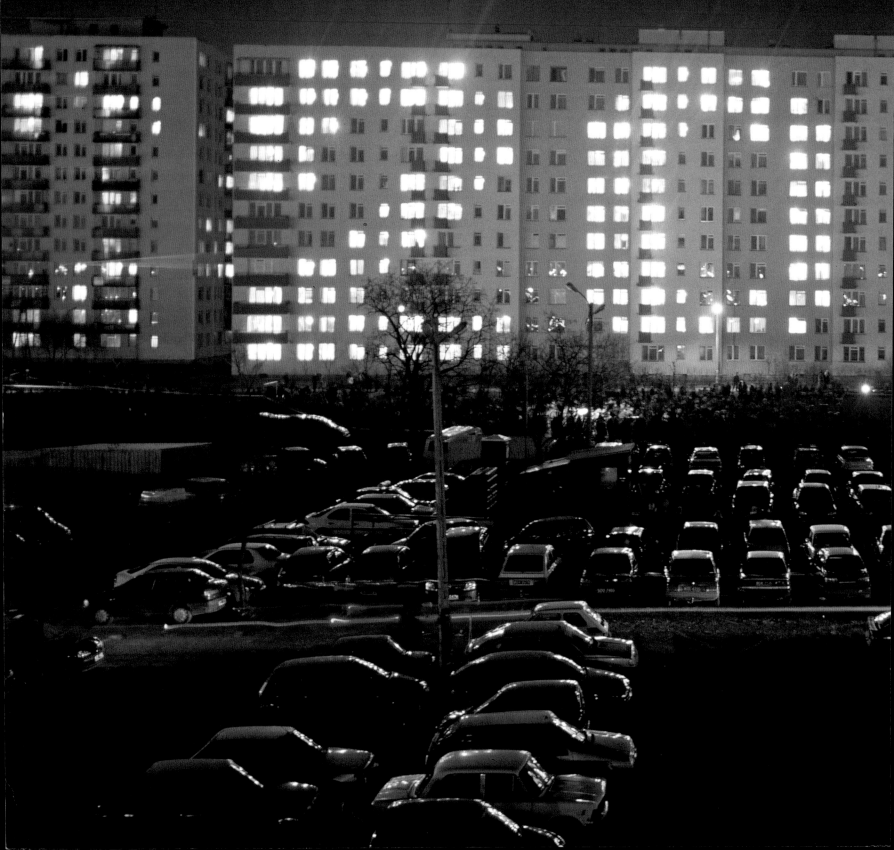

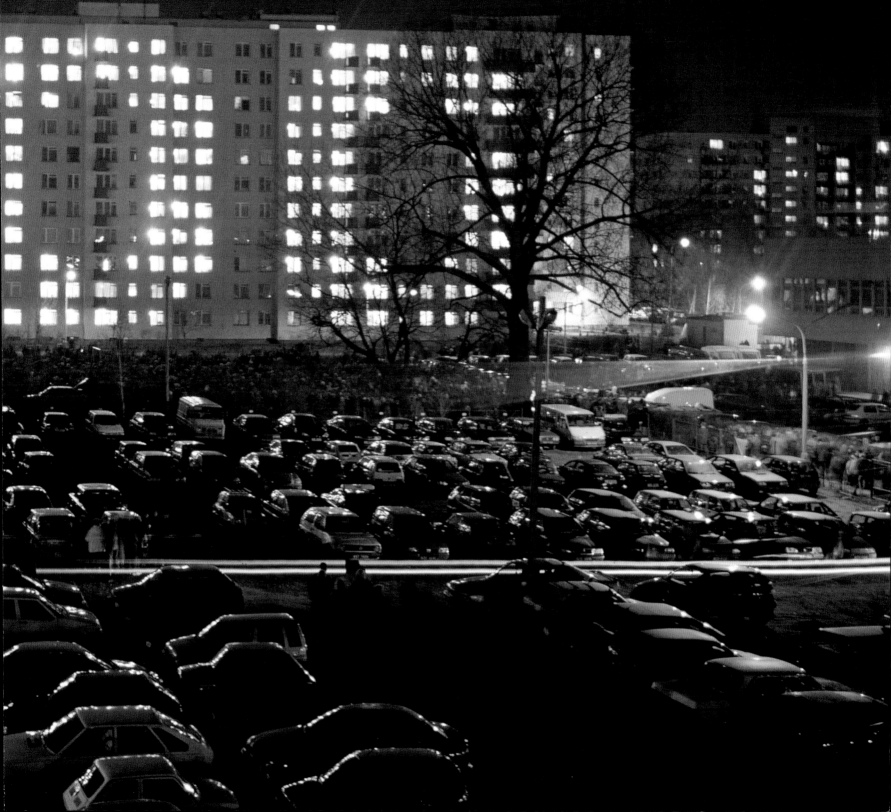

studied under Kowalski in an environment in which forms of intermedia expression were encouraged, if not required. Higgins's question about whether the performance should perhaps be understood as a result of the fusion of theatre, art, music, literature and life would have resonated positively in Kowalski's class. Higgins was not just pointing out that many of the most interesting post-war avant-garde works were intermedia but also pointing out that countless artists, many now forgotten, were involved in differentiating between specific intermedia art forms. For example, happening had had a committed and well-known champion in Poland in the person of Tadeusz Kantor.

The Exhibition as a Work of Art

Happenings and certain works by Althamer obviously have something in common, but there are also fundamental differences that should be mentioned in further discussion of his oeuvre. First of all, there is the origin of the sculpture. Althamer started as a figurative sculptor and never broke off his connections to the medium's traditions.[30] For example, after 2006 he created various figures whose subjects were his friends and family. The clad terracotta *Matejka with Son* (2006) is a portrait of his pregnant future wife. The ceramic work *Untitled*

(Embryo) (2006), an embryo lying on a cushion and exhibited on a slender wooden column, dates from the same year. *Matea* (2006-08) comes from to a trip to Greece with Matejka. As his contribution to the 'Grand Promenade' exhibition at the National Museum of Contemporary Art in Athens, Althamer set up a traditional sculptor's studio, in which he and Matejka also lived, along the footpath to the Acropolis. Matejka posed for Althamer, who modelled a classical standing female figure while she sculpted a bust that depicted him. He later had the ensemble sculpture of the studio situation, both sculptures along with a basket and chair, cast in aluminium.

Althamer has also regularly addressed his origins in the sculptures he has exhibited – for example by showing self-portraits together with other figurative work, usually in a single room, for the first time at the Miejsce Gallery in Cieszyn in 1995 and later in his 2007 solo exhibition 'One of Many', organized by the Fondazione Nicola Trussardi at the Palazzina Appiani in Milan, and again in the 2007 group exhibition 'After Nature' at the New Museum in New York. In Milan, Althamer was also finally able to realize a project that he had originally conceived in 1999 for Potsdamer Platz in Berlin: a nude portrait of the artist flying over the city. He sent his likeness, in the form of a recumbent body, twenty-one

opposite,
MASK, 1994
GLASSES, PLASTER
28 X 20 X 14 CM

below,
SELF-PORTRAIT (EMBRYO),
2006
CERAMICS, TEXTILE, WOOD
110 X 20 X 30 CM

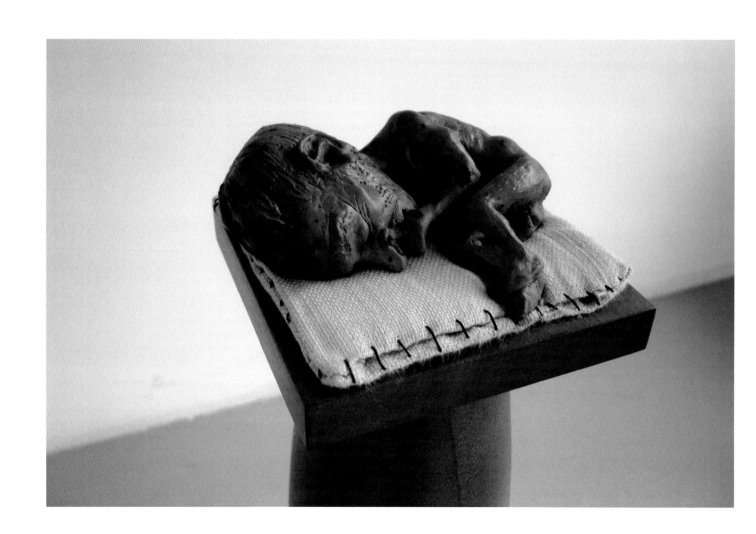

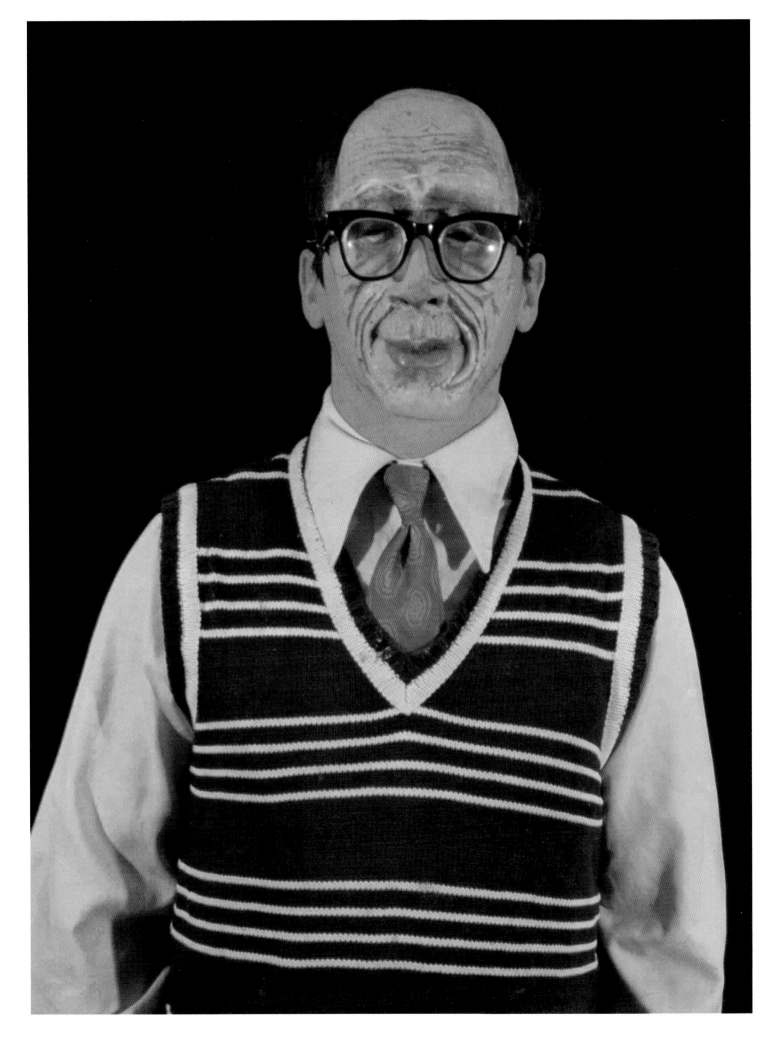

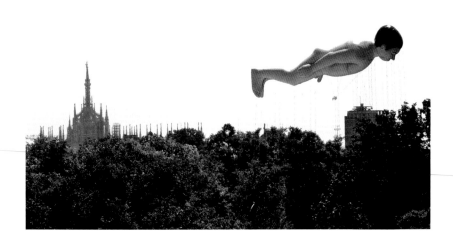

BALLOON, 1999-2007
NYLON, POLYESTER, ACRYLIC, ROPES, HELIUM
366 X 2100 X 671 CM

Conceived in 1999 but not executed until 2007,
this self-portrait was inspired by the idea of a
flying monument that reflects the scale of the
contemporary urban landscape. At the same time,
the artist was interested in the motif of flying as
a metaphor of spiritual peregrinations and in the
motif of the double, a mega-observer watching
from above on the artist's behalf.

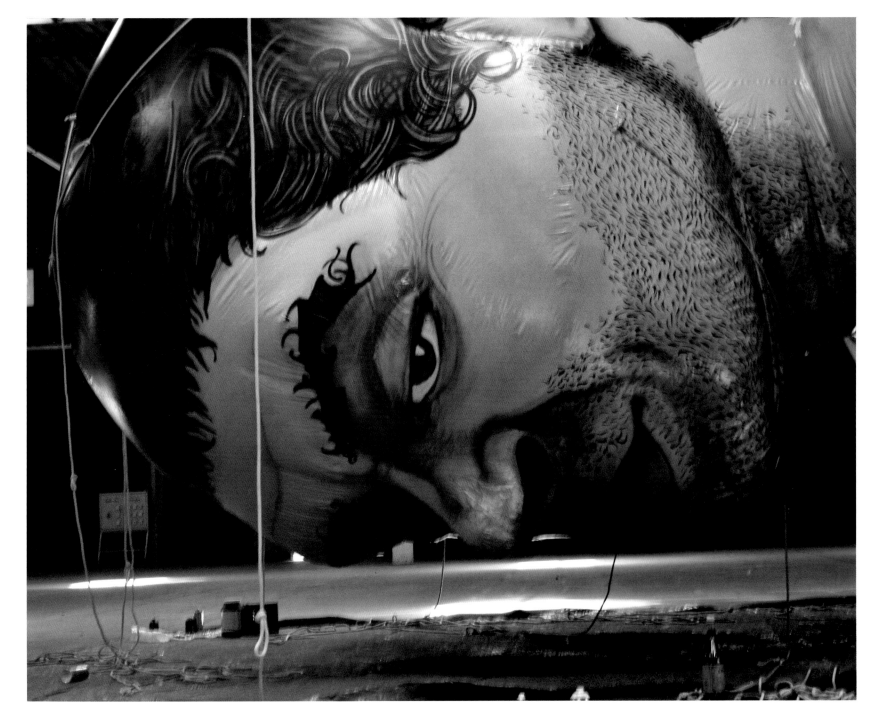

Upon completion of his one-year Deutscher Akademischer Austausch Dienst (DAAD) scholarship, the artist designed a presentation that summed up his stay in Berlin. He focused on the experience of moving to another city with his whole family, a city in which he participated to a limited extent and only in selected areas, remaining invisible in others. He was fascinated by the sense of disappearing and mingling with the crowd. Living for a year in Berlin, busy organizing life for his wife and kids, he had no time to participate in the city's artistic life. This is why, to sum up his stay, he organized an action at Alexanderplatz called Unsichtbar (Invisible), advertised by numerous posters printed with ink that disappeared over time. A number of people came to see the advertised event, and the artist simply didn't show up – he disappeared. At the same time, he organized an exhibition in his private flat of the artworks that he and his family had made during their stay in the city: his wife's paintings, his children's drawings and figurines, a video showing his work as a refuse collector in Berlin and, above all, Pawel and Monika, a portrait of himself and his then wife made of grass and animal intestines. The presentation was made to look like a family dinner.

Am Freitag, dem 28.06.2002, wird der osteuropäische Künstler Paweł Althamer von 17.00 bis 19.00 Uhr auf dem Alexanderplatz in Berlin-Mitte

unsichtbar

werden.

DAAD/Berliner Künstlerprogramm · Polnisches Institut Berlin

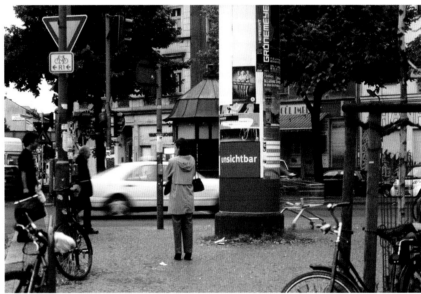

metres long and in a rigid pose, forty metres high into the sky in the park outside the Palazzina. *Balloon* (1999-2007) could not be missed in the park, and it delighted and fascinated both adults and children. But very few people at the exhibition noticed the elderly gentleman walking around in the villa: a double of the artist at the age of seventy (*Self-Portrait as an Old Man*, 2001-07).

It is striking how tightly Paweł Althamer links art and life together in his work, unlike Kaprow, who kept the two fields strictly apart in his happenings, which he saw as role play. Althamer's recontextualization of his artistic work as life in his real-time 'movies' is one consequence of this approach. This process was demonstrated, for example, in the *Unsichtbar* (Invisible) action in 2002 in Berlin's Alexanderplatz, which he announced on posters and flyers printed in ink that was not light-fast: 'On Friday 28.06.2002 the Eastern European artist Paweł Althamer will become invisible in Alexanderplatz in Berlin-Mitte from 17:00 to 19:00.' This action was linked

with the end of his one-year DAAD scholarship in Berlin, during which he had scarcely involved himself in the artistic and social life of the city because situating his family there took up a great deal of time. While he was staging his absence for the public, he opened an exhibition in his flat to present what he and his family had produced in Berlin: paintings by his then wife, drawings and objects by their children, a video work of his own and two nudes, *Paweł and Monika* (2002), executed using the same technique as his early *Study from Nature* (1991). The figure of the artist holds a video camera, and Monika's speaks on the phone. In the exhibition in their Berlin flat, the figures were standing at the open window, and the camera was pointing at the entrance to the building.

In his 1995 exhibition at the Miejsce Gallery in Cieszyn, there was a room for *Study from Nature* and next to it a second space for his alter ego, the attendant (*Untitled*, 1994). Althamer had been invited to take part in a group

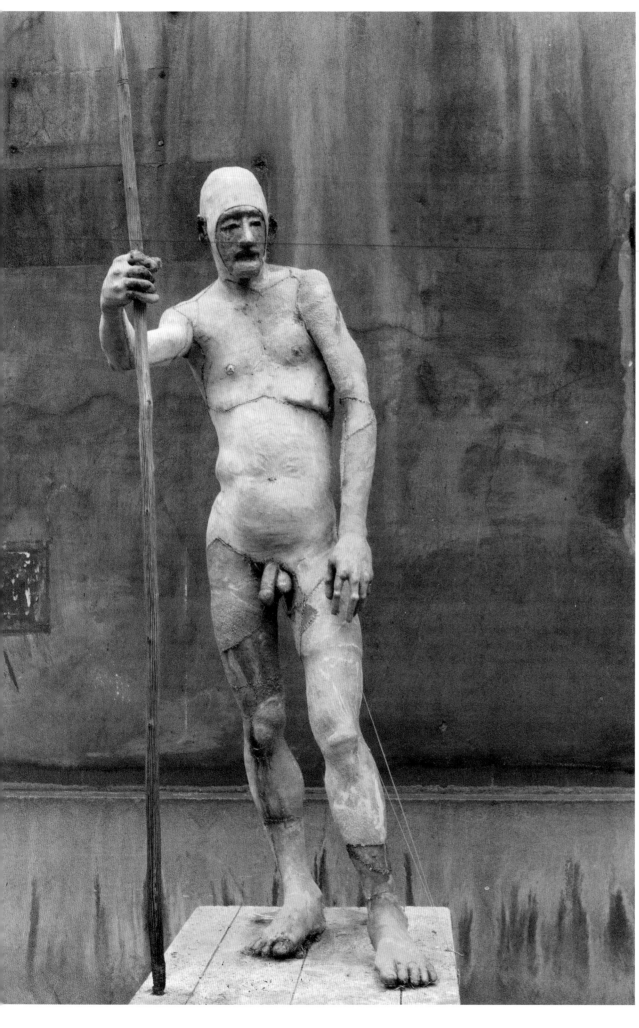

STUDY FROM NATURE, 1991
HAY, GRASS, HEMP FIBRE, ANIMAL INTESTINE,
WOOD
245 X 47 X 47 CM

PAWEL AND MONIKA, 2002
STRAW, HEMP FIBRE, ANIMAL INTESTINE,
WAX, HAIR, OLD WOODEN FLOOR TILES, USED
VIDEO CAMERA, USED GLASSES, USED MOBILE
PHONE, USED WRISTWATCH
178 X 111 X 75 CM

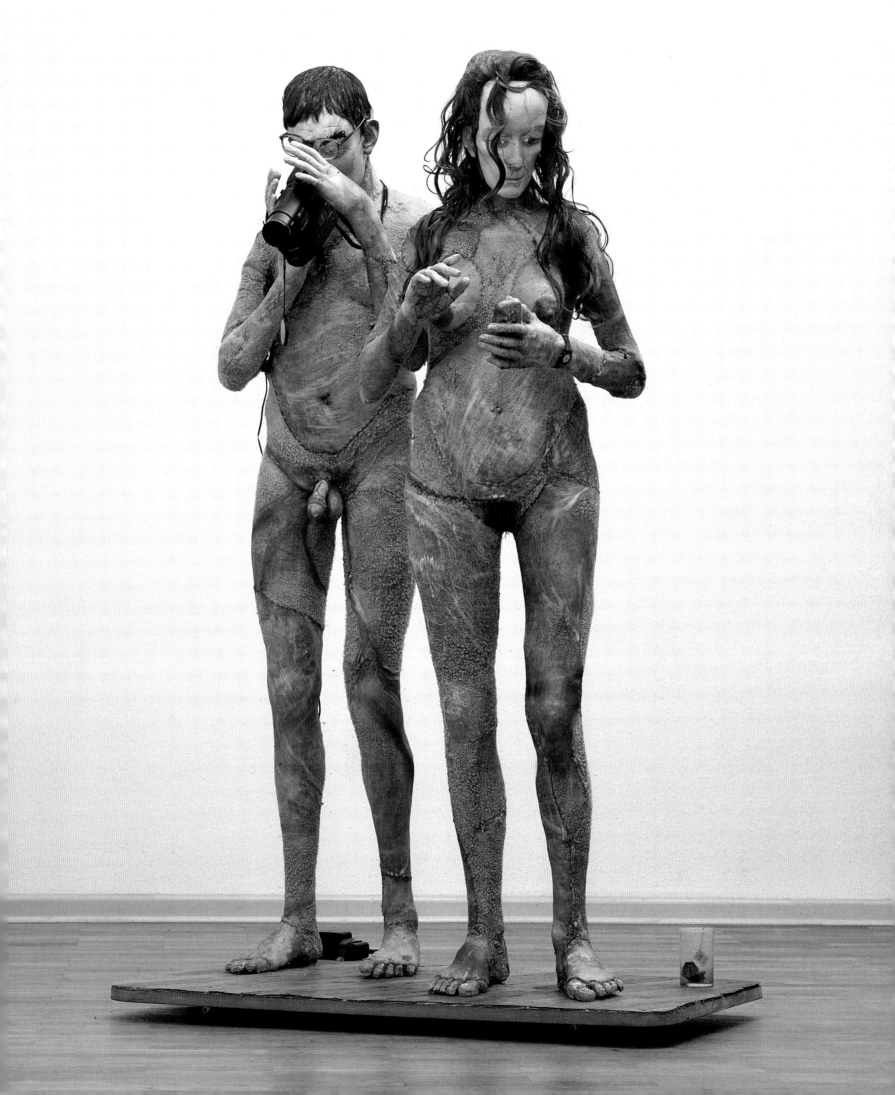

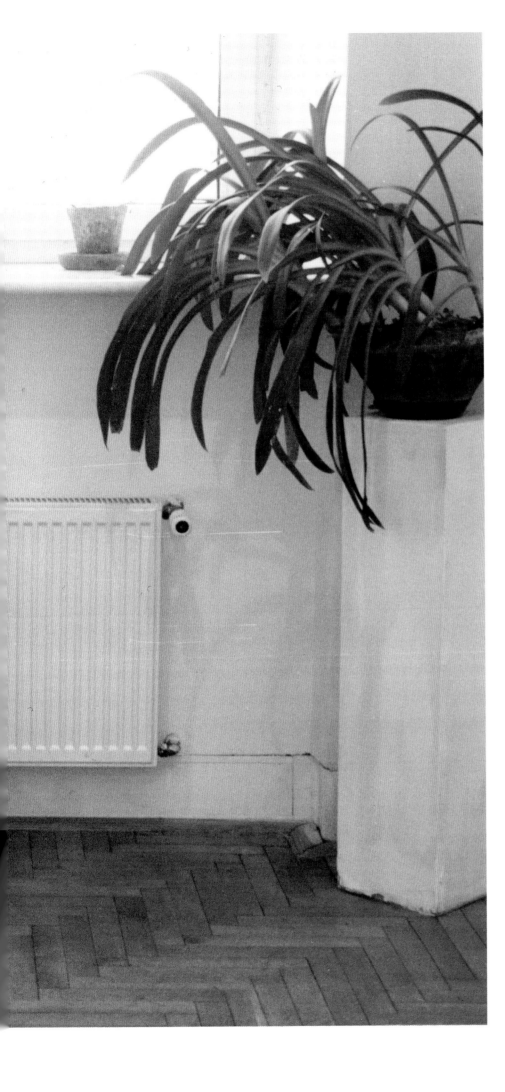

Invited to the group exhibition 'Germinations 8',
the artist carried out an interview with one of
the gallery's invigilators. He asked her what she
didn't like about her job, what she would like to
change and what he could do to make her job
more enjoyable. He then collected the things she
asked for and put them in the gallery. For the rest
of the exhibition she had a chair to sit on, tea and
juice to drink, a radio to listen to, plants to water,
and so on.

exhibition at the Zachęta National Gallery of Art in the previous year. While preparing for it he got into a conversation with the attendants and tried to find out how he could help to improve the working atmosphere. The female attendant he interviewed asked for items such as a chair, a radio, plants and drinks. Althamer's contribution to the exhibition was to grant this attendant a private space within the public exhibition space. In 1998 at his solo exhibition at the CCA in Warsaw he addressed the exhibition as medium by giving each space within the show a function of its own and furnishing it appropriately. There was a waiting room, a darkroom, a café and a club room with a video collection. Each gallery required visitors to come up with a different form of perception and communication that was not art-specific.

Althamer has often returned to addressing this ambivalent relationship with the gallery not just as a place to mediate and position his art but also as a commercial partner. In recent years, at the same time as he was becoming increasingly successful on the international art market, his critical approach to the art world became increasingly insistent and led to a series of significant exhibitions. For his 2003 show at the tiny Wrong Gallery in New York, which consisted of a bunch of flowers in a glass vase on a draped pedestal, he paid two Polish illegal immigrants to destroy the exhibition and the entire 'gallery' (which was just a glass door in front of a shallow niche). They were then to reconstruct it and wreck it again, repeatedly, as many times as the budget permitted during the course of the exhibition. In the same year, he had a solo exhibition at neugerriemschneider in the Mitte area of Berlin that presented the gallery as a dilapidated room in need of repair, with everything cleared out of it. Some very grubby art magazines dating from the current year were to be found in an old cardboard box under a makeshift covering of torn plastic sheeting. An exhibition review by Friedrich Reinhold stressed the exhibition's double connection with reality, saying it was reminiscent of the era before the Wall fell and at the same time a 'reminder of the future'.[31]

In 2007, for his second solo exhibition at neugerriemschneider, Althamer turned the space into an art studio. During the gallery's business hours, African immigrants whom Althamer had got to know in Warsaw carved sculptures. In the working area, which was set on a black floor in one corner of the white gallery, lay a larger-than-life ebony sculpture of the artist. On the walls were drawings of tools and scribbled ideas for work and exhibition concepts. A photograph of the men involved was taken later, and some of the figures they had carved

UNTITLED, 2003
PHOTOGRAPHIC DOCUMENTATION OF AN ACTION, THE WRONG GALLERY, NEW YORK

The artist hired illegal immigrants he had met in Greenpoint, a Polish neighbourhood in Brooklyn, to destroy the closet-size gallery, along with his exhibition in it, and then to repair it. The action's goal was to provide work for people with whom the artist felt a particular affinity: Poles coming to America in search of work. At the same time, it was a comment on an over-saturated economic system in which you have to destroy something to make room for something new.

NEUGERRIEMSCHNEIDER, 2003
SITE-SPECIFIC INSTALLATION,
NEUGERRIEMSCHNEIDER, BERLIN

Using set design, realistic retouching and
mystification, Althamer transformed the space
of a prestigious gallery into a complete ruin,
removing the doors and windows and leaving it
deserted around the clock. Like a vanitas, the
work shows what could happen if the art market
were to collapse or change radically, introducing
a temporariness and uncertainty into the routine
activities of galleries and artists.

during the exhibition were added to it. The 'black
workers', who were introduced and asked about the
project in the booklet accompanying the exhibition, had
no artistic background at all. At Althamer's suggestion,
and accompanied by him, they drew their inspiration
from a visit to the ethnological collections in Berlin. This
work does not just make the concept of authorship look
shaky, as Althamer's work so often does, but it has the
same effect on categories such as 'art as politics' or 'art
as social work', which had been applied to many artists'
work since the 1990s. Althamer defines *Black Market* as
a sculpture that can be worked on further each time. If
the work is shown, the studio can take up its work again,
and the new sculptures, again carved by black immi-
grants, will become part of the existing ensemble.

Invisible sculpture

Fairy Tale (2006), created for the 4th Berlin Biennial,
caused a considerable stir. A single athletic shoe was
exhibited in an otherwise empty room. It belonged to
Besin Olcay, a young man who, born in Turkey eighteen
years previously and raised in Berlin, was due to be
deported to Turkey with his family. A petition addressed
to Berlin's Minister for Home Affairs, which exhibition
visitors could sign, demanded that the senator grant
Olcay a residence permit 'on humanitarian grounds'.
For the Biennial Althamer originally intended to
restage his own experiences as an illegal immigrant in
Germany, while also getting hold of a residence permit
for an immigrant living in Berlin without papers, and
paying for this person's accommodation and language
lessons, among other things, from the exhibition budget.
Olcay's case came to his attention, and, shortly before
the Biennial opened, 'the focus, initially a generous
attempt to integrate an alien, shifted to declaring inte-
grated people to be aliens again,' wrote the *Frankfurter
Allgemeine Zeitung* on 31 March 2006.[32] Claire Bishop
said that the piece was 'perhaps the most iconoclastic
work in the Biennial' and pointed out that the work was
more than a concrete political action like the work of
Santiago Sierra: 'In Althamer's work, social collabora-
tion follows from a mode of self-portraiture in which
the artist replays, or "corrects", his own experience,
often through identification with so-called outsiders.'

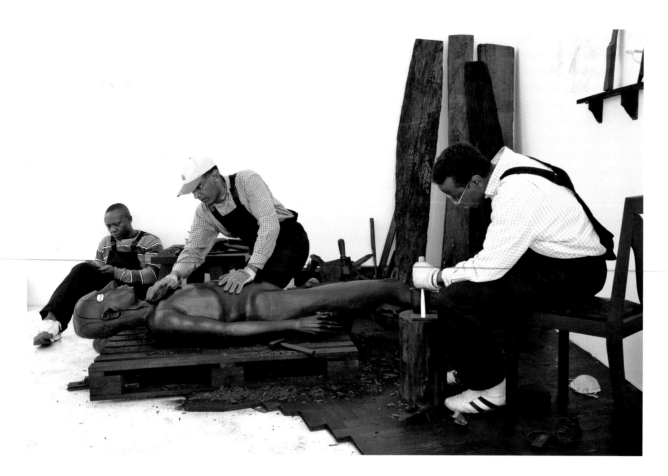

BLACK MARKET, 2007
PHOTOGRAPHIC DOCUMENTATION
OF AN ACTION
PVC, EBONY, SWAMP OAK, SMOKED
OAK, ANIMAL INTESTINE, CLAMS, FABRIC,
THREAD, WORKBENCH, VICE, VARIOUS TOOLS,
CARDBOARD, PLASTIC, BROOMS, BLACK
OVERALLS
SCULPTURE 226 X 63 X 30 CM
STUDIO OUTLINE 267 X 317 X 200 X 282 CM
NEUGERRIEMSCHNEIDER, BERLIN

The artist converted the gallery into a workshop,
bringing three African immigrants from Warsaw to
work on a sculpture while telling their own story.

FAIRY TALE, 2006
PHOTOGRAPHIC DOCUMENTATION
OF AN ACTION
4TH BERLIN BIENNIAL

The single shoe exhibited in an abandoned
building in Limienstrasse belonged to Besin
Olcay, a young man who was due to be deported
from Germany to Turkey. A petition addressed to
Germany's Minister for Home Affairs, displayed on
the wall for visitors to sign, demanded a residence
permit for Olcay on 'humanitarian grounds'.

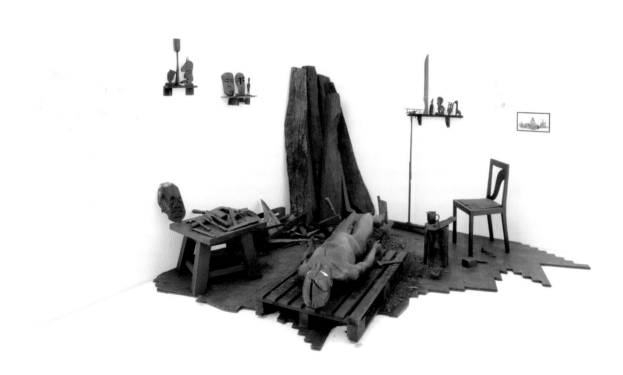

The project is also a performance in real time: as works like *Motion Picture* (2000) (for which he hired actors to perform everyday activities in one of Ljubljana's public squares) attest, Althamer is interested in directing reality, constructing narratives that develop without his knowing their outcome.'[33]

The *Motion Picture* she refers to is an action that has so far been performed in Ljubljana, Pittsburgh, Warsaw and, under the title *Film*, in London. This work, now in the Tate collection, consists of a real-time movie performed in the streets of a city. For each version the same roles are cast locally: a movie star in a car, a tourist with a camera, a businessman, a homeless man, a grandfather or grandmother, a child, a couple in love (man and woman), a person or two running across a street, and a street musician. In London Jude Law played the movie star. This version also included a film trailer, screened in local cinemas, that showed him arriving at the location in a private car and looking with great concentration at the other actors performing the everyday scene. On the soundtrack a voice speaks the

following words: 'Suddenly, I was surrounded by a cloud of flames. But soon I realized that in fact the fire burned within me. I was seized with joy and experienced illumination beyond description. I could feel that the universe was not made of dead matter but was a living presence. I felt eternal life within me. I reckoned that all people are immortal, and that the cosmic order makes all things work towards the common good. I understood that the basic principle of the world is what we call love and that in the long run we all can be sure of happiness.' Finally, a text appeared announcing the time (30 November 2007) and place (Borough Market) for the performance and asking the cinema audience to be aware of and to experience something that no film can show. For the real-time movie, Law and the other actors played their parts again, this time not for the camera but for spectators who had seen the trailer and the posters, and who Althamer intended to have a déjà-vu experience, as well as for anyone who happened to be passing. Each production of this work has been an attempt to create in a public space the conditions for viewing reality as a film.

MOTION PICTURE, 2000–04
PHOTOGRAPHIC DOCUMENTATION OF AN
ACTION, LJUBLJANA, PITTSBURGH AND
WARSAW

In one of the city's public squares at the same
hour over the course of several days, ten people
enacted a simple thirty-minute scene designed by
the artist. He was thus able to verify his nagging
intuition that reality could be perceived as a film,
that all that is needed is to define the frame,
specify the setting and watch the action unfold.
A scene, performed without a camera in the
public space, was a gentle attempt to engage the
sensitivity of the unsuspecting passers-by. The
artist was thus distorting the natural course of
events, revealing his passion for directing reality.
Someone who regularly passed through the area
might feel a sense of déjà vu.

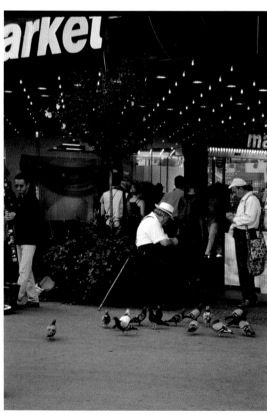

FILM 2000-07
POSTER AND PHOTOGRAPHIC DOCUMENTATION
OF AN ACTION, BOROUGH MARKET, LONDON

The artist's idea for Film was generated by the
simple association of cinema projection with
everyday reality, which he found more fascinating
than any movie he had seen. He produced a
trailer and showed it in local cinemas, ending with
this text: 'You will never see this in the movies /
Come / See / Experience / At Borough Market
/ Beginning 30 November at 11.30 am.' At the
appointed time and place, viewers could see the
scene played by the same actors but without a
camera, crew or fanfare to distinguish it from any
ordinary moment of city life.

In a recent interview the actor John Malkovich said that you don't need to act in a film, as only a few minutes of film are produced on each day of shooting: 'You could make a great film with a truck driver you'd just picked up in the street.'[34] Althamer's film projects follow this logic in a much more radical way than Malkovich intended. His logic expresses an artistic approach reminiscent of Augusto Boal's Theatre of the Oppressed, and he works with comparable methods. Boal was director of the Teatro de Arena de São Paulo from 1956 to 1971, during which time he developed a new form of theatre aimed at the large proportion of the Brazilian population living in abject poverty. He wanted to liberate the audience from their passive attitude and turn them into active participants. Plays were written and performed co-operatively at his theatre school. In the 1970s, in exile in Europe, Boal developed the Theatre of the Oppressed as a response, as he wrote in 1979, 'to repression in Latin America, where people are clubbed down every day in the open street, where workers', farmers', students' and artists' organizations are systematically smashed to pieces and the leaders arrested, tortured, murdered or forced into exile. That is where the Theatre of the Oppressed came into being.'[35] The Invisible Theatre is one of the Theatre of the Oppressed's many forms and techniques. Each piece deals with a current theme, is worked up by the actors together and performed unannounced in a public place. Boal writes, 'The Invisible Theatre is prepared and rehearsed like a normal theatrical performance. But the scene is performed where it happened or could happen. There is no set, no real location is transposed into a fictitious one: reality is its own stage set. [...] The Invisible Theatre plays to audiences who do not know that they are an audience and who are not therefore trapped in the rigid rituals of the conventional theatre that condemn them to be unable to act. Audiences have the same right to act as actors. Whether they acknowledge the scene or whether they walk on – they are always masters of their own decisions, they are subjects.'[36] This is definitely not about putting life and art on an equal footing but about trying out new ways and means of keeping art alive in people's consciousness as a socially relevant activity.

Essentially, sculpture is concerned with a body in space, a credo that Althamer has followed in his work from the outset. At the same time, performance allows him to come to terms with his person and the world he lives in. Rather than developing alongside sculpture, it has emerged as one of that medium's genuine expressive forms. As theorist Susanne Knaller has written, 'Performativity thus means simultaneity of participation and observation, reference and self-reflexivity, formation and action. Reality in the performative form is not the referential content, an outside or a not yet visible, but it derives its consistency only within and through this process.'[37] Althamer's action-oriented understanding of reality manifests itself in the way in which he relates

to the world and in his growing interest in participative work modes. Radicalizing his artistic approach in this way has made it possible for him to realize new and surprising projects in public spaces in recent years. Works like *Ścieżka* (Path, 2007), a trail cut through a field with the help of inmates from a nearby penal institution as part of the Skulptur Projekte Münster, or the various performances of real life as film, point the way forward for the future. Paweł Althamer is on the trail to an invisible sculpture.

TRANSLATED FROM GERMAN BY MICHAEL ROBINSON

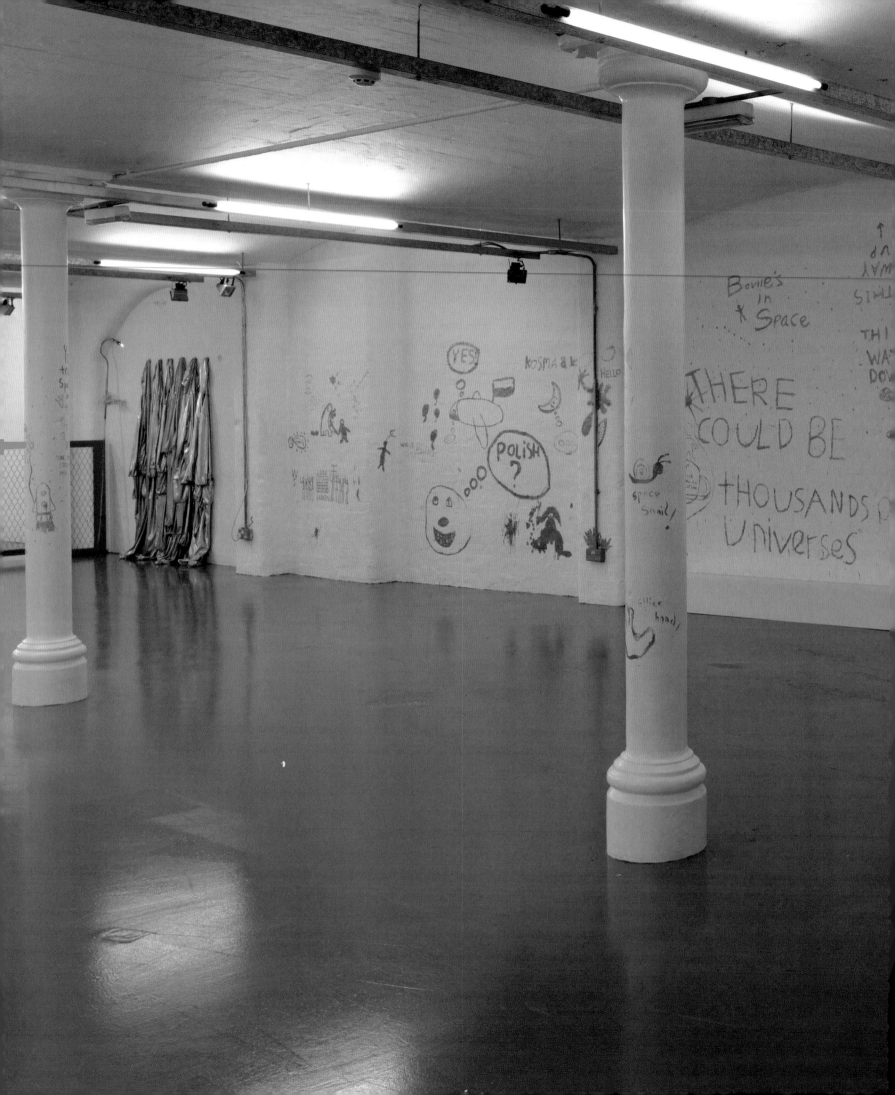

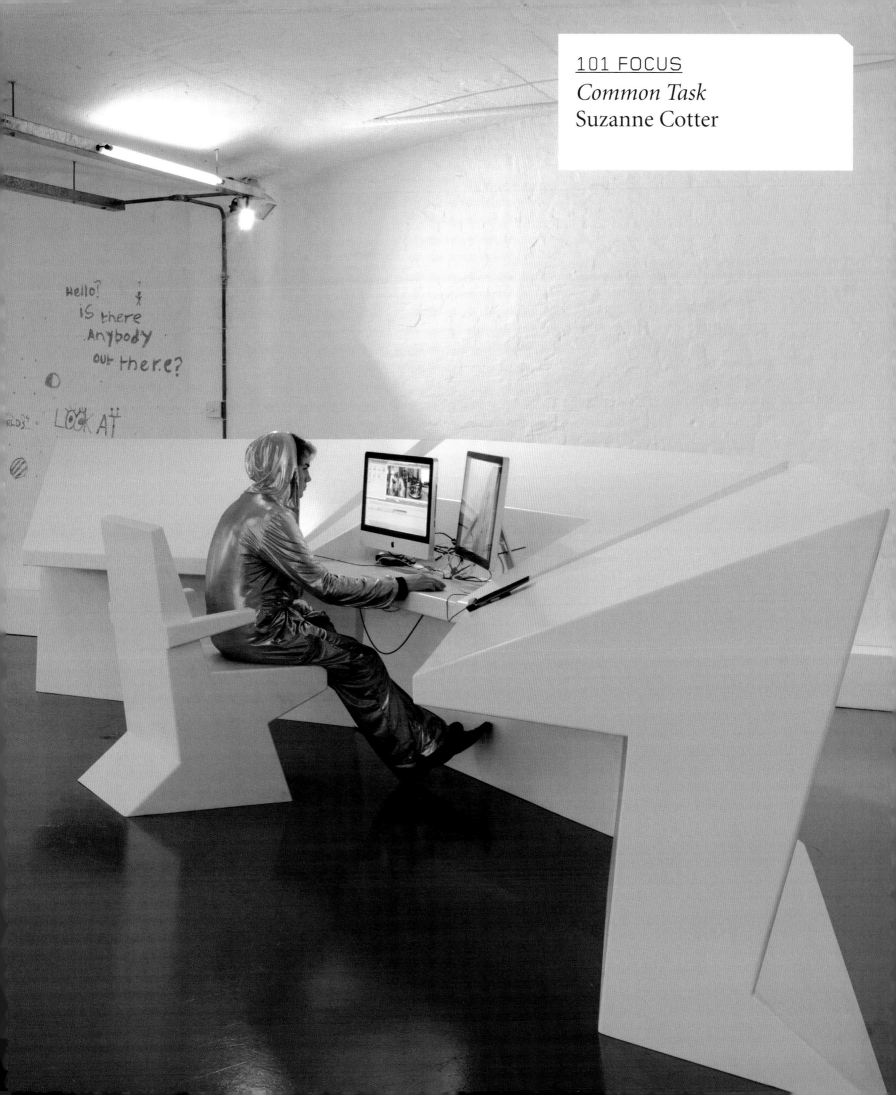

Common Task
Suzanne Cotter

Travel and transport have proved a central and lasting metaphor for Paweł Althamer. Both serve as vehicles for perceptual transformation and as allegories for the artistic journey itself, in which the artist assumes the role of alien or outsider. The astronaut or space traveller, in particular, has figured largely in this context, as has the artist as a Pied Piper-like figure leading those who choose to take part in reconfigured fields of possibility, such as his 'real-time films' in the streets of Ljubljana, Pittsburgh, Warsaw and London, or his Path for Skulptur Projekte Münster in 2007.

In an exhibition context, whether within a museum or gallery or in the recuperated spaces of international biennials, he has produced visual, spatial and cognitive alterations of radical simplicity. Rather than adopt the rhetoric of dismantling the museum or gallery context and its 'white cube' tradition, Althamer proposes its continuation as a conduit to an experience of heightened sensibility – art gallery as waiting room, portal from inside to outside, spaceship or teleport station. The fundamental nature of his proposition is the open field of possibility that it invites on the part of those who encounter such a situation and, should they so choose, become part of the work itself – or, perhaps more correctly, have the work become part of them.

Assuming the guise of a science-fiction film, Common Task originates in Althamer's local community of Bródno, a working-class housing estate, or 'block housing' as it is known, built in the 1970s, where Althamer has lived with his family for many years. Bródno is also the eponymous location where, with the help of its inhabitants switching on their interior lights at a prescribed time, Althamer orchestrated the creation of a monumental, illuminated '2000' to mark the new millennium. The core participants of Common Task, conceived in multiple episodes whose iterations extend across geographic and cultural space, are residents of 13 Krasnobrodzka Street, Bródno, including the artist's neighbours and family members. Assuming their roles of space-and-time travellers, Common Task participants wear specially created gold spacesuits adorned with the blue and white Common Task logo. The iconography of striding forth into distant galaxies, knowingly crafted by Althamer with the retro-futurist feel of a Soviet-style superhero comic book, suggests an earnestly playful trope for the formation of a new social consciousness in the wake of the post-Socialist era. As Althamer states in a filmed interview circulated on YouTube, 'The time is ripe to see our place of residence through the eyes of the world.'[1]

In early 2009 Althamer and the Common Task group travelled to Brasilia, the capital of Brazil designed in 1956 by urban planner Lúcio Costa and architect Oscar Niemeyer. There, they undertook activities both planned and contingent on the people and situations encountered along the way, including the costumed parades of Carnevale and the gathering of a religious group dedicated to manipulating cosmic energies for the

opposite and following pages,
COMMON TASK, 2008-PRESENT
PHOTOGRAPHIC DOCUMENTATION
OF AN ACTION

Accompanied by members of his local community in Bródno, the artist has embarked on an ongoing journey that has taken him from Warsaw to Brazil, Belgium, Mali and England.

below, COMMON TASK LOGO, 2008
TEXTILE
⌀ 8.5 CM

previous pages, COMMON TASK, 2008-PRESENT
PHOTOGRAPHIC DOCUMENTATION OF AN
ACTION, MODERN ART OXFORD

The artist converted the British institution into an imaginary space station for the Common Task travellers. Visitors were invited to wear one of the Common Task uniforms and join the group in a series of activities, such as following them on a walk through the nearby countryside or sitting with them in an editing suite where footage from the previous Common Task trips was being assembled.

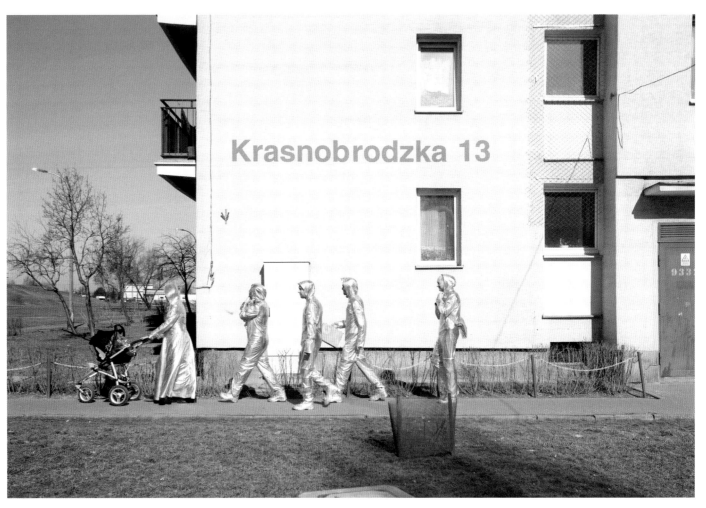

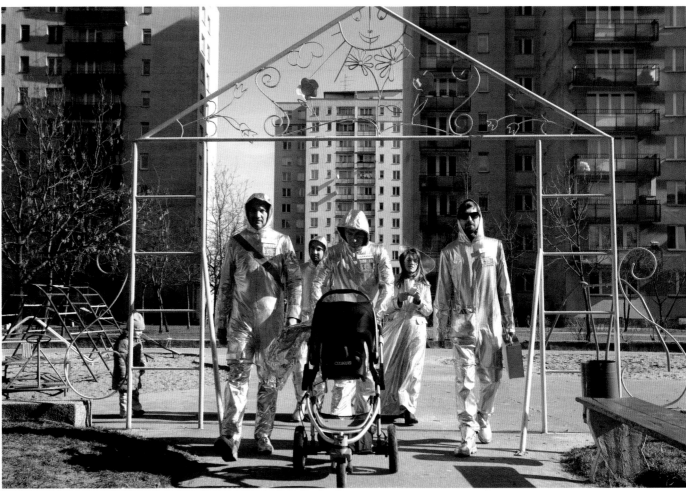

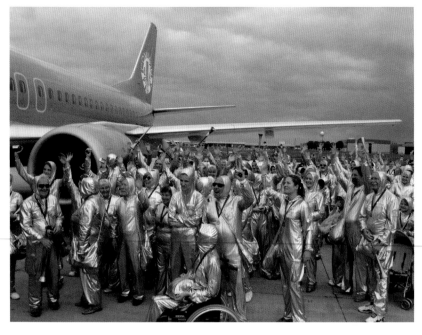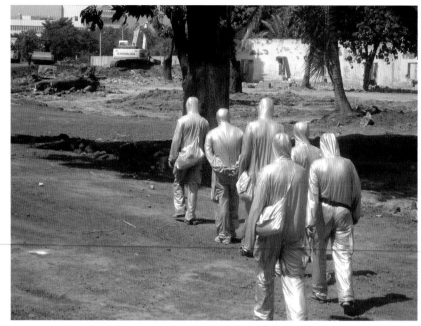

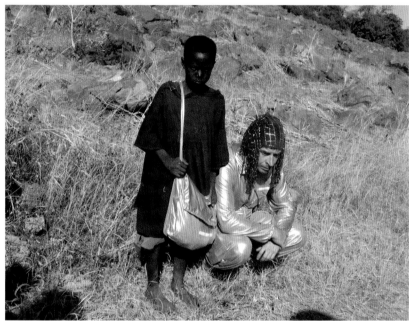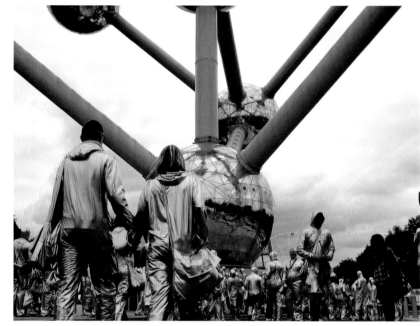

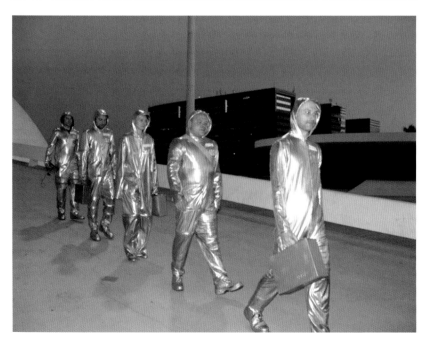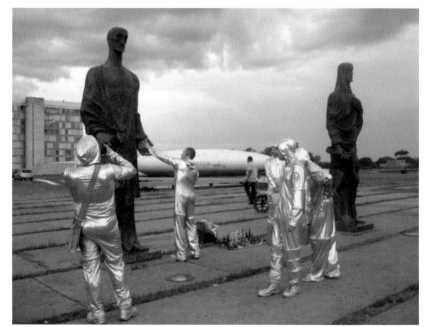

benefit of the community. On 4 June of the same year, to celebrate the twentieth anniversary of the end of communism in Poland, a 150-strong contingent of gold-suited Common Taskers flew to Brussels in a Lot Airlines Boeing 747, the exterior of which had been painted, in accordance with Althamer's designs, entirely in gold. Accompanied by journalists and anyone who wanted to join in, the group visited the site of Expo '58 and its Atomium monument before continuing on to the European parliament.

In November 2009 Althamer and a small group of his Bródno neighbours, accompanied by a guide and the filmmaker Cezary Ciszewski, travelled to Mali, where they spent several weeks with the Dogon people. Ciszewski's film, shot entirely with a Nokia mobile phone, captured the Common Task group travelling, arranging their passage from Bamako to the Dogon region of Bandiagara and spending time in the village of Bandiagara, where they visited ceremonial sites and took part in daily life. As with the earlier journeys, our knowledge of these events has been communicated retrospectively through photographs and film footage, which serve as

a kind of choreographed documentary, together with objects collected
as part of a time capsule to be displayed or enacted in a future context.
When Common Task was 'hosted' by Modern Art Oxford in the winter of
2009-10, Althamer had the gallery's reception spaces transformed into
his image of a space station, complete with a control module from which
a film editor/pilot edited the visual material brought back from Mali along
with new footage of journeys led by Althamer around Oxford with different
social groups. Among the objects presented in the gallery's altered space
were a wooden staff and a ceremonial Kanaga mask. Carved by one of the
village's young sculptors, the mask's geometric surfaces and vertical and
horizontal forms, which allude to the symbolic order of Dogon cosmology,
were covered by Althamer with a rich layering of gold leaf. Common Task's
emblematic use of gold, evocative of votive sculptures like the smiling
figurines of Byblos, also brings to mind that most alchemical of artists (and
an influential figure for Althamer) Joseph Beuys, particularly his 1965

performance How to Explain Pictures to a Dead Hare, for which Beuys covered his head and face with a mask of honey and gold.

While undeniably performative in its nature, Common Task constitutes also an expansion of Althamer's continued practice of self-portraiture, in which the artist is expressed and expresses himself through a process of collective enactment. His travels to Mali in 2009 with members of the Common Task group represented a personal journey of return. Althamer first travelled to Africa as part of a Polish ethnographic mission in 1991, while still a student at the Academy of Fine Art in Warsaw. The physical, social and spiritual revelations he experienced with the Dogon people at the time proved revelatory and, significantly, a catalyst for reconnecting with his housing estate of Bródno as a focus for his artistic production. In a conversation with his friend and fellow artist Artur Żmijewski about this earlier trip, Althamer reflected, 'Africa is still another way of searching this other world. It seemed to me that I could relate to this continent more than

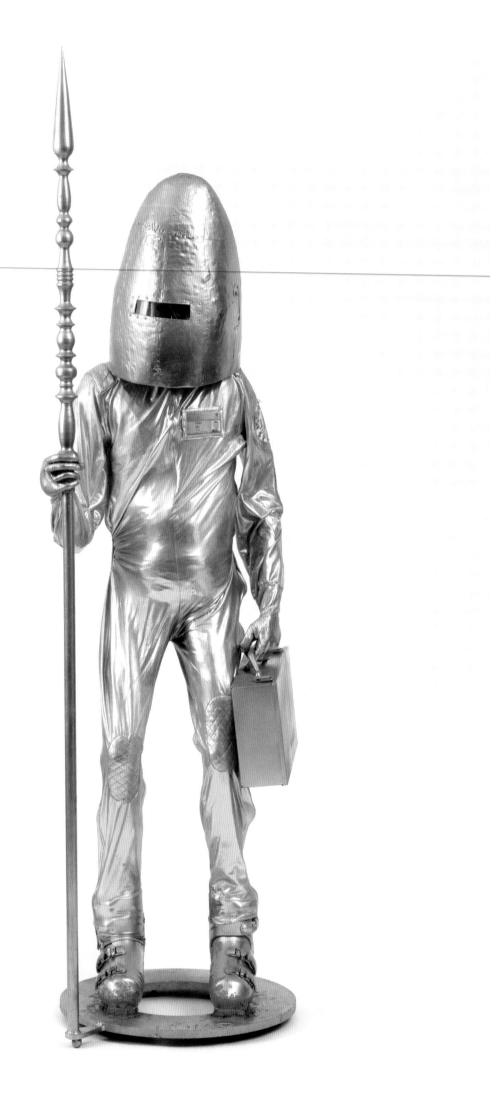

to what I see and witness here. Only after I had visited Africa did it turn out that here, without going anywhere, I can feel and live through what I've been missing. […] Over there I realized that the very place is here, in the Warsaw neighbourhood of Bródno. Bródno has this intense aura.'[2]

A number of other activities taking place locally, in and around Bródno, have provided vehicles for Common Task alongside the journeys around the globe and have reinforced Althamer's emphasis on this most local of sites as a locus of production. They include the opening of a new outdoor sculpture project in the park of Bródno, organized by the Museum of Contemporary Art, Warsaw, with the collaboration of Althamer, whose contribution, Paradise (2009), consisted of a redesign of the park's lakeside plantings inspired by children's drawings and images from old master paintings. Other events forming part of Common Task included the making of a golden gondola, which was launched on a canal in Bródno as a symbol of regeneration or as a cosmic vehicle, like the vessels for gods and departed souls depicted in Pharaonic mythology. In my conversation with the artist in 2010, he talked about a possible final, as yet unrealized task of pilgrimage to the seaside of Poland. Since then he has unveiled Bródno People (2010), a new collaborative public sculpture, again for Bródno, made from simple, 'poor' materials and inspired by August Rodin's The Burghers of Calais (1889).

One might consider Common Task as embodying the lightheartedness and the seriousness of Theodor Adorno's discussion of transcendence, a form of agency that pits empowerment and self-realization against a subsuming and easily manipulative state of social acquiescence that was the menace of the culture industry. The discussion in Commonwealth, in which Michael Hardt and Antonio Negri elaborate on the transformative and, for them, revolutionary potential of the common, also offers an interesting filter through which to reflect upon the significance of Common Task.[3] Central to the project, and to Althamer's art in general, is the non-hierarchical nature of Open Form, in which the ownership of a proposition, artistic or otherwise, is assumed and transformed by others. Elaborated by the Polish architect Oskar Hansen in the 1950s as a reaction to what was perceived as the dehumanizing dimensions of modernist architecture, Open Form privileges process over the singular object. In it, the viewer becomes a co-author of the work through active participation. Open Form was at the core of the teaching methods of Professor Grzegorz Kowalski, an assistant of Hansen's before becoming head of his sculpture studio at the Academy of Fine Arts, where Althamer was a student in the late 1980s and early 1990s.[4]

It is important to signal Hansen's principle as one that, although informed by an aspiring internationalist architectural discourse of the 1930s and 1940s, emerged out of the context of an ideologically divided Europe

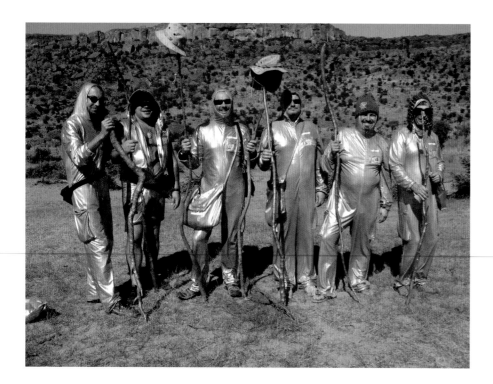

COMMON TASK, 2008–PRESENT
PHOTOGRAPHIC DOCUMENTATION OF AN
ACTION
left, MALI
opposite, OXFORD

following the Second World War. The ethical dimensions of the teachings of Hansen and Kowalski, assumed as an aesthetic and cultural position within the repressive diktats of Eastern European communism, have been extended by Althamer in contemporary terms. Describing himself as 'being of the Utopian strain in art',[5] his liberation of the field of art into the hands of all those who take part in it signals a project of emancipation that extends beyond the consideration of art historical teleology, from the performance practices of the 1960s to the present moment of 'post-institutional critique'. In its carving out of a new space, one of participation and visibility and 'endowed with a common voice', Althamer's trajectory enacts the 'redistribution of the sensible' that Jacques Rancière defined as political in art's potential to reconfigure the relationship between who is recognized as having a voice and who is not.[6]

This is not to say that one should attempt to confine Common Task to these purely political terms, just as one cannot easily ascribe the work to an aesthetic form that sits neatly either in the museum or in an art historical box of our making. What Althamer offers us is an unruly, not easily containable and richly provocative proposition, of fiction and history and of friction and people and places. In Althamer's case, art is life as self-realization. Self-reflective and seemingly unbounded in their generosity, the possibilities he alerts us to in the world seem imperfectly and optimistically endless. The potential is in each encounter, a question of singular moments that come together within a common sphere of experience. Whether consensus is achievable is not necessarily the point. Rather, it is the journey to test its limits that becomes significant.

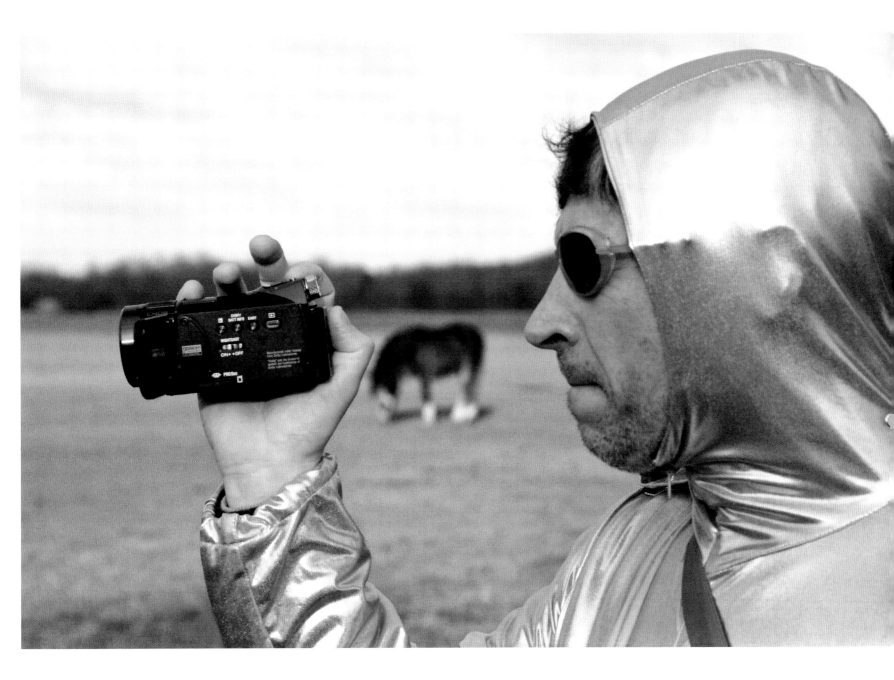

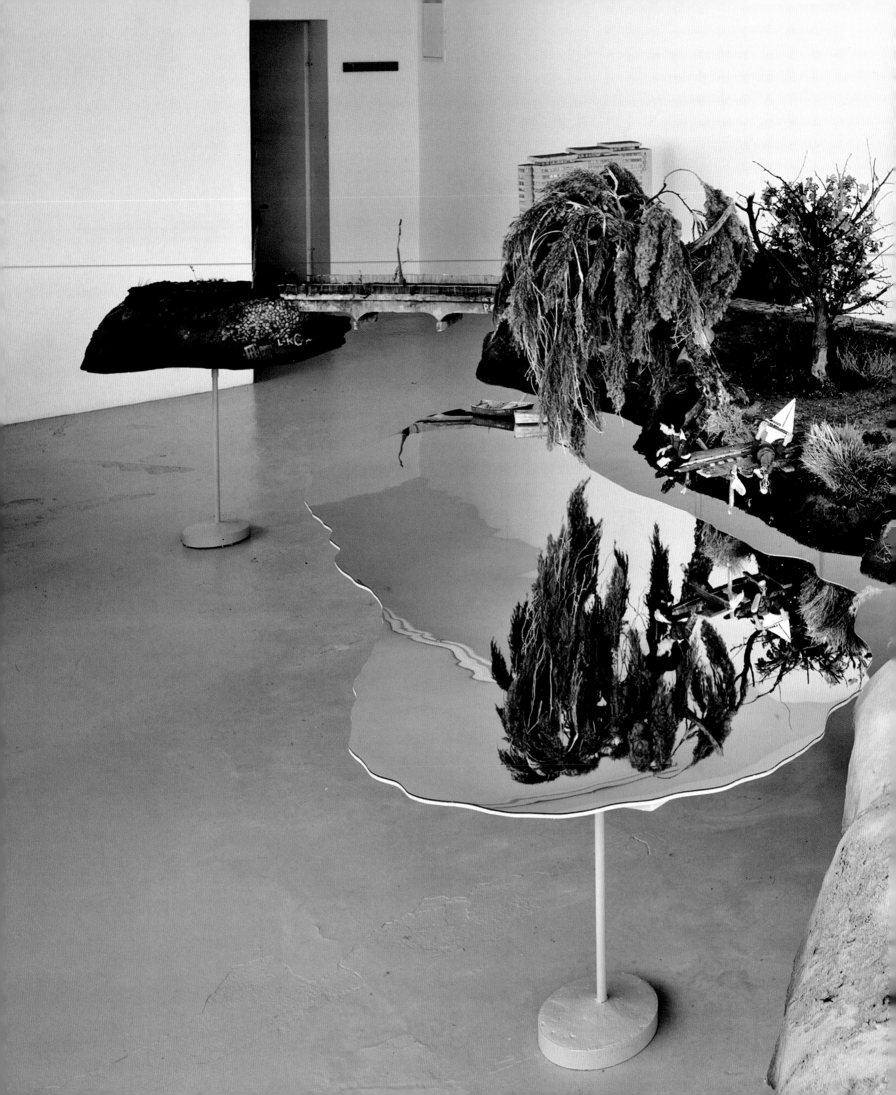

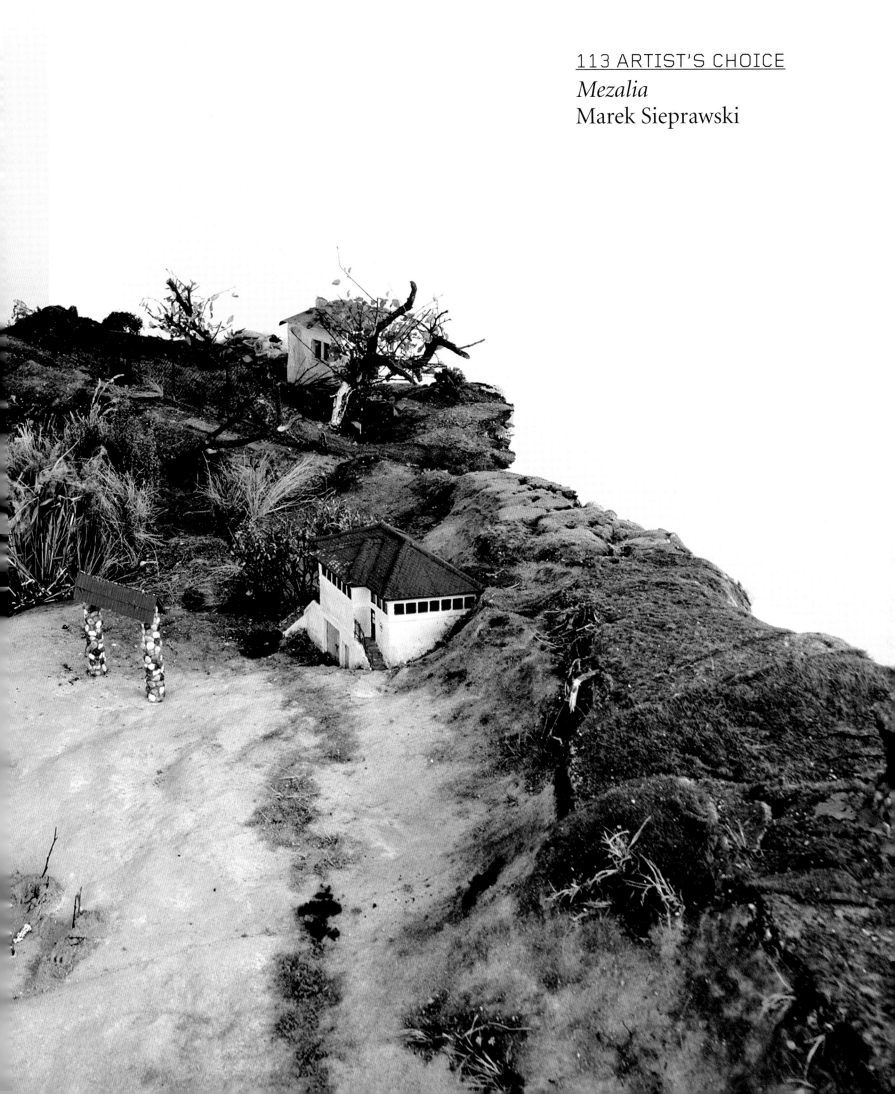

Mezalia
Marek Sieprawski

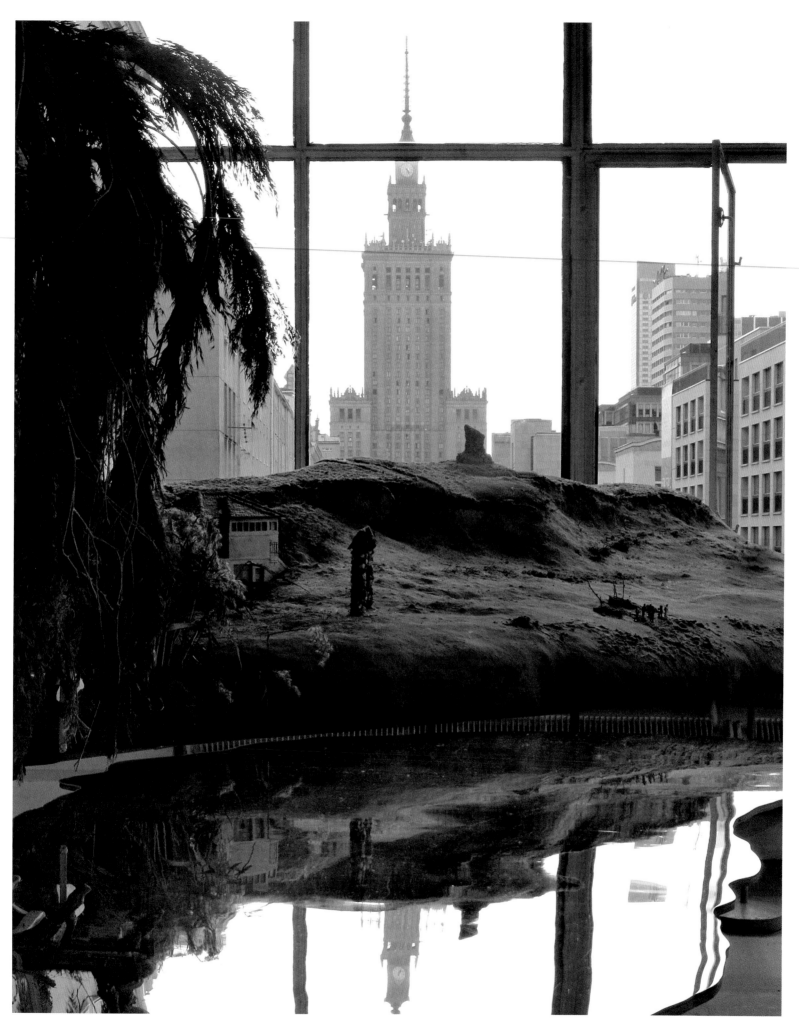

MEZALIA (WITH PAULINA ANTONIEWICZ AND
JACEK TASZAKOWSKI), 2010
STYROFOAM, METAL, CONCRETE, WOOD,
PLYWOOD, CLAY, ASPHALT, PAINT, STONE, SAND,
PLEXIGLAS, PLASTIC, TWIGS, LEAVES, FOIL,
CARDBOARD, RUBBER, POLYMER CLAY, WAX,
HAIR, TEXTILES
ARTIST'S FLAT 170 X 100 X 80 CM
FIELD AND LAKE 175 X 700 X 340 CM
WARSAW BUILDINGS 140 X 110 X 40 CM

Inspired by this short story by Polish writer
Marek Sieprawski, the artist called friend and
filmmaker Jacek Taszakowski to work on a film in
which Sieprawski's novel and the artist's own
childhood memories overlap. The set of the film,
which features a lake from the area where the
artist spent his childhood, a room in his former
apartment and three buildings in Warsaw, was
built at the Foksal Gallery Foundation and later
exhibited there as a sculpture.

I was sure I'd find him there. Whenever it gets cloudy, he goes down to the pond and sits on the broken jetty. He floats boats made of leaves and dips sticks in the water like fishing-rods. He usually takes his toy soldiers along and plays with them on the shore. Sometimes he puts those troops of his into bark dugouts and sends them off on dangerous 'naval' expeditions. The ones who survive the watery ordeal and make it back to shore are decorated and put into his special veterans' box. The box is sacred to him. He keeps hiding it, and I'm the only one he tells where. That's in case he forgets the hiding place, but I don't think that's ever likely to happen.

That day, I was carrying something down to the pond, too. Most of the time, I come empty-handed and play with whatever's there. But this time, I had a great big box tied with a blue bow under my arm.

Milo was sitting on the edge of the jetty, his legs dangling and skimming the surface of the water. His hat, with its huge rumpled brim, was pulled down low on his forehead as usual. He was holding a sagging twig in his hand, and lashing at the water with it.

'Hi,' I greeted him cheerfully.

He turned and nodded his head, then turned around again and went back to what he was doing. He was in a bad mood.

'Look what I got,' I said, thrusting the box in his direction, 'my Mom gave it to me.'

This time, he turned all the way round to face me.

'It's wrapped. Do you know what's inside?' he asked.

'I do, but I got Mom to wrap it up again for me. I wanted the two of us to open it together.'

'Cool,' he smiled. 'I'll undo the bow, you can take the lid off.'

'OK.'

We knelt beside the package and got to work. When I took the lid off, Milo was thrilled at the sight that greeted him.

'Whoa! A real sailboat!' he cried.

'It's great, huh?' I beamed.

'It's perfect.' Milo took the boat out of its box and inspected it from every angle. 'What's the occasion?'

'No reason,' I wanted to downplay the gift. 'Mom was in town, so she bought it for me.'

Milo sighed.

'Your Mom's nice. Mine broke my soldiers again.'

Milo's Mom can't stand his toy soldiers. She thinks toys like that are no good for you. So she destroys or throws out every toy soldier she gets her hands on. Even the innocent sentries. That's why Milo hides the box with the veterans. Good thing he has a lot of soldiers; he got them from his Dad.

'You know,' Milo said, forgetting his worries, 'we'll have to give that boat a spin.'

'A spin? Now?' I didn't like the idea, and the enthusiasm with which Milo said it was positively worrying.

'Sure! We'll send her on a voyage across the pond. Shame I don't have my soldiers here, they'd have a ball.'

'But Milo,' I protested fearfully. 'It's dangerous! Why take such a risk on the first day?'

'You keep saying that. Boats are made for sailing, am I right? We'll give her a trial run by the shore and then send her off to war.'

MEZALIA (WITH PAULINA ANTONIEWICZ AND
JACEK TASZAKOWSKI), 2010
STYROFOAM, METAL, CONCRETE, WOOD,
PLYWOOD, CLAY, ASPHALT, PAINT, STONE, SAND,
PLEXIGLAS, PLASTIC, TWIGS, LEAVES, FOIL,
CARDBOARD, RUBBER, POLYMER CLAY, WAX,
HAIR, TEXTILES
ARTIST'S STUDIO 170 X 100 X 80 CM
FIELD AND LAKE 175 X 700 X 340 CM
WARSAW BUILDINGS 140 X 110 X 40 CM

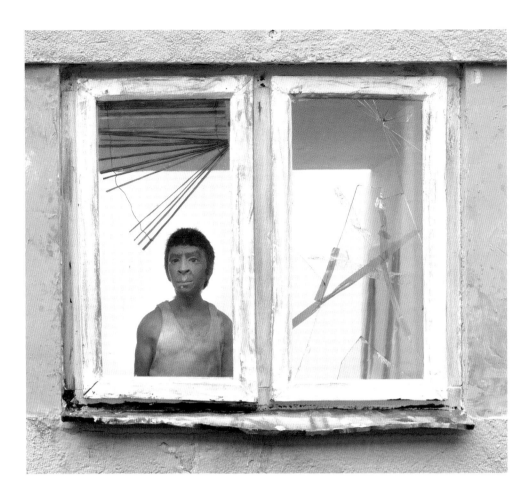

I knew I wouldn't be able to talk Milo out of it. I was scared, but ashamed to say no for fear of being called a sissy.

'F-fine, let's go try her out,' I agreed reluctantly. Deep down, I was hoping the launch wouldn't go well and that we'd have to give up the idea of sending the boat on a longer cruise.

Meanwhile, Milo had grabbed my prize and rushed off with it towards the shoreline. When I caught up with him, he had already taken his shoes off, rolled up his pant-cuffs, and was proudly holding the boat in the air.

'Relax,' he reassured me, 'there's no other way. Remember that wind-up tin clown you had? You were so careful with it. You didn't want to wind it up, and what happened? One night it was gone, and you never saw it again.'

He paused and then said:

'A boat has to be christened before it's launched. What do you want to call her?'

'Hmm… The Mezalia…' I quietly suggested a name that came to me from who knows where.

"The Mezalia? That's kinda…," he scowled. "But have it your way; after all it's your boat."

With a flourish, he lowered the boat onto the water and gave it a little push. The boat swayed slightly, then sailed smoothly forward, cleaving the water with its prow.

'Sails great!' Milo was thrilled.

'Nice,' I concurred with satisfaction, even though I knew the boat's fate was now sealed.

'No point in stalling,' Milo caught up with the boat. 'Let's see how she does in deeper water. The conditions are perfect. There's even a bit of a tide. No chance of her getting stuck somewhere in the middle of the pond.'

There was a slight breeze rippling the surface of the water. Somehow Milo's mood was getting to me.

'Let me have her,' I said. 'We'll go back on the jetty and I'll launch her off it myself.'

Milo waded ashore. He handed me the boat, then grabbed his shoes, and followed me barefoot.

We reached the edge of the bridge and lay face down on the boards. I leaned down so my hands touched the water.

'Be brave, Mezalia. Sail fearlessly and don't let us down,' I intoned, and gently dropped the boat into the water.

She swayed slightly, then righted herself and cut through the ripples on the water, her little sail billowing.

Milo cupped his chin in his hands and lay down on the jetty. I lay down in the same position, my heart beating hard, and watched my boat sailing off.

She sailed no faster than a leaf or a dugout, but she looked much nicer. She was far away by now. The wind tipped her to one side then another. She smoothly cut a course through the rotting leaves floating on the surface of the water.

'Go on! Go on!' Milo started making waves with his hands. They spread out into broad rings and reached the boat without doing it any harm. 'See, there was nothing to be afraid of,' he laughed, 'she's a fine ship.'

Then a sudden gust of wind rocked the boat, and it listed precariously.

'Oh!' I cried.

'Relax,' Milo said, but he was anxiously looking up at the sky, which was filling up with huge dark clouds.

Just then, another stronger gust made the Mezalia roll over onto its port side.

I let out a choked and painful moan.

'Drat!' cried Milo.

The little cloth sail slowly soaked up water and dragged the boat down until it capsized. My heart was pounding something awful.

'She's a goner,' I mumbled in despair.

Milo was nervously rocking on his feet. Meanwhile, the boat had vanished under the murky surface of the pond, halfway between us and the far shore.

'What'll I tell Mom?' I blurted out before breaking down in tears.

Milo stood off to one side, shifting his gaze from me to the spot where the boat had disappeared. He was rolling the hem of his jacket between his fingers. He seemed to be muttering something but I couldn't make out what it was. Suddenly, he bolted toward the shore and ran home.

I was still sitting there, crying and hurt, when Milo came back with his boxful of veterans. It was starting to rain as he arranged his troops on the edge of the jetty. His motions were a little jerky and some of the soldiers fell into the water. When he was done, he said in a serious tone:

'They'll stand watch all night. In honour of the Mezalia.'

I looked at him, and then at his soldiers. They were all standing there: the best and the bravest, lined up to pay tribute to my boat. It's a shame my mom didn't get to see it.

TRANSLATED FROM POLISH BY ARTUR ZAPAŁOWSKI

MEZALIA (WITH PAULINA ANTONIEWICZ AND
JACEK TASZAKOWSKI), 2010
STYROFOAM, METAL, CONCRETE, WOOD,
PLYWOOD, CLAY, ASPHALT, PAINT, STONE, SAND,
PLEXIGLAS, PLASTIC, TWIGS, LEAVES, FOIL,
CARDBOARD, RUBBER, POLYMER CLAY, WAX,
HAIR, TEXTILES
ARTIST'S STUDIO 170 X 100 X 80 CM
FIELD AND LAKE 175 X 700 X 340 CM
WARSAW BUILDINGS 140 X 110 X 40 CM

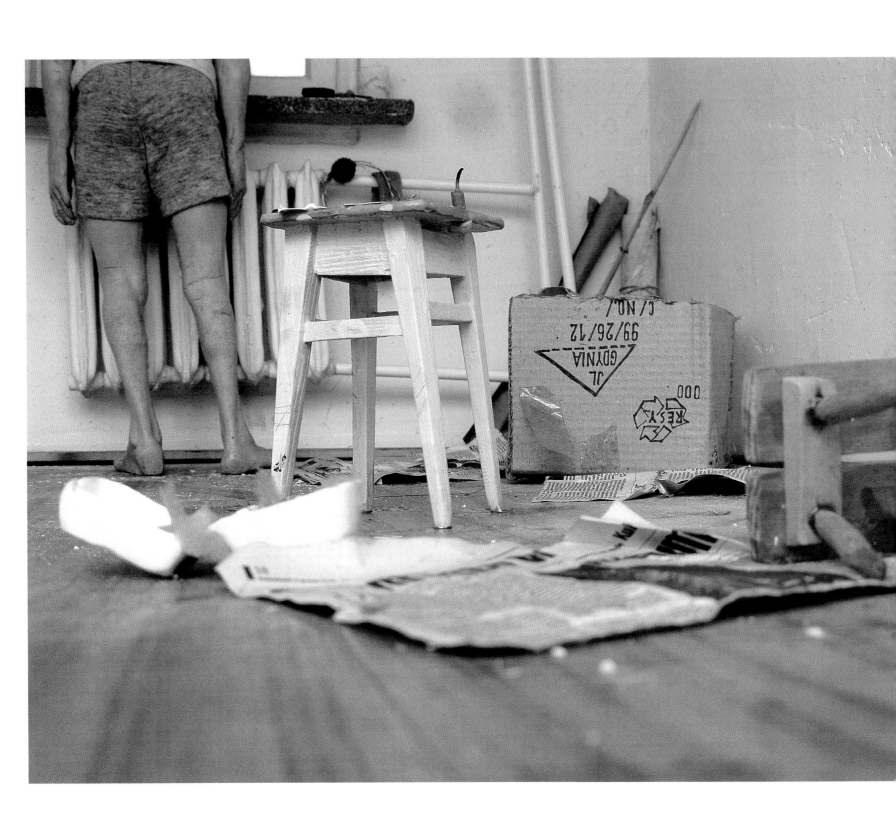

ŁAZIENKOWSKA

⑧

⑫

SPACER

25 VI 2001

ZAMEK UJAZDOWSKI
(CSW) — KAWIARNIA
ROZDROZE.

GODZINA 18 00

18.20 - 18.40

⑧ MOTOCYKLIŚCI

(DAWID)

18.20 - 18.45

⑨ SKY W ALEJCE, SŁUCHA

MUZYKI I PALI

18.30 - 19.00

⑩ CZŁOWIEK Z KAMERĄ

OGARNIA WSZYSTKO

18.30 - 19.00

BILBOARD
ART.

⑪ BIZNESMENI TELEFONUJĄ

PRZY JAGUARZE (MICHAŁ)

⑫ BRUNO NA HULAJNODZE

Z MAMĄ I SIOSTRĄ 18.35 - 18

⑬ PAN TADEUSZ 18.45 - 19.30

⑭ KINGA Z ZESPOŁEM

ŚPIEWA W KAWIARNI

18.30 - 19.10

The Song of a Skin Bag: Interview with
Artur Żmijewski, 1997

SELF-PORTRAIT IN A SUITCASE, 1996
USED SUITCASE, WOOD, METAL, WIRE,
PLYWOOD, CARDBOARD, CLAY POLYMER, WAX,
HAIR, PAINT, TEXTILES
60 X 80 X 50 CM

This work, which shows the artist in his old age,
uses the suitcase as a sort of time machine.
Its precisely designed microcosm, with its play
on scale, reflects the artist's reservations about
his social role. It was first exhibited in a Warsaw
shop window.

previous pages,
WALK, 2001
ACTION, CENTRE FOR CONTEMPORARY ART
UJAZDOWSKI CASTLE, WARSAW
DRAWING
86 X 60 CM

On the occasion of a series of lectures called 'My
History of Art', Althamer proposed a walk through
the area surrounding the Ujazdowski Castle. Some
of the scenery encountered during the walk was
staged by the artist.

ARTUR ŻMIJEWSKI: *Let's begin with dreams.*

PAWEŁ ALTHAMER: I dreamt of a friend of mine who came to visit wearing a Diesel jacket. He said, 'I bought this jacket because the tag said you could use it for flying. But I can't seem to get off the ground. Maybe you'd give it a go?' 'Sure!', I said. I put it on and was flying over the steeples. I remember the fascinating feeling of ascending. At the same time I was aware that the ability to fly depends on the subtle faith that floating in the air is possible. Whenever this faith faded, my altitude dropped noticeably. Soon after, I had a dream in which I flew over a park. I took a run-up before the eyes of the strollers and, much to their amazement, lifted off the ground. I spread out my arms and I was flying, happy as a bird. I soared over treetops. My first dream of flying came when I was about seven. I started levitating over my bed during a birthday party, until I felt my back rubbing against the ceiling. The guests were smacking their lips in admiration. I know that if only I could believe, I would actually fly. I could fly off the Palace of Culture and Science just as I could walk on water. But my faith is weak. This weakness comes from obsessive rationalism. Useful as it is, it also destroys the seemingly idiotic trust in the ability to fly, see the dead, and travel out of your body.

ŻMIJEWSKI: *You miss the world without gravity?*

ALTHAMER: Most people do. Take the popularity of the phrase 'get high', for example. Look at television: shampoo commercials where hair ceases to be material, or mobile network spots where everyone is floating high. Cosmetics and drinking water alike, all seem non-physical. Or take sports. Ski jumping offers its participants the opportunity to levitate. Or auto racing. These are obvious symptoms of nostalgia for being like the ether, recollections of past experiences when we had no bodies and were free to float freely and travel any distance. We were nothing but free will.

ŻMIJEWSKI: *Did you have a life before this life?*

ALTHAMER: I am convinced I was once a spirit. It comes from my dreams about flying, but also from the adolescent satisfaction with fast skateboarding and swooping down slides.

ŻMIJEWSKI: *You said that the people in your film* Dancers *(1997) are in fact spirits.*

ALTHAMER: Yes, dressed-up spirits enjoying the return to their original form. They already know that the decomposition of the body and death need not equal sadness and fear. They could also be seen as the anticipation of the return to the original, blissful shape of a freely floating spirit. I keep coming back to evenings I spent as a child when, with a group of other kids, I would hide under a blanket and tell stories about spirits and death. That was very exciting and has remained so to this day. I still think the mystery of death is extremely intriguing.

ŻMIJEWSKI: *Does that mean you are happy with the prospect of death?*

ALTHAMER: It is a schizophrenic happiness. I am happy, though at the same time death fills me with a purely animal fear for my body, to which I have become accustomed for over thirty years now. I got used to it, like an object I'm anxious to lose. Becoming aware that the body is merely a tool of the soul is a great achievement. I feel like an astronaut in the spacesuit of my own body; I'm a trapped soul.

ŻMIJEWSKI: *You have made a number of works which involved spacesuits, and have also enclosed yourself in a plastic bag filled with water, and in a steel container.*

ALTHAMER: The doctrine that the soul inhabits the body has been around for ages. I think the *Song of a Skin Bag* by the Chinese Master Xu Yun, a treatise on the transience and fleeting nature of the body, made many things clear to me. The body serves as an outfit, an address. My bodily address is Paweł Althamer. The steel container and the suit I once made were thought up as a palpable illustration of body and soul. They could be also regarded as instruments for exercises in dying. *Łódź* (Boat, 1991) would be the equivalent of a coffin, while the suit (*Astronaut Suit*, 1991) could stand for the body. I have also made a work that involved laminating clothes. Along with them I laminated everything I had in my pockets: from my identity card to a dried-out apple core. A nude figure covered with skin (bovine intestines) also resulted from my experience as an astronaut in the spacesuit of my body. The work which I am about to present in Kassel (*Astronaut 2*, 1997) addresses the same theme. It is the equivalent of a boat made of sheet metal. The suits will take the form of abandoned sacks, along with an individual who will inhabit an interior of my own construction for three months. This older man will appear as my doppelgänger — a distant me from the future looking back on what I did in my life, thinking, 'How ridiculous is everything Paweł sculpted. If, instead of sculpting these tiny figures, he had been going to the park and sitting on a bench, he would have seen more and lived his time to a fuller extent.' In order to convey all of this, I try to attain an easily accessible language that brings associations to the race for the moon. This is because if I openly declare I have travelled outside my body, people react with a puzzled expression and try to change the subject.

ŻMIJEWSKI: *Travelling outside the body, separating out the soul — how does one achieve all that?*

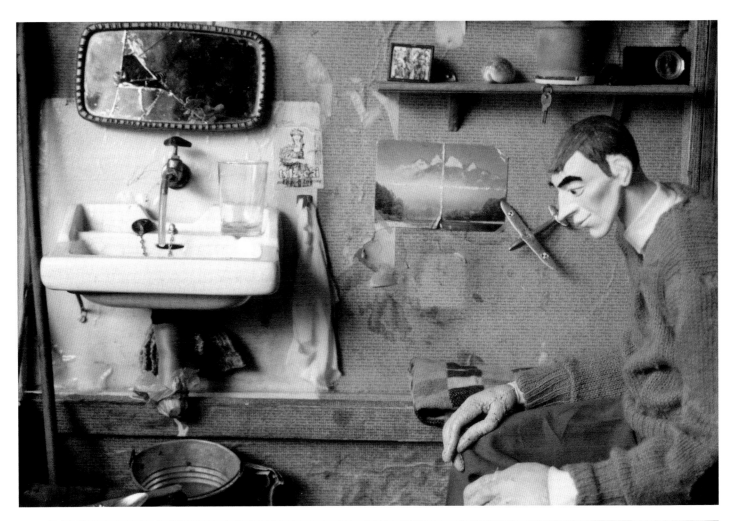

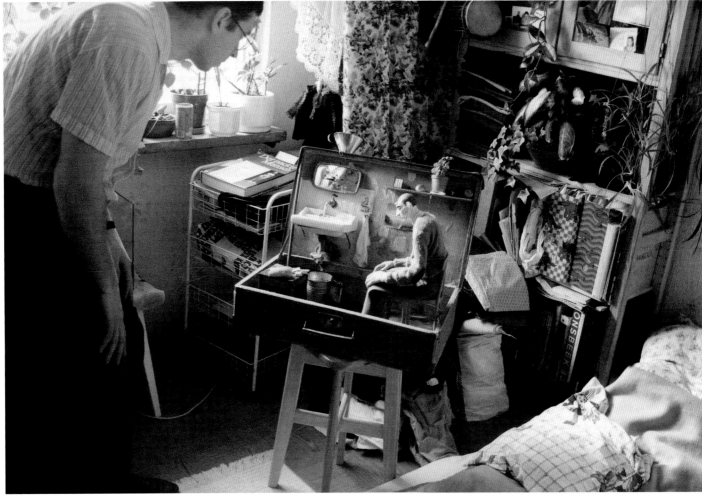

BOAT AND ASTRONAUT SUIT, 1991
PHOTOGRAPHIC DOCUMENTATION OF AN
ACTION, ACADEMY OF FINE ARTS, WARSAW

The artist built a metal crate capable of containing
a single occupant, which he climbed into while
wearing a white costume covering the whole
surface of his body, including his face. Part of a
series of works experimenting with the perception
of the body and the mind, it touches on the idea
of the astronaut in a space capsule ready to
depart, while at the same time offering a powerful
metaphor of a man stepping into his own grave

WATER, AIR, SPACE, 1991
PHOTOGRAPHIC DOCUMENTATION OF AN
ACTION, ACADEMY OF FINE ARTS, WARSAW

In this exercise in sensory deprivation witnessed
by the artist's fellow students, Althamer lay on
the floor in a large plastic bag with a small pipe
sticking through it allowing him to breathe. The
bag was slowly filled with cold water. The artist
experienced the amplification of sound from the
exterior and also a sort of out-of-body experience

ALTHAMER: Last time I was able to take off was seeing swans soaring into the sky. Rowing down the Biebrza River, observing birds take flight, I managed to take psychic flight over the neighbourhood, my body physically left behind in the raft. In one of my dreams I have developed a flight technique: walking faster allows me to accumulate both physical and spiritual energy. When I consciously experience the most minute movement of my body, each step becomes a run-up. Along with the movement, my consciousness is freed from three-dimensional space — this is the point at which I lift off the ground. I feel that exciting moment of ascension. All this happened to me in a dream. But I also experienced it while fully conscious, as the effect of an exercise described by Robert Monroe in a book on out-of-body experience. According to the instructions, you need to seize the brief moment before falling asleep, when the body is already dormant but the mind still alert. I tried it a couple of times, but kept falling asleep. One night however, I was very tired and discontinued the exercise, thinking that sleep would be a greater relief than waiting on the threshold. Then it happened. I felt like a spinning top, and a couple of spasms swept through my body. Paweł Althamer and myself were disconnected. I found myself floating a metre above him. I was scared as hell! A moment ago I was Paweł Althamer and knew what was going on. But now? What am I doing here and, what is more, who am I?! 'Get back home, back in your outfit — you're naked,' I sensed something howling. I leapt back into my body and, now as Paweł Althamer, I sat up, breathing heavily. I experienced exceptional joy mixed with paralyzing fear. It was a test, and it proved that I was not bold, or emotionally coordinated, enough to remain out of my body.

ŻMIJEWSKI: *What do you call the person that is extracted from Paweł Althamer?*

ALTHAMER: 'Self', which is a lot more myself than Paweł Althamer.

ŻMIJEWSKI: *Describe it in more detail.*

ALTHAMER: My outfit claims to be Paweł Althamer, and there's an ongoing dispute between me and the outfit as an earthly, male being. Althamer is at times stupid, while 'Self' is destined for wisdom. It's marked by wisdom but not through education. It's just the way it is. 'Self' is not the final step on the ladder; there's quite a number of us, each closer to the most pure 'Self'. Perhaps the latter is no longer a 'Self', but 'Us/we', a collective. Just look at us: Paweł and Artur, we're two different persons. But perhaps there's something that's both you and me — a common part. A community

of ants is perfectly organized because it possesses a collective self. Paweł Althamer is fascinated by the existence of a 'Self' that is wiser than he. Fathoming it is what he considers one of the most vital tasks in life. That 'Self' is much older than Althamer, containing emotions relating to a very distant past, but also much animality and cruelty. I know that, because I had a daydream, or a somnambulist collapse, during which I was transported back into what seemed like prehistory. I think that the theory of transmigration and reincarnation holds much ground.

ŻMIJEWSKI: *How ancient was the reality you managed to experience?*

ALTHAMER: It was a time when there was yet no language, and emotions were the dominant element in human nature. I fell into a trance and began travelling back into the past; the thing that allowed me to return was fear. If it weren't for that, I would have ceased being Althamer, returning to an animal existence in the woods. The past is extremely absorbing. While awake I'm certainly Paweł Althamer, but when I sleep things no longer look that simple.

ŻMIJEWSKI: *Who are you in your dreams?*

ALTHAMER: At the age of fifteen I dreamt I was a medieval knight, and a captive woman is brought to my tent. Now, Paweł Althamer had absolutely no idea what to do with her. But the knight didn't hesitate; he took the woman, spending the night with her. It was something that had not yet occurred in the life of Paweł Althamer. In my other dream I was a samurai. Clad as a warrior, I was walking up the steps of a Japanese stronghold. I had a sword, and wooden sandals with high struts on my feet. I remember the specific stance I adopted and the way I moved my feet. Later I saw exactly the same thing in Kurosawa's films, and felt it was very familiar. I was a great fan of samurai films. Perhaps this was the reason I started judo classes when I was ten.

These are all evidence of a life before life — not quite credible, as they do not go beyond dreams, vivid experience and recollections or behaviour I find difficult to explain. It might seem that I am a calm and quiet person. But the sight of thuggish or other violent behaviour awakens the inner warrior in me. If I'm afraid of conflict it's only because it would mean the death of one of the fighters. I crave a true duel. I feel imbued with the ethos of a knight-errant.

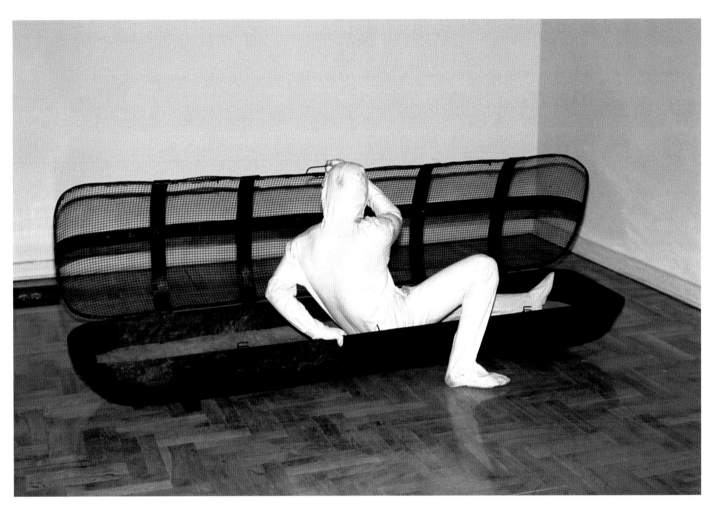

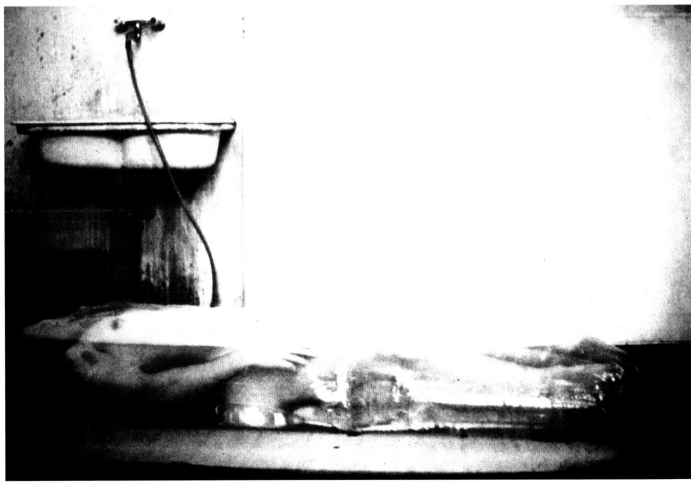

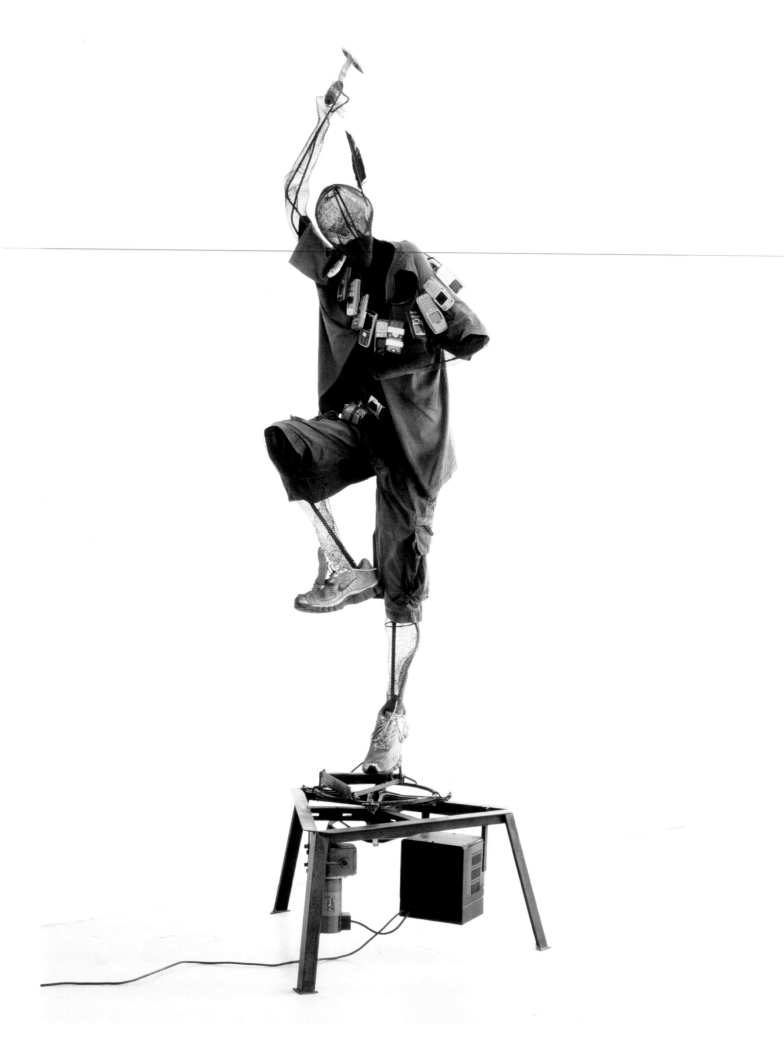

ŻMIJEWSKI: *Your sculpture and performances have often served as a stimulus for triggering 'altered states of consciousness'.*

ALTHAMER: Future projects will also have this objective. I remember how my parents used to take me around in a carrier. From the inside, observing the sky, feeling the bag pleasantly rocking, I could see the artificial-leather handles. I'd like to fabricate a large baby carriage, the kind my mom would use to take me for a stroll in Bródno Park. Reconstructing a fragment of my childhood will make it possible to reach secret spheres of spirituality.

ŻMIJEWSKI: *What is art for you, apart from a technique for surveying parallel realities and multidimensional worlds?*

ALTHAMER: My art is born out of a longing for a non-verbal language — such communication is a more precise and capacious vehicle for the author's thoughts and fascinations. This explains the wealth of artistic genres that allows various personalities and mental constitutions to find soul mates with whom they can exchange feelings. Compared to music, which travels from one body to another more quickly and easily, visual arts are in a losing position. Letting the music in requires much less activity than, say, perceiving a sculpture. This is why visual arts abandon objects for the sake of constructing situations and creating spectacles. Art is born out of nostalgia for a time when people were beings devoid of physical bodies, and the presence of other beings was marked by warm or cold fluxes, by silence and noise. Subtle changes in the surroundings meant that another entity was nearby. These beings needed no language; mere proximity was sufficient to know how they felt. The sole existence of feelings or thoughts was a message in itself. Documenta 10 in Kassel will have people coming like moths to a flame, in a flight of nostalgia for being immersed in the stream of intense emotions.

Apart from this, art allowed me to return to God. The more I become a child, the more I feel close to him. I experienced the full opening of the divine gates on LSD. On that day I realized that trying to speak about God is like chasing a speeding car. There's no way you can catch up with it, but you can at least keep it in sight. God is impossible to describe in words; he can only be experienced as presence. In the old days, this was the task of the temples — tranquil and empty. I remember wanting to enter a church once, but the door was closed, as it was already past opening hours. I found that very depressing and realized I had to search for a church somewhere else.

I found God in my daughter Weronika. When this little being appeared, I was overjoyed and grasped that it is He who emanates through her. He is in every one of us. Divinity hides beneath clothing — the real work of the Creator is nakedness. My interest in figurative sculpture stems from a fascination with divine creation. Even the most brutal rapist, although deep underneath, is guided by a sense of beauty that urges him to attack a beautiful rather than ugly woman.

ŻMIJEWSKI: *Well, that was an unexpected example! Did you just try to say something about the dark side of your soul?*

ALTHAMER: In a way. In kindergarten and primary school I was the head of a gang of rascals. I had a personal butler to tie my shoelaces and a servant to carry my schoolbag. I just had to have people at my command — I was a despot, a miniature Hitler. I organized the world according to my own rules and I knew how to enforce them. Besides, I loved to fight, so if anyone resisted …

As a sculptor I have power over matter — I create order according to my own rules. The order of the world is the way people perceive reality; being a tyrant, I use art to enforce my modes of perceiving and understanding it. This is why I'm in a losing position, because I can only promote my own human order, which is less rich than nature. When a tree drops its leaves and branches, they fall creating a circular pattern around the trunk, a mandala. Old stalks and leaves are distributed in a natural way,

creating a subtle order on the forest bed. Take a man with a rake, on the other hand; he heaps up the branches into one pile and the leaves into another. This is the order of man — poor, rational and lethal.

ŻMIJEWSKI: *I know you have been to Africa. Was that a quest for orders beyond the rational?*

ALTHAMER: Yes. Africa is a world yet undiscovered. Not everything has been measured and examined yet. It is also home to the Dogon people, who claim they arrived on earth in a spaceship from the third moon of Syrius. The astronomers had no clue of its existence until recently; it was discovered only a few years ago. The Dogon bury their dead among rock formations, in locations that would be a challenge to a professionally equipped mountaineer. But how do they get there? There's still a lot that can happen in Africa. A long time ago, in response to an academic assignment to prepare a study of a head, I shaved my own. I thought there's no better way to experience a head and its form that to shave one's own head bald. I felt like I had just grown a head; I started to sense the world with its entire surface. I talked about it with several people, with the best intentions of sharing the discovery. But they would answer, 'Suuure, it'd be even better if you put out a piece of shit and say it's a sculpture!' That gives you an idea of the level of debate. For public opinion the artist is a weirdo. The shaman would be his equivalent among the African peoples, walking with his drum, not bothered by anyone. This is a person through which you are able to communicate with the 'other being'. But nobody is particularly interested in 'other beings' in Poland, where transcendental contact is provided by the priest.

ŻMIJEWSKI: *Paweł Althamer on the 'dark continent'. Your soul strongly vibrated.*

ALTHAMER: My soul split in two there, as I was constantly accompanied by the spirit of African marijuana, which entered my body after the first joint. I felt an ecstatic delight in ordinary objects: a mug or the shape of a fork. Food was a celebration. Oh, how joyful it was to fill your stomach! I felt I had telepathic abilities and I didn't open my mouth a single time for two weeks. I don't know if anyone picked up my mental messages. Every day, for several hours, we travelled across the desert in a truck. The whole time I sang, 'Thank you, Loooord! We thank you, O almighty King in heaven!'

ŻMIJEWSKI: *Let us thank Him again that you made it back in good mental condition!*

ALTHAMER: But I kept the ability to experience delight. Recently I took a walk in

ONE OF THE LETTERS THE ARTIST WROTE TO
HIS WIFE DURING HIS FIRST TRIP TO AFRICA,
1991

'A feeling of being distanced from all events
around me and those I take part in. I call it a film,
in which I'm playing my own part and watching at
the same time.'

Bródno Park, which, though usually filthy, looked like the ideal cover for a Jehovah's Witnesses' brochure. Clouds rolling across the sky, people sunbathing, a seventy-year-old man embracing a seventy-year-old woman, both sitting on ultra-green spring grass, children playing in the background — in short, an idyll. I saw trees covered with flowers and frozen wide-eyed in amazement. Now every day I get up at five in the morning and head to the workshop. I leave at dawn witnessing the greatest phenomenon of the day: brisk air, the vibrating energy of the waking sun. If I only knew how to trace such moments, my life would be a paradise. Just one more true story, to conclude. Some Jehovah's Witnesses gave me a leaflet with the question, 'What comes to mind when you look at the picture on the flipside of this flyer? Don't you miss such bliss, peace and prosperity? Probably, but is hope that such conditions will ever exist on Earth a mere daydream or utopia?' I'm not a Jehovah's Witness, but the fact that their blissful vision will come true seems unquestionable to me. There will be a better world than this one.

ŻMIJEWSKI: *How can you know that?*

ALTHAMER: Because it's everyone's wish.

TRANSLATED FROM POLISH BY KRZYSZTOF KOŚCIUCZUK

LSD (WITH ARTUR ZMIJEWSKI), 2003
VIDEO
15 MIN. 40 SEC.
PEYOTE (WITH ARTUR ZMIJEWSKI), 2003
VIDEO
14 MIN. 50 SEC.
FROM THE SERIES SO-CALLED WAVES AND
OTHER PHENOMENA OF THE MIND

ARTUR ŻMIJEWSKI: *Do you remember what you told me about your solitude in the desert? About your sense of unquenched solitude …*

PAWEŁ ALTHAMER: I remember. That solitude gave rise to a longing to meet someone who could soothe this solitude and the sadness of it. And I guess I've met him, I experienced that moment of euphoria in the desert. The native Indian ritual of peyote eating obviously helped me in this.

ŻMIJEWSKI: *Who was the one you've met?*

ALTHAMER: It was our father, our wonderful father, also known as God. But the word has recently become somewhat unpopular, so maybe it's better to call him a Spirit, or Mescalito, or Manitou. 'He' also sounds good, 'I met Him.' So I met Him, and he said, 'It's nice seeing you again, because we've already met several times, and I've been keeping an eye on you.' I asked Him, 'Why don't I have any visions, I ate so much peyote I actually puked it, and still no visions? I came to Mexico, to the desert, the super exotic thing, craving for a spectacle, and still no vision.' And he said, 'What do you need visions for? Don't you have plenty of them? Look at your friends, at the plants around you, immerse yourself in all this, experience how great they feel in your presence and how great you feel in their presence. It's complete bliss. And your sense of solitude has been probably a result of a deficit of affection, perhaps your wife doesn't love you enough, your children don't appreciate you, you've become a bit trashy, a bit old. All those are just illusions, because love pours on you every day. But obviously you've had to make this distant trip because you longed for confirmation. I can tell you now with a clear conscience that you participate in great love. I can do everything for you: I can cause you to have a great night here with your friends, no lightning will strike at you, you will have a great, satisfying meeting.'

Which is exactly what happened. To thank Him, to express my enthusiasm and gratitude, I raised a burning torch made with a dried flower of the yucca plant. Euphoria filled me for the whole day. The problem is that euphoria can't last forever. Constant euphoria would cause me to be taken for a madman. So I have to live under camouflage, to conceal the ecstasy that fills me. Still, I'll do my best to carry this great gift of trust and love that I've received into the world, to share it with my friends and colleagues. Order exists, I have no doubt about it, though its constellations are unknown. When I asked Him, 'What does it mean to be a shaman? Do I need a mask or an ability to dance in a special way to become one?,' he replied, 'You are a shaman. You know of my presence and that already makes you a shaman. And not everyone

knows about me … You can call me dad, or buddy. Well, friend … I'm standing beside you right now! I can hit you on the head to prove that, or prick you with a cactus, I can attack you with a snake, but do you really need more proof?'

ŻMIJEWSKI: *There, in the desert, nothing spectacular really happened … except the desert itself.*

ALTHAMER: Collecting the wood, starting the fire was really great. Prosaic activities are truly powerful. I hope I live my whole life in a prosaic way. It was fantastic! What spectacular ordinariness!

Really extraordinary! I was delighted. I didn't know how to express that and from time to time I was doing something strange: raising the torch, smiling like an idiot. An idiotic smile is probably an expression of infinite happiness. Unfortunately, many idiots get labelled as incurably ill … You need a bit of restraint in using your smile.

ŻMIJEWSKI: *In what way did you feel His presence? Did you feel it in your body?*

ALTHAMER: I was feeling a flow of energy in my chest and head. You can of course say this was because of peyote poisoning, but I had wanted to meet Him, had been seeking various ways. One of these was to go to the desert and eat the cactus. Seek and ye shall find. Ask and ye shall be given. These things have long been written about, and yet human distrust is infinite. Mine too.

ŻMIJEWSKI: *Besides feeling this presence in your body, how else can you describe it? Do you see Him? Where? In the sand, in the air, in the sun?*

ALTHAMER: He is omnipresent. He is in me. He is me. I am Him. There were moments when I felt immensely proud that I was a God, that I could discover His presence in myself. I felt that I had to let out some huge, loud cry, a donkey's neigh, a bird's song, a frog's croak. I wanted to dance, run around, hop with joy. It was euphoria. Of course, after euphoria comes a time for reflection, because maintaining His presence requires overcoming difficulties – I know that I'll meet people who'll call me crazy or stupid, ridicule my euphoria. But He says, 'Be strong, love above all, understand that my presence will help you. You will forgive them, understand that they err. Your single testimony won't be enough, it's a long work on yourself, on others, on the world.'

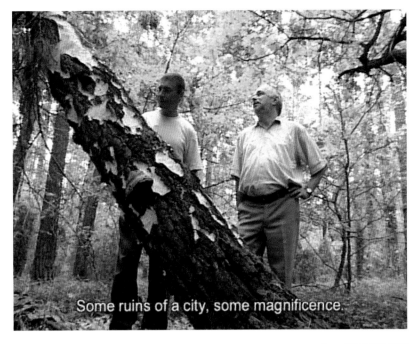

Some ruins of a city, some magnificence.

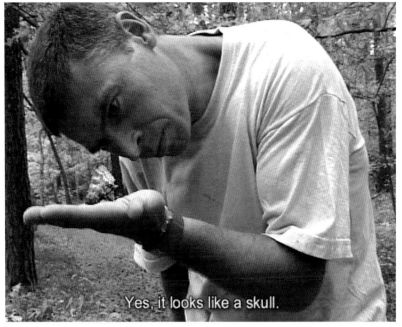

Yes, it looks like a skull.

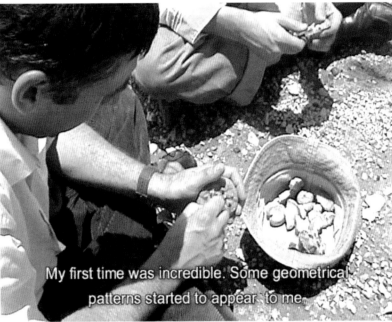

My first time was incredible. Some geometrical patterns started to appear to me.

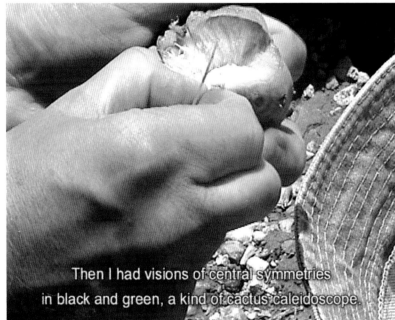

Then I had visions of central symmetries in black and green, a kind of cactus caleidoscope.

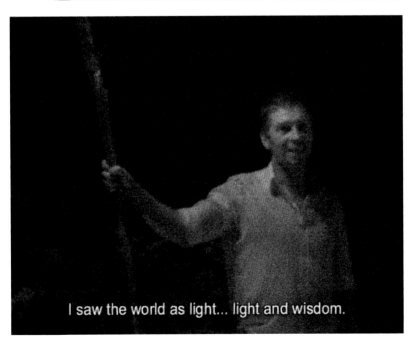

I saw the world as light... light and wisdom.

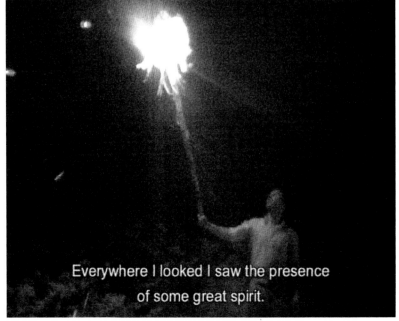

Everywhere I looked I saw the presence of some great spirit.

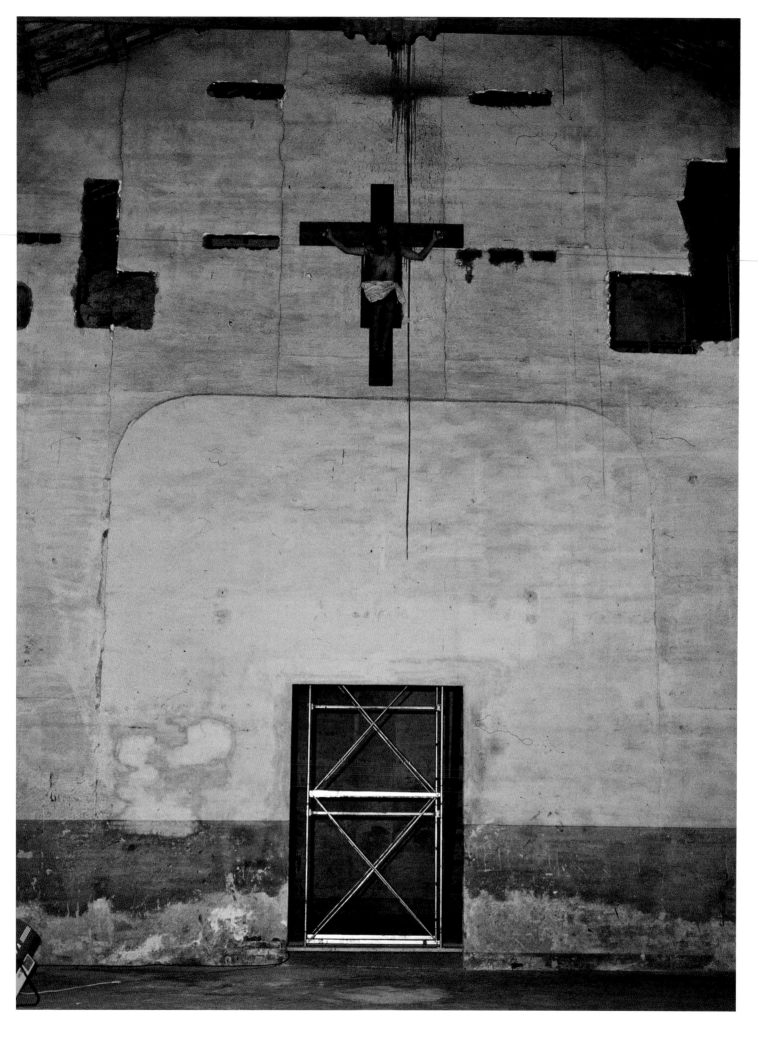

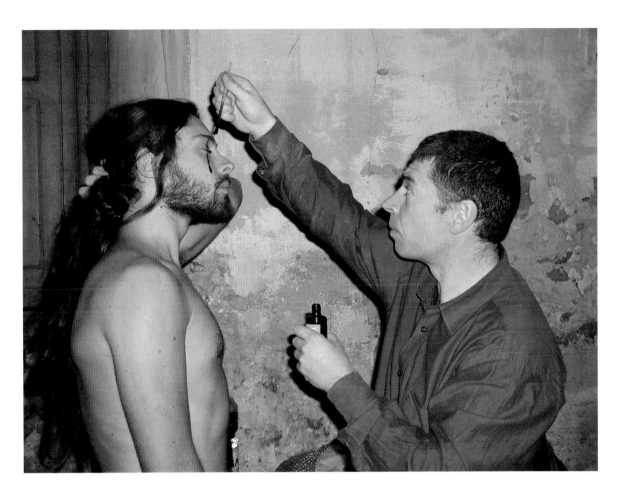

UNTITLED, 2002
PHOTOGRAPHIC DOCUMENTATION OF AN
ACTION, GALLERIA CLAUDIO POLESCHI, LUCCA,
ITALY

The artist responded to the architecture of the
gallery – a disused church in the medieval town
of Lucca – by creating a live crucifixion, giving the
place a glimpse of its past.

Yes, His presence causes madness. I guess someone fully possessed, fully aware of God's presence would today be perceived as a complete madman. Making a confession like this in public carries a great risk. All those who travel to the Mexican desert are confronted with spirit, with space. They come from different cultures, but they all want the same, they need support because they've become lost. They were born, got a name, have their families, have their jobs, but they still experience uncertainty – is this all? In the desert, many get an answer and become stronger. I was made stronger and motivated to keep working on myself and the world.

ŻMIJEWSKI: *I wonder how many there are like you …*

ALTHAMER: My way may seem crazy to you. But those who are really nagged by something seek radical solutions, such as taking an excursion to the forest and talking to an oak tree, swimming in a lake in the night, going to a church, running a marathon or perhaps performing some other sports feat, doing something special or distinct. These are all ways of gaining personal power.

ŻMIJEWSKI: *What does it mean that you were a God? How does it manifest itself? How do you display it? How do you feel it?*

ALTHAMER: We have words like love or adoration. There is love that you can feel towards one person, and there is love that you can feel towards everything and everyone. It's really boundless, and it gives you power. It means that if someone looks at you disapprovingly, you still have full understanding of them. You are happy that you've met them. It is the state of being happy with everything that happens. And it is madness, this love is madness. But it's just so that reason doesn't follow. Reason can verify things post-fact, correct them, but in real time it just doesn't follow.

Love is a power that I've experienced on several occasions. Love is what I felt in the

desert. I simply felt that my presence bestowed love upon the participants of our trip. Perhaps not everybody will be aware of that, but the gift will be given. Love is for free, it costs nothing. You can get it with every breath. It is also an awareness, and the burden of that awareness. But this is a burden you'll be happy to bear. You'll be happy to face all kinds of difficulties and challenges. And you'll want bigger and bigger ones. This precisely is power. Super power.

ŻMIJEWSKI: *What do you mean?*

ALTHAMER: Impenetrable power. I don't know its roots, don't know its origin, but it's probably this power that makes the plants grow and blossom, and makes people grow and become wiser.

ŻMIJEWSKI: *You had this power?*

ALTHAMER: Yes, I was revelling in it. I was unable to formulate it, unable to say anything. I could only send it by the fastest mail service that exists, faster than e-mail, simply as a smile. I could emanate it. I felt that everywhere I was, people should be feeling happy because I was among them. And I was the very emanation of love. That was what I felt. I was also able to perceive the emanations of love, for instance the beauty present in the sophisticated shapes of the cacti, the stones, the clouds, in the path lines, in falling rain, in sun shining. For me, all these were simply forms of love materialized. At some point, love and hate became one. I started understanding them as one. There was no power that could defeat me.

My work is to make others understand this too. Fundamentally, we're all bound to succeed, we have to go through various problems and attempts to solve them, in order to achieve the state known as harmony, understanding, awareness. Yes, this is a utopia that I believe in.

ŻMIJEWSKI: *Did you have the power to make plants grow?*

ALTHAMER: My presence in the desert was as natural as that of the cacti or the yuccas. I saw a storm coming, but I had the feeling that the clouds would go round us if I only wished it strongly enough. That if I ask with all commitment for lightning not to strike us, for no danger to threaten us, that is what will happen. I even stood secretly between the tents and declared that the place should be inviolable so that everyone could have a good night's sleep. We set up the tents in the dark, the night was beautiful, it wasn't raining, there was no storm, everything went around us. It seems to me that I had expressed a wish earlier for the spirit to be kind to us, for us to have a good trip, for nothing bad to happen. If I remained strong and trustful in this friendly power, then there would be no problem I wouldn't be able to solve. You can see this as madness, but I have the courage to say it now.

ŻMIJEWSKI: *Couldn't you experience the same thing in Europe, in Poland? You've made such a distant trip, covered thousands of miles, to meet a spirit. I know that peyote doesn't grow in Poland, but there are other methods, other transporters.*

ALTHAMER: I am still young, distrustful, unwise, so my voyage had to be longer, my pilgrimage had to be a long-distance one. But of course in Poland, in Warsaw, in Bródno, you can find people who make this voyage every day. Their trips are far shorter, their faith far stronger, and their presence in the spiritual world far deeper. You can have a meeting like the one in the desert in the nave of any church, or even the nave of any tram or bus, or in the nave, or even the aisle, of any bus stop or shop. There is no hierarchy, everything is within reach. But people go and wander in the deserts because man needs to make a trip, or perform a ritual, to meet the spiritual world. They must sometimes get drunk or get seriously ill to experience their voyage.

ŻMIJEWSKI: *Do you think you've been chosen by Mescalito, or by Manitou, or by our European God, to preach such things?*

SELF-PORTRAIT AS AN OLD MAN, 2001-07
PHOTOGRAPHIC DOCUMENTATION OF AN
ACTION, FONDAZIONE NICOLA TRUSSARDI,
MILAN

Using a drawing and a description of the artist's looks, characteristics and clothing, a search was conducted for the artist's double, age seventy. The double was then hired to appear daily at the 'One of Many' exhibition at Fondazione Nicola Trussardi. This work was originally presented in 2001 at the Ludwig Museum in Cologne for the exhibition 'I Promise It is Political'.

SELF-PORTRAIT AS AN OLD MAN, 2001
DRAWING ON PAPER
24 X 21 CM

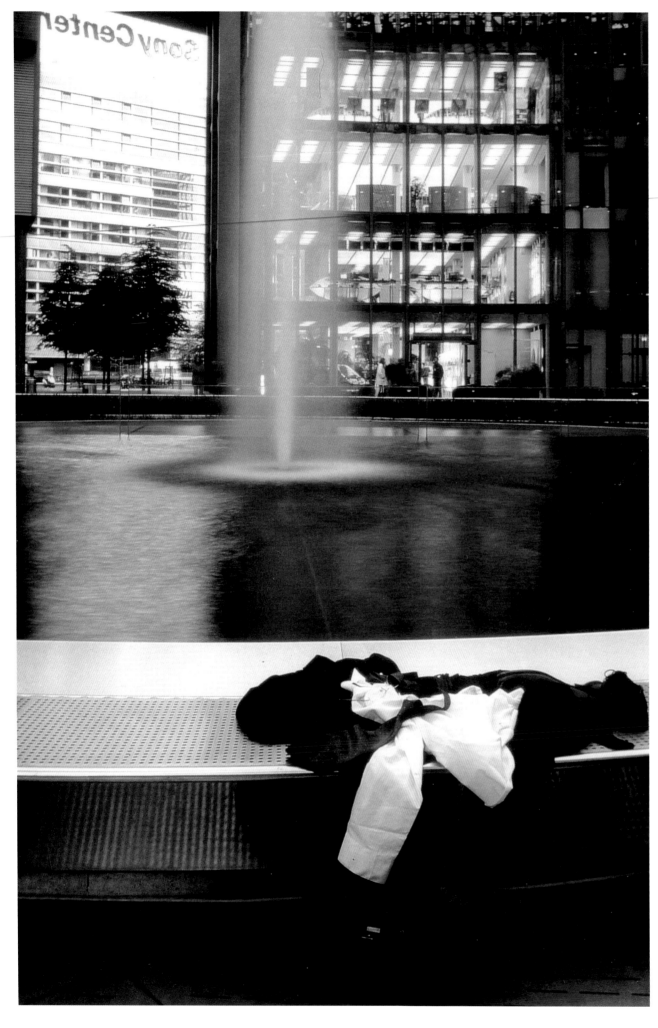

ALTHAMER: Some people build houses, others work in a office, still others write songs. There are those too who only wander around or sit on the sidewalk. There is an order to all this. In the desert, I felt that I was the one, like Neo in the Matrix. It made me proud, which has immediately led to the thought that I was the last one, not the first one, that my predestination would give me joy, but it would be the joy of a monk who is a lesser mortal. 'Blessed are the meek.' This, of course, doesn't mean that you can't be a man of politics, or science, or art. So, yes, I'm the chosen one, but not in terms of being a champion. I'm a star, but if you look at the sky, there are millions of stars. Millions of stars of various intensity, and each one has power.

ŻMIJEWSKI: *How have you been chosen?*

ALTHAMER: My great luck was that I discovered a connection with the spiritual world, that I had several occasions to meet my Great Daddy. That in itself is a sufficient distinguishment. Some will negate what has happened to me. There are people who need celebrity, who need names, such as Catholicism, the Orthodox Church or Islam. I've no problem with belonging to any religion. There is a thought in Buddhism that everyone chooses their place in the world, chooses their family, their future. This is called karma. So I'm lucky to have a karma that is quite spiritual. I won't be wandering around in a hopeless sense that my life is some unending toil. I'm happy to be learning here and now, to be studying things that to many may seem inaccessible.

ŻMIJEWSKI: *I'm interested in what it means that God is in you. How does the fact manifest itself, besides the surge of energy in your chest and head? How do you recognize this presence?*

ALTHAMER: It can manifest itself in, for instance, a sense of being immortal, in a belief that my existence here is completely transitory, that my voyage on earth is only temporary. My life isn't some single-time, laborious story that will end in a funeral. A sense of timelessness and non-mortality accompanies me at all times. I have no fear of death. Of course, I worry about my family and friends, if I were to leave them, but I myself feel immortal. In the context of today's world, this is madness, but I say what I'm thinking and feeling.

ŻMIJEWSKI: *So what were you able to do, what were you able to cause to happen as God?*

ALTHAMER: I was a completely happy person who could consciously influence others' happiness, their sense of security. It seems to me that I was able to influence the weather. Had it not been for me, our friends Maurycy and Ilian, with whom we went to Real de Catorce, wouldn't have had such a great experience in the desert. They ate the cactus but, which they subsequently admitted, they had no visions at all. But they felt great. I realized then that the fact that they didn't have a vision could be related to my person. They didn't need a vision, instead they should be acknowledging each other, should be feeling enchanted with each other, living happily together.

ŻMIJEWSKI: *Tell me about the sense of solitude that you had felt before Mescalito came. What kind of a feeling was it?*

ALTHAMER: I had this conversation with my wife, who told me that she felt underestimated, that I wasn't showing my affection for her, that I wasn't a good husband because I didn't know how to make her happy. I thought that I was doing my best, that I was loving her. But I guess I didn't know how to express it, I didn't know how to make the ordinary gestures, like hugging, kissing, saying 'I love you'. It seemed to me that as long as I was emitting it, sending it from heart to heart, she understood. So this led to a feeling of being misunderstood and lonely.

Besides, there are very few people with whom I can share my fascination with the spiritual world. I lead an inner life, rarely meet other people, don't party. This tells me that I'm a bit different, that my needs are different from those of most of my friends. I know that there are people like me who feel great when on their own, who spend their

UFO, 2004
PHOTOGRAPHIC DOCUMENTATION
OF AN ACTION
WARSAW-BERLIN RAILWAY, POLAND

A seven-metre-high wooden construction
wrapped in silver foil was erected in the middle of
a field close to the Polish-German border, near
the Warsaw-Berlin rail line. Locals helped with the
construction of the 'spaceship'. Children in 'alien'
spacesuits designed by the artist strolled around
the ship at the times when trains passed by. The
work was like the set of a science fiction film that
random viewers could watch for a few seconds
from the passing express train.

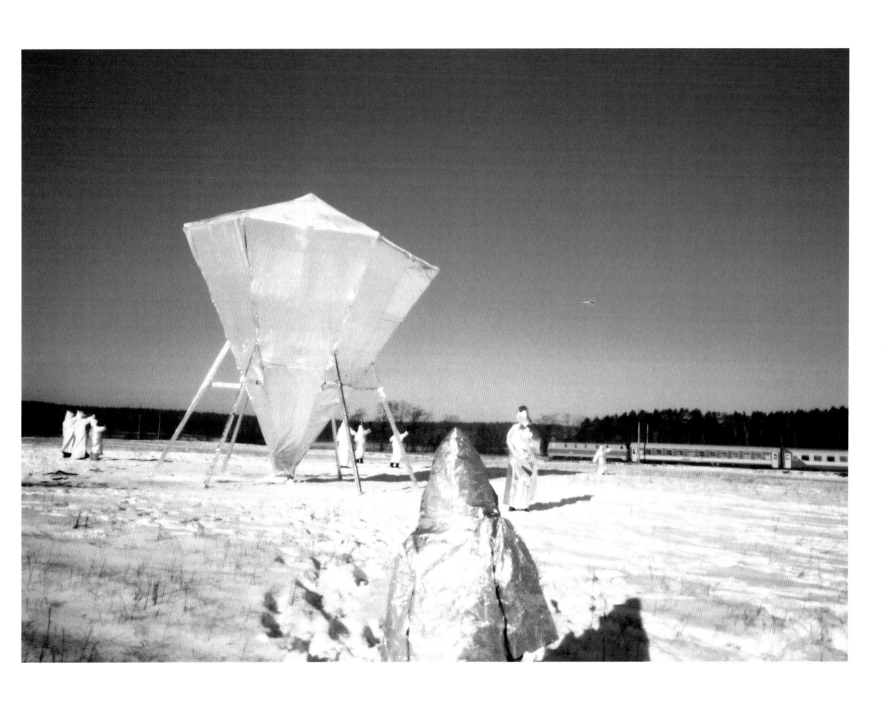

time walking or working in solitude. From time to time I can be a party animal, can have a good time, can mingle with the crowd, but even then I feel a sense of isolation. Which is probably why I once did a project called *Kosmonauta*, where I walked the streets dressed in something resembling a spacesuit. I still feel as if I've landed on an unknown planet. Of course, I know how to behave not to be exposed, but a feeling keeps nagging me that I'm an alien here. I have a family, but even having a family, having children, I don't have a place of my own. It is as if I couldn't fulfil my role. I like to spend time alone, avoiding people, friends, deep into myself. I keep feeling that I'm a man without a place, even if I was born somewhere, had parents. I remember that when my parents were still carrying me in a bag, when I was too small to speak, I was unable to articulate my amazement that I was where I was. This world keeps making me wonder, and I've still not settled in it. It is a bit like if I went to Bolivia, settled in some village, and kept feeling alien. And though I'd know the language by then, know the customs, I'd still feel alien. So here, on earth, I feel like a newcomer, someone who's here only for the time being. And this feeling is with me all the time, despite the whole stabilization that I've worked out. There is a memory in me of some other, unknown place. I'm only passing through here, paying a short visit, and I don't know where my voyage will take me. But I feel that I have a mission, that if I found myself here after all I have to fulfil my obligations, such as being a father, or a husband. These are very difficult things, an extreme psycho-training.

ŻMIJEWSKI: *Under the influence of peyote, did you feel your body, were you fully aware of what was happening to it?*

ALTHAMER: I felt that my body was strong, that I was capable of collecting the wood, breaking the branches, starting a fire. I felt that this body, combined with the omnipotent spirit, could do a lot of things and could be useful in various situations. 'God's servant.' I understand the load of the anachronisms, such extremely outdated associations, but the term 'God's servant' aptly describes who I became after taking peyote. As God's servant I was able to start a fire and be delighted with it, able to set up the tent, and able to use all my skills to make our bivouac a nice experience so that we would have a great time in the desert.

ŻMIJEWSKI: *Tell me, do you still feel Mescalito working in you? We returned from the desert about three hours ago.*

ALTHAMER: I feel this effect insofar as my sense of isolation has returned, that everything around me seems strange, as if I were experiencing everything anew. It is a very early-childhood type of an experience, everything seems strange, people, streets, the taste of beer and wine is so unusual.

ŻMIJEWSKI: *Well, yes, we've drunk some wine.*

ALTHAMER: I actually feel a bit drunk. But I'm at peace, I've told you some things, but I didn't say anything that would be untrue. I've tried to express what I'm feeling, and relate as truly as possible the story that has happened. I'm full of optimism because I've received a lot of energy, a gift of power. I've received a gift of power and

trust in the meaningfulness of the things that I've been doing so far – directed towards simplicity, towards contact with other people, towards developing relations with them, whether they're interested in art or not. For this is not about art, it's about relations between people, relations with the world.

ŻMIJEWSKI: *Who or what do you think Mescalito is?*

ALTHAMER: Mescalito is a spirit that is in the cactus. If you eat the cactus, the spirit will wake up, talk to you, make contact with you, and will also wake up your spirit, show it the reality that you need. Perhaps he will bestow you with visions if you crave for them. He will know what you need. I remember that when we ate our tasty peyote-and-cane-sugar soup for the second time, I fell asleep. I was tired, wanted to sleep, so Mescalito showed me the right place – under a tree, under a yucca that breathed peace, there was shadow. I fell asleep and slept. I slept great. When I woke up, my perception of reality seemed to be returning to norm. I remember that I asked myself, 'Where is this Mescalito, where is this cactus ghost, where are the promised visions?' And I heard an answer: 'What do you need visions for if you can stand right in front of me, can make direct, friendly contact with me. So take advantage of my presence, ask.' So Mescalito is a guide. He took me in front of the Almighty. And, indeed, wherever I looked I saw the presence of a great spirit. I talked to him. The contact was casual, easy, friendly. I was enchanted with the directness of what he was saying. It reminded me of talking to my professor, the late Jerzy Stajuda. It seems to me that Stajuda passed knowledge in a very subtle way. He didn't teach, but rather simply said what he thought, and these were very pointed remarks, directed precisely at you, and stemming from an understanding of who you were and what you were interested in.

So God proved a friend, a guardian and a buddy rather than the thunder thrower. He told me He would manifest and express himself in various ways. And it's only up to my alertness how often I recognize Him. And He will speak on everyday, ordinary things. So everything I do should lead me towards greater alertness and vigilance to everything that happens around me. Our conversation is also a result of me meeting Him, because I've had to tell someone about it, even if I'm afraid that what I'm saying will make me look ridiculous.

ŻMIJEWSKI: *What you are saying isn't ridiculous.*

ALTHAMER: I pursue simplicity through complications and twisted paths. I've always distanced myself from the beads, the rosaries, the traditional prayers, which in our tradition seem to be the natural thing. I was long a fervent opponent of religiousness and Christian metaphysics. I preferred to use illegal or not wholly accepted substances. My first meeting took place thanks to LSD. I was seriously hit, and I subsequently turned towards religiousness, towards things that I had been pushing away from myself. My first meeting with the mushrooms, the psilocybes in the forest, was a great ecstasy. Power manifested itself to me in full glory and greatness. In spite of all my doubts and reservations, I was physically, through all my senses, confronted with a spirit, with the spirit of the world. I understood the world as light, light and wisdom. As if the image and emotions hit me simultaneously. I felt a great tranquility and understood the harmony of everything around me. That made me reflect on my rebellious attitude, and led to its softening. And each next time – and there weren't many, because I was rather an abstinent user – I was confronted with a power that in the Christian tradition is referred to as God. I can't find any better word, though I realise that the word 'God' is rather unpopular these days. But I can still confidently use it, though let's remember not to abuse it lest it loses its proper strength.
There are many ways, but all, I guess, lead to a confrontation with a being, a presence, an intelligence that people have frequently tried to describe, name, build a programme based on its emanation. One thing is certain: it isn't a hostile power. It is an extraordinary emanation of a force we've traditionally described as love and peace. You can call it order, harmony or garden. Becoming aware of its presence makes one stronger rather than weaker, though it may cause a certain dissonance with your life as it has been so far.

ŻMIJEWSKI: *Garden? Why do you call it a garden?*

ALTHAMER: What I mean by garden is a search for an order, for harmony, for the meeting of various elements that at first sight could seem at odds or out of place with each other. Garden is a place where they all can find their place. You can see earth as a garden where people, animals and plants seek mutual harmony.

ŻMIJEWSKI: *Did the meeting in the desert satisfy you?*

ALTHAMER: Yes. I was farthest from thinking that I missed something just because I didn't see any dragons, snakes, or outstanding colours. I saw what you saw too. And I didn't feel short of anything. Another stage of maturity, another phase, you can't keep expecting a light and sound show every time.

Everything was equally important: the expedition for the tent, the decision who'll stay and pick the wood and who'll go for the packs. Then preparing the meal, keeping the fire. I think it was a very intense, holy story. Very simple and full of emotion, the winning of each other's confidence, the forming of relations between us. At some point, we created a small community that was handling everything just fine. Maurycy and Ilian brought the food, we started the fire. We sat and looked at the stars, in full bliss, in tranquility. It was a comfortable, leisurely situation, but some small tasks arose and everyone found themselves fully capable. I don't think anyone thought they were short of emotion, though things could appear boring, there were no thunders, no dramatic stories, just a night in the desert. But for me that night was very intense. I felt a bit like an observer, wishing well for the trip of the great couple of Maurycy and Ilian. I saw them as a couple representing the humanity – a man and a woman who came to the desert to spend their time together in a spiritual setting. But I also felt part of your trip, Artur, you as someone who with his camera registering only the visible, who had the right to feel bored because you didn't meet any spirits in the desert.

ŻMIJEWSKI: *Is there something I didn't ask you?*

ALTHAMER: Probably, but there are always questions to ask. For instance, how is it that I sit at this moment at the table in a kitchen in Mexico? This seems a rather difficult question, given that I live in Bródno, in Warsaw. Of course, I can refer to the invitations, the artistic projects, to my friendship with Mariana and Barbara, and also to the one with Santiago, who all live in Mexico. But if you look deeper than that, you can perhaps find a higher power that has been guiding my steps. My presence at this table, in this kitchen, wasn't fully intended.

TRANSLATED FROM POLISH BY MARCIN WAWRZYŃCZAK

BRÓDNO PEOPLE (WITH PAWEŁ BUCHHOLZ, MARCIN LESZCZYŃSKI, MICHAŁ MIODUSZEWSKI, SŁAWOMIR MOCARSKI, JULIA PETELSKA AND JĘDRZEJ ROGOZIŃSKI), 2010 STEEL, RUBBER WHEELS, RECYCLED METAL, METAL MESH, RECYCLED PLASTIC, FOIL, WOOD, SILVER CLOTH, SOUND SYSTEM, LIGHT, SILVER SPRAY PAINT, BROWN ACRYLIC PAINT, METAL CORD, USED CABLES, USED CLOTHES, USED BOXING GLOVES, USED BABY STROLLER, USED HOME APPLIANCES (AN IRON, PARTS OF A WASHING MACHINE), USED MOTORCYCLE HELMETS, USED SUNGLASSES, USED SHOES, USED SKI BOOTS, USED PLASTER, FOUND MEDALS AND AWARDS
230 X 600 X 130 CM

Realized with the artist's neighbours from his apartment block in Bródno, the sculpture is based on Auguste Rodin's The Burghers of Calais (1889). Althamer wanted to create a contemporary interpretation for an era dominated by film images. Each figure/sculpture is a self-portrait of one of the neighbours, including Althamer himself, and executed under the artist's supervision and with his help. Made through a range of techniques, each figure is a strong portrait of the person depicted. All have been styled to resemble characters from science fiction movies, as the artist wanted to present them as characters from a film in real time.

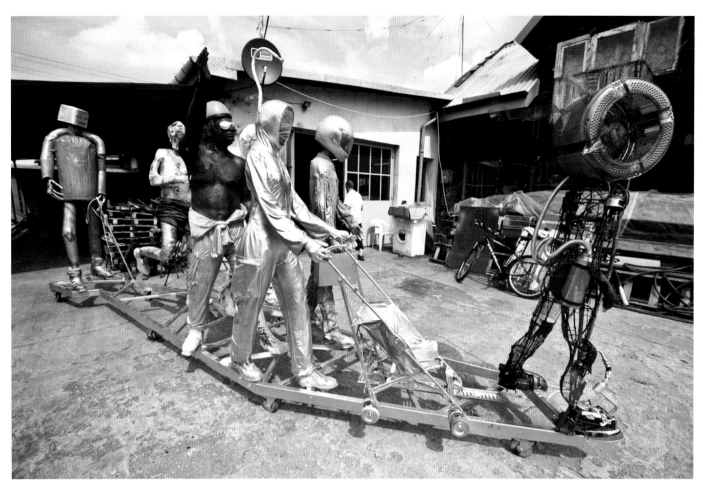

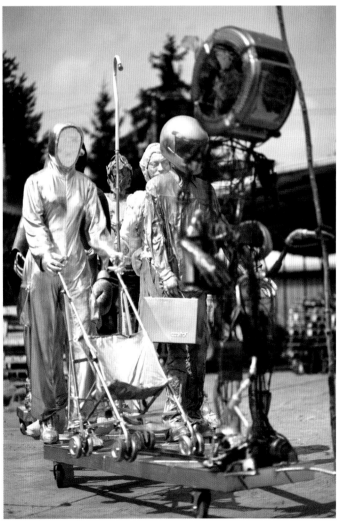

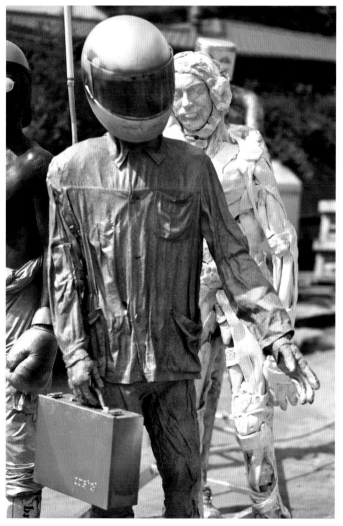

INTERVIEW PAGES 007-033

1 Adam Szymczyk, *Galeria a.r.t. 1991-1997*, Galeria
a.r.t., Płock, 1997, pp. 18-19.
2 *Król Maciuś Pierwszy* (King Matt the First) is a 1923 book by Janusz
Korczak, a Polish-Jewish author, pediatrician and child pedagogue. The
protagonist of the book is a child prince who must take the throne after
the sudden death of his father and learn to rule the country. Dr Korczak
and the children from his orphanage in the Warsaw ghetto were deported
in August 1942 and most likely murdered in the Treblinka extermination
camp.
3 Vasanta Ejma is a Polish breatharian. A spiritual teacher, she is herald of a
'new world', portent of a 'daylight on Earth'. She has authored several books
about the transformation of the body adapted to life without foods thanks
to changes in one's consciousness.
4 Vasanta Ejma, *Doświadczenie życia bez jedzenia*, Horus, Poznań, Poland,
2002.

SURVEY PAGES 037-99

1 Joanna Mytkowska, 'Berichte von Reisen in die Ferne', *Paweł Althamer/
Artur Żmijewski: So genannte Wellen und andere Phänomene des Geistes*,
Kunstverein für die Rheinlande und Westfalen, Düsseldorf, 2003, p. 36.
2 Rosalind E. Krauss, 'Sculpture in the Expanded Field', *The Originality
of the Avant-Garde and Other Modernist Myths*, MIT Press, Cambridge,
Massachusetts, 1988, p. 279.
3 Brigitte Hausmann, 'Neun Kunstprojekte', *Einstein Spaces: Neun
Kunstprojekte in Berlin, Potsdam und Caputh im Rahmen des Einsteinjahres
2005*, Büro Einsteinfestival/Einstein-Forum, Berlin, 2005, p. 20.
4 Hans Belting, 'Zum Werkbegriff der künstlerischen Moderne', *Szenarien der
Moderne: Kunst und ihre offenen Grenzen*, Philo Fine Arts, Hamburg, 2005,
p. 67.
5 It was called the Visual Structures Studio from 1970.
6 Oskar Hansen, *Towards Open Form*, Christoph Kellerrevolver, Warsaw and
Frankfurt, 2005, p. 143.
7 Michał Woliński, 'Building Activity, Sculpting Communication', *Piktogram*,
no. 5/6, 2006, p. 29.
8 Grzegorz Kowalski quoted in Łukasz Ronduda, 'Grzegorz Kowalski:
Didactics of the Partnership', *Piktogram*, p. 120 (note 4).
9 Grzegorz Kowalski in conversation with the author at the Foksal Gallery
Foundation in Warsaw, 15 January 2009.
10 Magdalena Magiera and Maciek Świetlik in conversation with Paweł
Althamer, 'Paweł Althamer: Play-Grounded', *Mono-Kultur*, no. 17, 2008,
pp. 16-17.
11 Grzegorz Kowalski, 'Althamer: Life Study', *Paweł Althamer: The Vincent
Award 2004*, Bonnefantenmuseum, Maastricht, 2004, pp. 27-8.
12 Magdalena Magiera and Maciek Świetlik in conversation with Paweł
Althamer, op. cit.
13 Martin Prinzhorn, 'Looking back without being able to see', *Afterall*, no.
5, 2002, p. 26.
14 Paweł Althamer, 'Air-conditioning', *Paweł Althamer*, Galeria Kronika,
Bytom, and Foksal Gallery, Warsaw, 1996, pp. 6-12.
15 Both works are now in the Tate Collection in London.
16 In addition to Paweł Althamer, the Foksal Gallery Foundation represents
artists such as Artur Żmijewski, Wilhelm Sasnal and Monika Sosnowska.
Another key element of the Foundation's work is maintaining the studio
of Edward Krasiński (1925-2005), a co-founder of the Foksal Gallery. The
Foundation represents his estate, and his studio was recently extended to
include a project space and a guest room.
17 Krzysztof Kościuczuk, 'FGF Warsaw, 2007: (De)Construction', *Piktogram*,
no. 11, 2008, pp. 102-7.
18 Roman Kurzmeyer, *Viereck und Kosmos – Künstler, Lebensreformer,
Okkultisten, Spiritisten in Amden 1901-1912: Max Nopper, Josua Klein,
Fidus, Otto Meyer-Amden*, Springer, Vienna/New York, 1999.
19 Irena Jakimowicz, *Witkacy: Malarz*, (Wydawnictwa, Artystyczne I
Filmowe), Warsaw, 1987.
20 Philipp Kaiser, 'Weronika: Paweł Althamer in Amden', *Kunst-Bulletin*, no.
9, 2001, pp. 22-5.

21 Peter Weibel, 'Vorwort', *Kontext Kunst: The Art of the 90's*, DuMont,
Cologne, 1994, p. 11.
22 Ibid., p. 14.
23 Boris Groys, 'Der ein-gebildete Kontext', ibid., pp. 257-81.
24 Francesco Bonami, 'The Legacy of a Myth Maker', *Tate Etc.*, no. 3, spring
2005, p. 75.
25 Andrzej Przywara, 'Paweł Althamer, ein Regisseur der Wirklichkeit', in
freiheit / endlich: Polnische Kunst nach 1989, Staatliche Kunsthalle Baden-
Baden, Museum Narodowe W Warszawie, Polenmuseum Rapperswil,
2000-01, pp. 24-7.
26 See Jeff Kelley, *Childsplay: The Art of Allan Kaprow*, University of
California Press, Berkely/Los Angeles/London, 2004, p. 18f.
27 Allan Kaprow (ed.), *Assemblage, Environments & Happenings*, H. N.
Abrams, New York, 1966, p. 151f.
28 Clement Greenberg, 'Intermedia', in Clement Greenberg and Robert C.
Morgan (ed.), *Clement Greenberg Late Writings*, University of Minnesota
Press, Minneapolis, 2007.
29 Dick Higgins, 'Intermedia (1965)', *Horizons: The Poetics and Theory of
Intermedia*, Southern Illinois University Press, Carbondale/Edwardsville,
1984, p. 23.
30 For the difference between modernist and generic art, i.e. 'art that has
broken off all connections with the specific professions and traditions of
painting and sculpture', see Thierry de Duve, *Kant after Duchamp*, MIT
Press, Boston, 1998.
31 Friedrich Reinhold, 'Es war einmal, wie es einmal sein wird: Paweł
Althamer, neugerriemschneider, Berlin', *Monopol*, no. 10, 2003, pp. 78-79.
32 Claire Bishop, '1000 Words: Paweł Althamer', *Artforum*, May 2006.
33 Peter Richter, 'Die Kunst des Abschiebestopps', *Frankfurter Allgemeine
Zeitung*, 31 March 2006.
34 Marco Schmidt, 'Ist Schauspielern wie Sex, Mister Malkovich?',
Frankfurter Allgemeine Zeitung, no. 14, 17 January 2009.
35 Augusto Boal, *Theater der Unterdrückten*, Suhrkamp, Frankfurt am Main,
1979, p. 67.
36 Ibid., p. 99.
37 Susanne Knaller, 'Autobiografie und Realismus in der zeitgenössischen
Kunst: Mit Beobachtungen zu Sophie Calle und zum künstlerischen
Dokumentarfilm', *Realitätskonstruktionen in der zeitgenössischen Kultur:
Beiträge zu Literatur, Kunst, Fotografie, Film und zum Alltagsleben*, Böhlau,
Vienna/Cologne/Weimar, 2008, p. 60.

FOCUS PAGES 101-111

1 vodpod.com/watch/3824482-pawel-althamer-common-task-eng
2 Paweł Althamer in conversation with Artur Żmijewski, Warsaw, 3 February
1993, in Artur Żmijewski, 'Brodnó Nirvana', *Drżące ciała. Rozmowy z
artystami (Trembling Bodies. Conversations with Artists)*, Wydawnictwo
Krytyki Politycznej, Warsaw, 2008, pp. 57, translation by Eva Dabrowska.
3 Michael Hardt and Antonio Negri, *Commonwealth*, Harvard University
Press, Cambridge, Massachusetts, 2009.
4 See Michał Woliński, 'Building Activity, Sculpting Communication',
Piktogram 5-6, 2006, English translation, pp. 27-35; see also Oskar Hansen,
Towards Open Form, Foksal Gallery Foundation and Warsaw Academy of
Fine Arts Museum, Warsaw, 2005.
5 In conversation with the author, February 2009
6 Jacques Rancière, *Le partage du sensible: esthétique
et politique*, La fabrique-editions, Paris, 2000.

CHRONOLOGY: Paweł Althamer, born 1967 in Warsaw,
lives and works in Warsaw.

SELECTED EXHIBITIONS AND PROJECTS
1988–96

SELECTED ARTICLES AND INTERVIEWS
1988-96

THE ARTIST AT WORK ON STUDY FROM NATURE,
WARSAW, 1991

1988-1993
Paweł Althamer attends the Academy of Fine Arts, Warsaw

1991
ACADEMY OF FINE ARTS MUSEUM (with Jacek Adamas),
Warsaw (solo)

'Magicians and Mystics',
CENTRE FOR CONTEMPORARY ART UJAZDOWSKI CASTLE,
Warsaw (group)

1992
GALERIA A.R.T., Płock, Poland (solo)

'Dialogi dziet i postaw',
CENTRUM RZEŹBY POLSKIEJ, Orońsko, Poland (group)

'Die andere Seite',
LUDWIG FORUM, Aachen, Germany (group)

'A Home Exhibition of Photographs',
KATARZYNA KOZYRA'S FLAT, Warsaw (group)

'Studies of the Nude',
GALERIA A.R.T., Płock, Poland (group)

'Polish Contemporary Art',
ESPACE PERIRESC, Toulon, France (group)

1993
'Studies from Nature',
GALERIA A.R.T., Płock, Poland (solo)

'Diploma',
GALERIA A.R.T., Płock, Poland (solo)

'Unvollkommen',
MUSEUM BOCHUM, Germany (group)

SONSBEEK '93, Arnhem, Netherlands (group)

1993
Żmijewski, Artur, 'Bródnowska nirwana: Rozmowa z Pawłem
Althamerem', Czereja, March

1994
'Fairy Tale',
GALERIA WOK, Warsaw (solo)

'Germinations 8',
ACADEMIE ST JOOST, Hogeschool West-Brabant, Breda,
Belgium, toured to ZACHĘTA NATIONAL GALLERY OF ART,
Warsaw (group)

1995
MIEJSCE GALLERY, Cieszyn, Poland (solo)

'Transhumatio',
PICTURE GALLERY, Kaunas, Latvia (group)

'Anti-Bodies',
CENTRE FOR CONTEMPORARY ART, Warsaw (group)

'Oikos',
MUZEUM OKRĘGOWE, Bydgoszcz (group)

1995
Przywara, Andrzej, 'Kosmonauta', Kresy, January

1996
FOKSAL GALLERY, Warsaw (solo)

'The After Life',
GALERIA KRONIKA, Bytom, Poland (solo)

PAWEŁ ALTHAMER

OTWARCIE GODZ. 18
6 MARCA 1995
WYSTAWA TRWA DO
17 MARCA 1995

GALERIA MIEJSCE CIESZYN UL. NOWE MIASTO 27
Wystawa (1) z cyklu „Na południu". Zrealizowano dzięki Fundacji Pro Helvetia i Fundacji Kultury.

Galeria Foksal
SBWA Warszawa
Paweł Althamer

uprzejmie zapraszamy
na otwarcie wystawy
w piątek 28 czerwca 1996 r.
o godzinie 18
ul. Foksal 1/4, tel/fax 022 - 27 62 43

Kunsthalle
Basel

Paweł
Althamer

9/1997

Centrum
Sztuki
Współczesnej
Zamek
Ujazdowski

Zapraszamy na
otwarcie wystawy
w piątek 16.01.98
o godzinie 18.00

Paweł
Althamer
Wystawa

kurator: Marek Goździewski

00-461 Warszawa
Al. Ujazdowskie 6
tel. 628 12 71/3
fax 628 99 50

wystawa czynna od 17.01 do 1.03
codziennie oprócz poniedziałków
w godzinach 11.00-17.00,
w piątki do 21.00

BRÓDNO
Paweł Althamer

SELECTED <u>EXHIBITIONS AND PROJECTS</u>
1996–2000

SELECTED <u>ARTICLES AND INTERVIEWS</u>
1997–2000

1996 (cont.)
'Me and AIDS',
KINO STOLICA, Warsaw, and GALERIA A.R.T, Płock (group)

'Art Park',
BWA GALLERY, Biała Podlaska, Poland (group)

1997
'Bródno',
CINEMA TECZA, Warsaw (solo)

KUNSTHALLE BASEL (solo)

'Kosmonauta',
GALERIA A.R.T., Płock, Poland (solo)

'Parteitag 1',
GALERIA A.R.T., Płock, Poland, toured to BWA GALLERY, Katowice,
Poland (group)

DOCUMENTA 10, Kassel, Germany (group)

'Passport: Exchange, (Ex)change',
TEMPLE BAR GALLERY AND STUDIOS, Dublin, toured to ZACHĘTA
NATIONAL GALLERY OF ART, Warsaw (group)

1997
Szymczyk, Adam, 'A Seemingly Innocent Subversion of Reality',
<u>Siksi</u>, summer

1998
'Wystawa/Exhibition'
CENTRE FOR CONTEMPORARY ART UJAZDOWSKI CASTLE,
Warsaw (solo)

'There is Nothing Like a Bad Coincidence',
MEDIUM GALLERY, Bratislava (group)

'W tym szczególnym momencie',
CENTRE FOR CONTEMPORARY ART UJAZDOWSKI CASTLE,
Warsaw (group)

'Parteitag 2',
GALERIA A.R.T, Płock, Poland (group)

'Poliptyk',
BWA GALLERY, Katowice, Poland (group)

1999
SAMMLUNG HOFFMANN, Berlin (solo)

FOKSAL GALLERY, Warsaw (solo)

'Welcome to the Art World',
BADISCHER KUNSTVEREIN, Karlsruhe, Germany (group)

'14 Contemporary Art Days',
ARSENAL GALLERY, Bialystok, Poland (group)

'Fauna',
ZACHĘTA NATIONAL GALLERY OF ART, Warsaw (group)

CITY SLEEPERS, MIDNIGHT WALKERS, multiple venues,
Amsterdam (group)

'Figura w rzeźbie polskiej XIX-XXw',
CENTRUM RZEŹBY POLSKIEJ, Orónsko, toured to ZACHĘTA
NATIONAL GALLERY OF ART, Warsaw (group)

2000
'Bródno 2000', Warsaw (solo)

2000
Cameron, Dan, 'Manifesta 3', <u>Artforum</u>, December

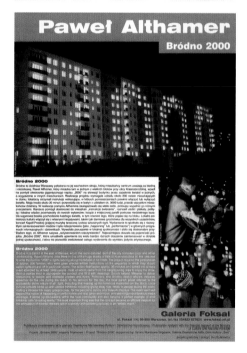

2000 (cont.)
'Biały autobus',
GALERIA BWA, Zielona Góra, Poland (solo)

'Re:Location',
OK CENTRUM FÜR GEGENWART KUNST, Linz, Austria (group)

'Colored Grey 1956–1970',
ZACHĘTA NATIONAL GALLERY OF ART, Warsaw (group)

MANIFESTA 3, Ljubljana (group)

5th LYON BIENNIAL (group)

'Amateur 1900-2000',
GÖTEBORGS KONSTMUSEUM, toured to ODDZIAŁ MUSEUM
NARODOWEGO, Warsaw; NATIONAL MUSEUM, Szczecin, Poland;
POLISH MUSEUM, Rapperswil, Switzerland (group)

'In Freiheit/eindlich: Polnische Kunst nach 1989',
STAATLICHE KUNSTHALLE, Baden-Baden, Germany (group)

'Finale di Partita - Endgame - Fin de Partie',
BIAGIOTTI ARTE, Florence (group)

2001
MUSEUM OF CONTEMPORARY ART, Chicago (solo)

'House on a Tree',
FOKSAL GALLERY FOUNDATION, Warsaw (solo)

'Weronika',
ATELIER AMDEN, Switzerland (solo)

'V – International Communities',
ROOSEUM CENTRE FOR CONTEMPORARY ARTS, Malmö, Sweden
(group)

'Milano Europa 2000',
PALAZZO DELLA TRIENNALE, Milan (group)

'Dialog III',
OK CENTRUM FÜR GEGENWARTSKUNST, Linz, Austria (group)

'Enjoy/Survive',
MIGROS MUSEUM, Zurich (group)

'Neue Welt',
FRANKFURTER KUNSTVEREIN, Frankfurt (group)

'Spotkania Ezoteryczne',
BAŁTYCKA GALERIA SZTUKI WSPÓŁCZESNEJ, Słupsk, Poland
(group)

'Museum unserer Wünsche',
LUDWIG MUSEUM, Cologne (group)

'Poetry Summer',
Multiple venues, Watou, Belgium (group)

'Jubilee Exhibition',
ZACHĘTA NATIONAL GALLERY OF ART, Warsaw (group)

'Ausgeträumt...',
SECESSION, Vienna (group)

1st TIRANA BIENNIAL (group)

'Abbild: Recent Portraiture and Depiction',
LANDESMUSEUM JOANNEUM, Graz, Austria (group)

2001
Kaiser, Philipp, 'Weronika: Paweł Althamer in Amden',
<u>Kunst-Bulletin</u>, September

THE ARTIST IN FRONT OF HIS TENT DURING 'BRING ON THE CLOWNS', FRIEZE ART FAIR, LONDON, 2003

PAWEL ALTHAMER

THE WRONG GALLERY 516-A 1/2 W. 20TH ST.

SELECTED EXHIBITIONS AND PROJECTS
2001-03

SELECTED ARTICLES AND INTERVIEWS
2001-03

2001 (cont.)
Althamer is artist-in-residency at the Deutscher Akademischer Austausch Dienst (DAAD), Berlin

2002
'Unsichtbar',
DEUTSCHER AKADEMISCHER AUSTAUSCH DIENST (DAAD), Berlin (solo)

LE CINEMA ITINERANT/DE RONDREIZENDE CINEMA, multiple locations, Belgium (solo)

'Prisoners',
KUNSTVEREIN MÜNSTER, Germany (solo)

STUDIO TOMMASEO, Trieste (solo)

CLAUDIO POLESCHI ARTE CONTEMPORANEA, Lucca, Italy (solo)

'The Fancy-dress Ball',
CENTRE FOR CONTEMPORARY ART UJAZDOWSKI CASTLE, Warsaw (solo)

'The Collective Unconsciousness',
MIGROS MUSEUM, Zurich (group)

'In Prague',
GALERIA VACLAVA SPALY, Prague (group)

'I Promise It's Political',
LUDWIG MUSEUM, Cologne (group)

'Warum',
MARTIN GROPIUS BAU, Berlin (group)

'Adel Abdessemed, Paweł Althamer, Eran Schaerf',
FONDAZIONE LANFRANCO BALDI, Pelago, Italy (group)

2002
Bartelik, Marel, 'The Place In Between', Art in America, January

Bonami, Francesco, 'Paweł Althamer: Requiem for a Dream', Flash Art, no. 223, March-April

Prinzhorn, Martin, 'Looking back without being able to see'; Adam Szymczyk, 'The Annotated Althamer', Afterall, May 2002

2003
THE WRONG GALLERY, New York (solo)

NEUGERRIEMSCHNEIDER, Berlin (solo)

'So genannte Wellen und andere Phänomene des Geistes' (with Artur Żmijewski),
KUNSTVEREIN FÜR DIE RHEINLANDE UND WESTFALEN, Düsseldorf (solo)

'Contemporary Art for All Children',
ZACHĘTA NATIONAL GALLERY OF ART, Warsaw (group)

50th VENICE BIENNALE (group)

'Hidden in a Daylight',
FOKSAL GALLERY FOUNDATION, Cieszyn, Poland (group)

'Now What? Dreaming a Better World in Six Parts',
BAK, Utrecht, Netherlands (group)

'Views 2003: The Deutsche Bank Cultural Foundation Award',
ZACHĘTA NATIONAL GALLERY OF ART, Warsaw (group)

'Institutional Aesthetics',
MUSEUM OF CONTEMPORARY ART KIASMA, Helsinki (group)

'Art Focus 4' (with Artur Żmijewski),
ISRAEL MUSEUM, Jerusalem (group)

'Way of life...',
CENTER FOR CONTEMPORARY ART ŁAŹNIA, Gdansk, Poland (group)

2003
Eggel, Caroline, 'Paweł Althamer in der Galerie neugerriemschneider', Kunst-Bulletin, June

Leoni, Chiara, 'Paweł Althamer: Spaceman', Flash Art Italia, June-July

Schwarzenberger, Sebastian, 'Paweł Althamer', Zitty, 26 June-9 July

Herbstreuth, Peter, 'Penner auf Durchreise', Der Tagesspiegel, 26 July

Osswald, Anja, 'Paweł Althamer I', Neue Review, July

Christensen, Jan, Christiane Rekade and Raimar Stange, 'Paweł Althamer II', Neue Review, July

Schlaegel, Andreas, 'Paweł Althamer at neugerriemschneider', Flash Art, October

Bradley, Will, 'Social Work', Frieze, October

Reinhold, Friedrich, 'Es war einmal, wie es einmal sein wird', Monopol, no. 10, October

Allen, Jennifer, 'Paweł Althamer', Artforum, November

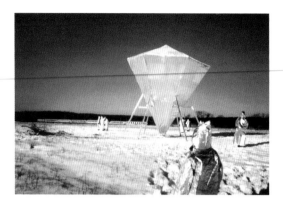

2004
'Spacer z Fundacja Galerii Foksal po Pradze (Walk with Foksal
Gallery Foundation in Praga district)',
FOKSAL GALLERY FOUNDATION, Warsaw (solo)

'Paweł and Vincent: The Vincent Van Gogh Bi-annual Award for
Contemporary Art in Europe',
BONNEFANTENMUSEUM MAASTRICHT, Netherlands (solo)

'Warschau-Moskau 1990-2000',
ZACHĘTA NATIONAL GALLERY OF ART, Warsaw, toured to
TRETYAKOV STATE GALLERY, Moscow (group)

'Under the White-Red Flag: New Art from Poland',
ESTONIAN ART MUSEUM, Tallinn, toured to CONTEMPORARY
ART CENTRE, Vilnius; NATIONAL CENTRE FOR CONTEMPORARY
ARTS, Moscow; NIZHNY TAGIL MUSEUM OF FINE ARTS,
Sverdlovsk Oblast, Russia (group)

'Stanisław Ignacy Witkiewicz: Philosophical Margins',
CENTRE FOR CONTEMPORARY ART UJAZDOWSKI CASTLE,
Warsaw (group)

'Prym',
BWA GALLERY, Zielona Góra, Poland (group)

'Akademy East/West',
TANZQUARTIER, Vienna (group)

DE KLEINE BIENNIAL, Multiple venues, Utrecht, Netherlands
(group)

'Atomkrieg',
KUNSTHAUS DRESDEN, Germany (group)

'Artists' Favourites',
INSTITUTE OF CONTEMPORARY ARTS (ICA), London (group)

'Nowa Huta: Kunst aus polnischer Sicht',
WESTFÄLISCHER KUNSTVEREIN, Münster, Germany (group)

'Duty and Rebellion: Academy of Fine Arts in Warsaw
1944–2004',
ZACHĘTA NATIONAL GALLERY OF ART, Warsaw (group)

'Utopia Station',
HAUS DER KUNST, Munich (group)

54th CARNEGIE INTERNATIONAL, Pittsburgh (group)

'Dreaming of a Better World in Six Parts',
BASIS VOOR ACTUELE KUNS (BAK), Utrecht, the Netherlands
(group)

Paweł Althamer is the recipient of the Vincent Van Gogh Award
for Contemporary Art in Europe, Maastricht, Netherlands

2005
'Paweł Althamer Zachęca (Paweł Althamer Incites)',
ZACHĘTA NATIONAL GALLERY OF ART, Warsaw (solo)

'Akademie: Kunstlehren und lernen' (with Artur Żmijewski and the
Nowolipie Group),
KUNSTVEREIN IN HAMBURG (solo)

'Kollektive Kreativität' (with Artur Żmijewski),
KUNSTHALLE FRIDERICIANUM, Kassel, Germany (solo)

1st MOSCOW BIENNIAL (group)

2004
Prince, Mark, 'Value Added', <u>Art Monthly</u>, March

Salzbrenner, Uwe, 'Ein Mast auf dem Sprung', <u>Sächsische
Zeitung</u>, 7 July

Dora, Grit, 'Vergessene Bedrohung: "Atomkrieg" im Kunsthaus
Dresden', <u>Dresdner Kulturmagazin</u>, July-August

Shaw, Francesca D., and Lavinia Garulli, 'Was will Europa?',
<u>Flash Art</u>, no. 237, July–September

'Maastricht: Paweł Althamer erhält Vincent van Gogh Preis',
<u>Kunst-Bulletin</u>, September

Göricke, Jutta, 'Narren sagen die Wahrheit', <u>Süddeutsche
Zeitung</u>, 19 October

Lorch, Catrin, 'Wünsche im Astronautenanzug', <u>Frankfurter
Allgemeine Zeitung</u>, 30 October

Jansen, Gregor, 'Paweł Althamer im Bonnefantenmuseum',
<u>Kunst-Bulletin</u>, no. 12, December

2005
Bonami, Francesco, 'The Legacy of a Myth Maker', <u>Tate Etc.</u>,
spring

Heingartner, Douglas, 'Paweł Althamer', <u>Frieze</u>, April

Mazur, Adam, 'Paweł Althamer at Zachęta Gallery', <u>Flash Art</u>,
May-June

Bankowsky, Jack, 'Tent Community', <u>Artforum</u>, October

KENDO (2005) IN THE METAL WORKSHOP OF THE
ARTIST'S FATHER (RIGHT)

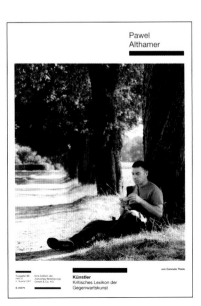

2005 (cont.)
'The Theatre of Art: Masterpieces from the Collection of the
Ludwig Museum',
CENTRO D'ARTE CONTEMPORANEA VILLA MANIN, Codroipo,
Italy (group)

'Das unmögliche Theater/The Impossible Theatre',
KUNSTHALLE WIEN, Vienna, toured to BARBICAN ART GALLERY,
London; ZACHĘTA NATIONAL GALLERY OF ART, Warsaw (group)

'Positioning: In the New Reality of Europe',
NATIONAL MUSEUM OF ART, Osaka, toured to HIROSHIMA
CITY MUSEUM OF CONTEMPORARY ART; MUSEUM OF
CONTEMPORARY ART, Tokyo (group)

9th ISTANBUL BIENNIAL (group)

'Gott sehen',
KARTAUSE ITTINGEN, Switzerland (group)

'Einstein Spaces',
ARCHENHOLD-STERNWARTE, Berlin (group)

'Not a Drop But the Fall',
KÜNSTLERHAUS BREMEN, Germany (group)

'At the Very Center of Attention',
CENTRE FOR CONTEMPORARY ART UJAZDOWSKI CASTLE,
Warsaw (group)

2006
'In the Centre Pompidou, Espace 315',
CENTRE POMPIDOU, Paris (solo)

'Kontakt: ...aus der Sammlung der Erste Bank-Gruppe',
MUSEUM MODERN KUNST STIFTUNG LUDWIG, Vienna, toured to
MUSEUM OF CONTEMPORARY ART BELGRADE; INSTITUTE OF
CONTEMPORARY ART, Dunaújvàros, Hungary (group)

'The Grand Promenade',
NATIONAL MUSEUM OF CONTEMPORARY ART, Athens (group)

4th BERLIN BIENNIAL (group)

'You won't feel a thing: On Panic, Obsession, Rituality and
Anhesthesia',
KUNSTHAUS DRESDEN, Germany (group)

'Strange Powers',
CREATIVE TIME, New York (group)

'Gegenstände/Handlungsformen: Verabschiedung von Angelika
Stepken'
BADISCHER KUNSTVEREIN, Karlsruhe, Germany (group)

'1,2,3... Avant-Garde',
CENTRE FOR CONTEMPORARY ART UJAZDOWSKI CASTLE,
Warsaw, toured to SALA REKALDE, Bilbao (group)

'Sculptures in the park'
CENTRO D'ARTE CONTEMPORANEA VILLA MANIN, Codroipo,
Italy (group)

2006
Richter, Peter, 'Die Kunst des Abschiebestopps', <u>Frankfurter
Allgemeine Zeitung</u>, 31 March

Kuhn, Nicola, 'Märchen und Wahrheit', <u>Der Tagesspiegel</u>, 3 April

Buhr, Elke, 'Märchen', <u>Frankfurter Rundschau</u>, 3 April

Rauterberg, Hanno, 'Objektkunst mit Mensch', <u>Die Zeit</u>, 6 April

Bishop, Claire, 'Paweł Althamer', <u>Artforum</u>, May 2006

Woliński, Michał, 'Building Activity, Sculpting Communication',
<u>Piktogram</u>, no. 5-6

Apin, Nina, 'Ich tue es für mein Gewissen', <u>Tageszeitung</u>,
22 August

Piron, François, 'Centre Pompidou Espace 315', <u>Flash Art</u>,
no. 251, November-December

Colin, Anna, 'Paweł Althamer: Centre Pompidou Espace 315',
<u>Art Press</u>, no. 329, December

2007
'Black Market',
NEUGERRIEMSCHNEIDER, Berlin (solo)

'One of Many',
FONDAZIONE NICOLA TRUSSARDI, Milan (solo)

2007
Saunders, Matt, 'Paweł Althamer', <u>Frieze</u>, May

Bonazzoli, Francesca, 'Paweł Althamer: Scoprite il mio corpo e la
mia mente', <u>Corriere della Sera</u>, 6 May

'Ganz Schön Aufgeblasen', <u>View</u>, no. 6, June

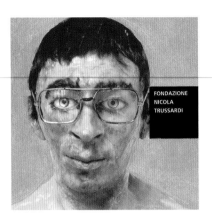

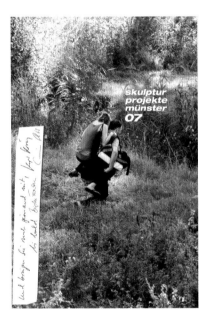

2007 (cont.)
'Polish Socialist Conceptualism of the 70s',
ORCHARD, New York (group)

'Quantity as Quality',
KUNSTHALLE EXNERGASSE, Vienna (group)

'The Present: The Monique Zajfen Collection',
STEDELIJK MUSEUM, Amsterdam (group)

SKULPTUR PROJEKTE MÜNSTER, Germany (group)

'Concrete Legacy: From Corbusier to the Homeboys',
CENTRE FOR CONTEMPORARY ART UJAZDOWSKI CASTLE,
Warsaw (group)

'Pensa, Piensa, Think',
CENTRE D'ART SANTA MONICA, Barcelona (group)

'Dream and Trauma',
KUNSTHALLE WIEN and MUSEUM MODERNER KUNST STIFTUNG
LUDWIG, Vienna (group)

27th BIENNIAL OF GRAPHIC ARTS, Ljubljana (group)

'Volksgarten: Politics of Belonging',
KUNSTHAUS GRAZ, Austria (group)

'Kunstmaschinen: Maschinenkunst',
SCHIRN KUNSTHALLE, Frankfurt, toured to MUSEUM TINGUELY,
Basel (group)

'The World as a Stage',
TATE MODERN, London (group)

2008
'Le dernier qui parle',
FONDS REGIONAL D'ART CONTEMPORAIN (FRAC)
CHAMPAGNE-ARDENNE, France (group)

'Mimétisme',
EXTRA CITY, Antwerp (group)

'Featured Figure: Works from the Dakis Joannou Collection',
DESTE FOUNDATION, Athens (group)

'Double Agent',
INSTITUTE OF CONTEMPORARY ARTS (ICA), London, toured to
BALTIC CENTRE FOR CONTEMPORARY ART, Gateshead, England;
WARWICK ARTS CENTRE, Coventry, England (group)

'Le parole tra noi leggere: La distanza è una finzione',
VIA NUOVA ARTE CONTEMPORANEA, Florence (group)

'Shifting Identities',
KUNSTHAUS ZÜRICH, toured to VILNIUS CONTEMPORARY ART
CENTRE, Lithuania (group)

'After Nature',
NEW MUSEUM, New York (group)

'The Fifth Floor: Ideas Taking Spaces',
TATE LIVERPOOL (group)

'Art Comes Before Gold',
MUSEUM OF MODERN ART WARSAW (group)

1st BRUSSELS BIENNIAL (group)

'Eyes Wide Open',
STEDELIJK MUSEUM, Amsterdam (group)

2007 (cont.)
Schiff Hajo, 'Skulptur Projecte Münster 07', <u>Artist Kunstmagazin</u>,
no. 72

Casavecchia, Barbara, 'Paweł is Out', <u>Mousse</u>, no. 9, summer

Esplund, Lance, 'An Apocalyptic State of Mind', <u>The New York
Sun</u>, 17 July

Koldehoff, Stefan, 'Zumutung als Ziel', <u>Monopol</u>, no. 8

Noé, Paola, 'Paweł Althamer at Fondazione Trussardi', <u>Artforum</u>,
September

Vallese, Gloria, 'Le Lezione della Tenebre', <u>Arte</u>, September

Althamer, Paweł, 'Top Ten', <u>Artforum</u>, November

Woliński, Michał, 'Warsaw: An Alternative Guide for Art Lovers',
<u>Mousse</u>, no. 11, November

2008
Gioni, Massimiliano, 'The Hero with a Thousand Faces'; Catherine
Wood, 'Magic Realism'; Adam Szymczyk, 'A Real Allegory and the
Origins of the World', <u>Parkett</u>, no. 82, May

Szymczyk, Adam, Magdalena Magiera and Maciek Świetlik, 'Paweł
Althamer: Play-Grounded', <u>Mono-Kultur</u>, no. 17

Johnson, Ken, 'Sometimes the Darkest Visions Boast the Blackest
Humor', <u>The New York Times</u>, 19 July

Büsing, Nicole, and Heiko Klass, 'Paweł Althamer, Artist'
<u>Kunstmagazin</u>, 31 July

Schjeldahl, Peter, 'Feeling Blue', <u>The New Yorker</u>, 4 August

Basara, Zbigniew, 'Jork, Nowy, Strach w wielkim mieście', <u>Gazeta
Polen</u>, 9 August

Birnir, Adda, 'Death! Fire! Mayhem! Art!', <u>The Village Voice</u>,
13-19 August

'Poetic License', <u>The Boston Globe</u>, 31 August

Budick, Ariella, 'After Nature', <u>Financial Times</u>, 3 September

Saltz, Jerry, 'Let's Get Serious for a Moment, <u>New York Magazine</u>,
22 September

Wei, Lilly, 'After Nature', <u>Artnews</u>, October

Kościuczuk, Krysztof, 'FGF Warsaw 2007: (De)Construction',
<u>Piktogram</u>, no. 11

BRUNO ALTHAMER PAINTING BALLOON, 1999-2007,
BRUGES CENTRAAL FESTIVAL, BELGIUM

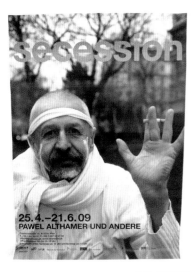

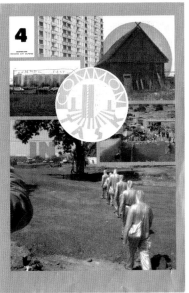

2008 (cont.)
'Periphere Blicke und Kollektive Körper',
MUSEION, Bozen, Italy (group)

2009
'Frühling',
KUNSTHALLE FRIDERICIANUM, Kassel, Germany (solo)

'Paweł Althamer und Andere',
SECESSION, Vienna (solo)

'Marzyciel/Dreamer' (with Nowolipie Group)
HEPPEN TRANSFER, Warsaw (solo)

'Common Task',
MODERN ART OXFORD (solo)

'Take a Look at Me Now',
SAINSBURY CENTRE FOR VISUAL ARTS, Norwich, England
(group)

2009
Grzonka, Patricia, 'Paweł Althamer und Andere', Kunstbulletin,
no. 6, June

Banasiak, Jakub, 'What is to be done?', Flash Art, no. 267, July-
September

2010
'Mezalia'
FOKSAL GALLERY FOUNDATION, Warsaw (solo)

LUDWIG FORUM, Aachen, Germany (solo)

'Star City: The Future Under Communism',
NOTTINGHAM CONTEMPORARY, England (group)

'Skin Fruit: Selections from the Dakis Joannou Collection',
NEW MUSEUM, New York (group)

'Les Promesses du Passé/The Promises of the Past',
CENTRE POMPIDOU, Paris (group)

'Statuesque',
CITY HALL PARK, New York (group)

8th GWANGJU BIENNIAL, South Korea (group)

'Luc Tuymans Exhibition Trail',
BRUGES CENTRAAL FESTIVAL, Belgium (group)

'Alpha Omega',
DESTE FOUNDATION, Athens (group)

'Plus Ultra: Opere dalla Collezione Sandretto Re Rebaudengo',
MUSEUM OF CONTEMPORARY ART (MACRO), Rome (group)

'Curated by_Vienna',
GALERIE DANA CHARKASI, Vienna (curated by Paweł Althamer)

Paweł Althamer is the recipient of the Aachen Art Prize

2010
Robecchi, Michele, 'Paweł Althamer: Common Task', Flash Art,
no. 277, March-April

Schjedahl, Peter, 'Big Time: Skin Fruit at the New Museum',
The New Yorker, 4 March

Smith, Roberta, 'Anti-Mainstream Museum's Mainstream Show',
The New York Times, 4 March

2011
'8 1/2',
FONDAZIONE NICOLA TRUSSARDI and FONDAZIONE PITTI
DISCOVERY, Florence (group)

2011
Bishop, Claire, 'Something for Everyone: The Art of Paweł
Althamer', Artforum, February

BIBLIOGRAPHY

MONOGRAPHS, EXHIBITION CATALOGUES AND SURVEYS

Althamer, Paweł, Adam Szymczyk and Andrzej Przywara, Paweł Althamer, Foksal Gallery, Warsaw, and Kronika Gallery, Bytom, Poland, 1996

Althamer, Paweł, and Krzysztof Żwirblis, Bródno, Fundację im. Stefania Batorego, Warsaw, 1997

Althamer, Paweł, Peter Pakesch and Andrzej Przywara, Paweł Althamer, Kunsthalle Basel, 1997

Althamer, Paweł, and Pier Luigi Tazzi, Paweł Althamer, Claudio Poleschi Arte Contemporanea, Lucca, Italy, 2002

Althamer, Paweł, Rita Kersting, Joanna Mytkowska, Grzegorz Kowalski and Artur Żmijewski, Paweł Althamer and Artur Żmijewski: So gennante Wellen und andere Phänomene des Geistes, Kunstverein für die Rheinlande und Westfalen, Düsseldorf, and Revolver, Berlin, 2003

Althamer, Paweł, Charles Esche, Andrzej Przywara, Paula van den Bosch and Artur Żmijewski, Paweł Althamer: The Vincent Award 2004, Hatje Cantz, Oesterfield, and Bonnefantenmuseum, Maastricht, 2005

Althamer, Paweł, and Magda Kardasz, Paweł Althamer at Zachęta, Zachęta National Gallery of Art, Warsaw, 2005

Althamer, Paweł, Céline Ahond, Ziad Antar, Liliana Basarab, et. al., Paweł Althamer: Espace 315 au Centre Pompidou, Centre Pompidou, Paris, 2006

Althamer, Paweł, Peter Pakesch and Johannes Schlebrügge, Paweł Althamer: Black Market – Fame & Fortune Bulletin, Schlebrügge, Vienna, and Neugerrienschneider, Berlin, 2007

Althamer, Paweł, and Suzanne Cotter, Paweł Althamer: Common Task, Modern Art Oxford, 2009

Althamer, Paweł, et. al., Frühling, Kunsthalle Fridericianum, Kassel, and Walther König, Cologne, 2009

Althamer, Paweł, Roman Kurzmeyer, Adam Szymczyk and Suzanne Cotter, Paweł Althamer, Phaidon, London, 2011

Armstrong, Richard, Francesco Bonami, Laura Hoptman, Midori Matsui, Cuauhtémoc Medina, Jean-Pierre Mercier, Elizabeth Smith, Branka Stipančić and Elizabeth Thomas, 54th Carnegie International, Carnegie Museum of Art, Pittsburgh, 2004

Backstein, Joseph, Daniel Birnbaum, Iara Boubnova, Nicolas Bourriaud, Rosa Martínez and Hans Ulrich Obrist, Dialectics of Hope, Moscow Biennial, 2005

Blázquez Abascal, Jimena, Valeria Varas and Raúl Rispa, Sculptures Parks in Europe: A Guide to Art and Nature, Birkhäuser, Basel, 2006

Bonami, Francesco, Ole Bouman, Maria Hlavajová, Kathrin Rhomberg, Slavoj Žižek, Critical Art Ensemble, Hans Ulrich Obrist, Olesya Turkina and Viktor Mazin, Manifesta 3, Cankarjev Dom, Ljubljana, 2000

Bonami, Francesco, Dreams and Conflicts: The Dictatorship of the Viewer, La Biennale di Venezia and Rizzoli, Milan, 2003

Bonami, Francesco, and Sarah Cosulich Canarutto, The Theatre of Art: Masterpieces from the Collection of the Ludwig Museum, Villa Manin, Codroipo, Italy, 2005

Bonami, Francesco (ed.), Bidibidobidiboo: Works from Collezione Sandretto Re Rebaudengo, Skira, Milan, 2005

Bonami, Francesco, and Sarah Cosulich Canarutto, Sculptures in the Park, Villa Manin, Codroipo, Italy, 2006

Bücher Gruppe, Polnischer Bildhauer, Books LLC, Cincinnati, 2010

Carr-Gomm, Philip, A Brief History of Nakedness, Reaktion Books, London, 2010

Cattelan, Maurizio, Massimiliano Gioni and Ali Subotnick, Checkpoint Charley, Berlin Biennial and Kunst-Werke, Berlin, 2005

Cattelan, Maurizio, Massimiliano Gioni and Ali Subotnick, Of Mice and Men, Berlin Biennial, Kunst-Werke, Berlin, and Hatje Cantz, Ostfildern, 2006

Collins, Jusith, Sculpture Today, Phaidon, London, 2007

Cosulich Canarutto, Sarah, and Andrzej Przywara, Trieste Contemporanea: Dialoghi con l'arte dell'Europa Centro Orientale, Studio Tommaseo, Trieste, Italy, 2002

Cotter, Suzanne, Andrew Nairne and Victoria Pomery, Arrivals: Art from the New Europe, Modern Art Oxford, 2007

David, Catherine, Jean-François Chevrier and Françoise Joly, Documenta 10: Politics/Poetics, Fridericianum Museum, Kassel, and Hatje Cantz, Ostfildern, 1997

Deitch, Jeffrey (ed.), Fractured Figure Volume 1, Deste Foundation, Athens, 2008

De Marchis, Giorgio, Alessandra Mottola Molfino and Lucia Matino, Milano Europa 2000, Elemond, PAC and Palazzo della Triennale, Milan, 2000

Dohm, Katharina (ed.), Kunstmaschinen Maschinenkunst/Art Machines Machine Art, Heidelberg and Shirn Kunsthalle, Frankfurt, and Museum Tinguely, Basel, 2007

Farquharson, Alex, Lukasz Ronduda, Barbara Piwowarska (eds.), Francesco Manacorda, et. al., Star City: The Future Under Communism, Nottingham Contemporary, Tranzit and Mammal Foundation, Białowieża, Poland, 2011

Folie, Sabine, Jaroslaw Suchan and Hanna Wroblewska, The Impossible Theater: Performativity in the Works of Paweł Althamer, Tadeusz Kantor, Katarzyna Kozyra, Robert Kusmirowski and Artur Żmijewski, Moderne Kunst Nürnberg, Germany, 2006

Franzen, Brigitte, Kaspar König and Carina Plath, Skulptur Projekte Münster, Walther König, Cologne, 2007

Gioni, Massimiliano (ed.), After Nature, New Museum of Contemporary Art, New York, 2008

Gioni, Massimiliano (ed.), What Good is the Moon?, Hatje Cantz, Ostfildern, and Fondazione Nicola Trussardi, Milan, 2010

Gioni, Massimiliano (ed.), 10,000 Lives, Gwangju Biennial Foundation, 2010

Goehler, Adrienne, Verflüssigungen: Wege und Umwege vom Sozialstaat zur Kulturgesellschaft, Campus, Frankfurt and New York, 2006

Grosenic, Uta, and Burkhard Riemschneider, Art Now, Taschen, Cologne, 2002

Groys, Boris, and Diana Reese, Welcome to the Art World, Badischer Kunstverein, Germany, 1999

Heartney, Eleanor, Art & Today, Phaidon, London, 2008

Heidenreich, Stefan, and Susanne Pfeffer, Not a drop but the Fall: A Project by Elmgreen and Dragset, Künstlerhaus Bremen and Revolver, Berlin, 2006

Hoffmann, Jens, and Lucy Shanahan, Artists' Favourites Act I, Institute of Contemporary Art, London 2004

Hoffmann, Jens, The Next Documenta Should Be Curated By An Artist, E-Flux, New York, and Revolver, Frankfurt, 2004

Hoffmann, Jens, and Joan Jonas, Art Works Perform, Thames & Hudson, London, 2005

Holzwarth, Hans Werner (ed) Art Now Vol. 3, Taschen, Cologne, 2008

Huck, Brigitte, Georg Kargl, Paul Katzberger, Wolfgang Kos, Heike Maier and Peter Trummer, Evn Sammlung: 95-05, Walther König, Cologne, 2006

Kremer, Mark, Maria Hlavajova and Annie Fletcher (eds.), Now What? Artists Write!, Bak Basis voor Actuele Kunst, Utrecht, and Revolver, Frankfurt, 2004

Leonhard, Yvonne (ed.), Einstein Spaces, Büro Einsteinfestival Einstein-Forum, Berlin, 2005

Mallon, Stephanie, Skulptur Projekte Münster: Die Geschichte, das Konzept und der Erfolg der Skulpturen-Ausstellung im öffentlichen Raum, Grin, Munich, 2010

Martin, Jean-Hubert, Partage d'Exotismes: 5th Biennial de Lyon, Réunion des Musées Nationaux, Lyon, 2000

Matt, Gerald, Angela Stief, Edelbert Köb, Elisabeth Bronfen and Hilary Rubenstein Hatch, Dream and Trauma: Works from the Dakis Joannou Collection, Athens, Hatje Cantz, Ostfildern, and Kunstalle Wien, Vienna, 2008

Monsvoisin, Alain (ed.), Dictionnaire International de la Sculpture Moderne & Contemporaine, Edition Du Regard, Paris, 2008

Monkiewicz, Dorota, Dirk Teuber (eds) and Andrzej Przywara, In Freiheit, endlich: Polnische Kunst nach 1989, Kunsthalle Baden-Baden, Germany, 2000

Morgan, Jessica, and Catherine Wood, The World as a Stage, Tate, London, 2007

Mytkowska, Johanna, Andrzej Przywara, Adam Szymczyk, Anna Niesterowicz, Agata Jakubowska, Piotr Rypson, Sebastian Cichoki, Lukasz Gorczyka, Charles Esche, Violetta Sajkiewisz, Anke Kempkes and Michał Woliński, Hidden in a Daylight Hotel, Foksal Gallery Foundation, Warsaw, 2003

Obrist, Hans Ulrich (ed.), Do It, E-Flux, New York, and Revolver, Frankfurt, 2004

Politi, Giancarlo, Gezim Qëndro, Ahu Antmen, Francesco Bonami, Jens Hoffmann, Massimiliano Gioni, Helena Kontova, Edi Muka, Hans Ulrich Obrist, Michele Robecchi and Wolf-Günter Thiel, Escape: Tirana Biennial 1, Politi Editore, Milan, 2001

Rhomberg, Kathrin, Ausgeträumt, Secession, Vienna, 2002

Szymczyk, Adam (ed.), Galeria a. r. t. 1992-1997, Galeria a. r. t., Płock, Poland, 1997

Tazzi, Pier Luigi, Finale di Partita - Endgame - Fin de Partie, Biagiotti Arte, Florence, 2000

Tazzi, Pier Luigi, Adel Abdessemed, Paweł Althamer, Eran Schaerf, Fondazione Lanfranco Baldi, Pelago, Italy, 2002

Vanderlinden, Barbara (ed.), Shahidul Alam, Bart De Baere, Charles Esche, Mária Hlavajová, Anselm Franke, Abdellah Karroum, Pierre-Olivier Rollin, Nicolaus Schafhausen and Florian Waldvogel, Brussels Biennial 1, Walther König, Cologne, 2009

Van der Pol, Bik, Adam Budak, Thomas Hirschhorn, Helmut Konrad, Christian Kravagna, Suzana Milevska, Peter Pakesch, Katia Schurl, Özlem Sulak, Sissi Tax, Stephen Willats and Nira Yuval-Davis, Volksgarten: Politics of Belonging, Kunsthaus Graz, Austria, 2007

Varadinis, Mirjam, Christoph Becker, Tan Walchli, Kurt Imhof and Peter J. Schneemann, Shifting Identities, JRP Ringier and Kunsthaus Zurich, 2008

Williams, Gilda (ed.), Igor Zabel, et. al. Cream 3, Phaidon, London, 2003

ARTICLES AND REVIEWS

Allen, Jennifer, 'Paweł Althamer', Artforum, November 2003

Althamer, Paweł, 'Top Ten', Artforum, November 2007

Apin, Nina, 'Ich tue es für mein Gewissen', Tageszeitung, 22 August 2006

Banasiak, Jakub, 'What is to be done?', Flash Art, no. 267, July-September 2009

Bankowsky, Jack, 'Tent Community', Artforum, October 2005

Bartelik, Marel, 'The Place in Between', Art in America, January 2002

Basara, Zbigniew, 'Jork, Nowy, Strach w wielkim mieście', Gazeta Puleri, 9 August 2000

Birnir, Adda, 'Death! Fire! Mayhem! Art!', The Village Voice, 13-19 August 2008

Bishop, Claire, 'Paweł Althamer talks about Fairy Tale', Artforum, May 2006

Bishop, Claire, 'Something for Everyone: The Art of Paweł Althamer', Artforum, February 2011

Bonami, Francesco, 'Paweł Althamer: Requiem for a Dream', Flash Art, no. 223, March-April 2002

Bonami, Francesco, 'The Legacy of a Myth Maker', Tate Etc., spring 2005

Bonazzoli, Francesca, 'Paweł Althamer: Scoprite il mio corpo e la mia mente', Corriere della Sera, 6 May 2007

Bradley, Will, 'Social Work', Frieze, October 2003

Budick, Ariella, 'After Nature', Financial Times, 3 September 2008

Buhr, Elke, 'Märchen', Frankfurter Rundschau, 3 April 2006

Büsing, Nicole, and Heiko Klass, 'Paweł Althamer, Artist' Kunstmagazin, 31 July 2008

Cameron, Dan, 'Manifesta 3', Artforum, December 2000

Casavecchia, Barbara, 'Paweł is Out', Mousse, no. 9, Summer 2007

Christensen, Jan, Christiane Rekade and Raimar Stange, 'Paweł Althamer II', Neue Review, July 2003

Colin, Anna, 'Paweł Althamer: Centre Pompidou Espace 315', Art Press, no. 329, December 2006

Dora, Grit, 'Vergessene Bedrohung: "Atomkrieg" im Kunsthaus Dresden', Dresdner Kulturmagazin, July-August 2004

Eggel, Caroline, 'Paweł Althamer in der Galerie neugerriemschneider', Kunst-Bulletin, June 2003

Esplund, Lance, 'An Apocalyptic State of Mind', The New York Sun, 17 July 2007

'Ganz Schön Aufgeblasen', View, no. 6, June 2007

Gioni, Massimiliano, 'The Hero with a Thousand Faces', Parkett, May 2008, no. 82, May 2008

Göricke, Jutta, 'Narren sagen die Wahrheit', Süddeutsche Zeitung, 19 October 2004

Grzonka, Patricia, 'Paweł Althamer und Andere', Kunst-Bulletin, no. 6, June 2009

Heingartner, Douglas, 'Paweł Althamer', Frieze, April 2005

Herbstreuth, Peter, 'Penner auf Durchreise', Der Tagesspiegel, 26 July 2003

Kaiser, Philipp, 'Weronika: Paweł Althamer in Amden', Kunst-Bulletin, September 2001

Koldehoff, Stefan, 'Zumutung als Ziel', Monopol, no. 8, 2007

Kościuczuk, Krysztof, 'FGF Warsaw 2007: (De) Construction', Piktogram, no. 11, 2008

Kuhn, Nicola, 'Märchen und Wahrheit', Der Tagesspiegel, 3 April 2006

Jansen, Gregor, 'Paweł Althamer im Bonnefantenmuseum', Kunst-Bulletin, no. 12, December 2004

Johnson, Ken, 'Sometimes the Darkest Visions Boast the Blackest Humor', The New York Times, 19 July 2008

Leoni, Chiara, 'Paweł Althamer: Spaceman', Flash Art Italia, June-July 2003

Lorch, Catrin, 'Wünsche im Astronautenanzug', Frankfurter Allgemeine Zeitung, 30 October 2004

'Maastricht: Paweł Althamer erhält Vincent van Gogh Preis', Kunst-Bulletin, September 2004

Magiera, Magdalena, Maciek Świetlik and Adam Szymczyk, 'Paweł Althamer: Play-Grounded', Mono-Kultur, no. 17, 2008

Mazur, Adam, 'Paweł Althamer at Zachęta Gallery', Flash Art, May-June 2005

Noé, Paola, 'Paweł Althamer at Fondazione Trussardi', Artforum, September 2007

Osswald, Anja, 'Paweł Althamer I', Neue Review, July 2003

Piron, François, 'Centre Pompidou Espace 315', Flash Art, no. 251, November-December 2006

'Poetic License', The Boston Globe, 31 August 2008

Prince, Mark, 'Value Added', Art Monthly, March 2004

Prinzhorn, Martin, 'Looking back without being able to see', Afterall, May 2002

Przywara, Andrzej, 'Kosmonauta', Kresy, January 1995

Rauterberg, Hanno, 'Objektkunst mit Mensch', Die Zeit, 6 April 2006

Reinhold, Friedrich, 'Es war einmal, wie es einmal sein wird', Monopol, no. 10, October 2003

Richter, Peter, 'Die Kunst des Abschiebestopps', Frankfurter Allgemeine Zeitung, 31 March 2006

Robecchi, Michele, 'Paweł Althamer: Common Task', Flash Art, no. 277, March-April 2010

Saltz, Jerry, 'Let's Get Serious for a Moment', New York Magazine, 22 September 2008

Salzbrenner, Uwe, 'Ein Mast auf dem Sprung', Sächsische Zeitung, 7 July 2004

Saunders, Matt, 'Paweł Althamer', Frieze, May, 2007

Schiff, Hajo, 'Skulptur Projecte Münster 07', Artist Kunstmagazin, no. 72, 2004

Schjeldahl, Peter, 'Feeling Blue', The New Yorker, 4 August 2008

Schjedahl, Peter, 'Big Time: Skin Fruit at the New Museum', The New Yorker, 4 March 2010

Schlaegel, Andreas, 'Paweł Althamer at neugerriemschneider', Flash Art, October 2003

Schwarzenberger, Sebastian, 'Paweł Althamer', Zitty, 26 June-9 July 2003

Shaw, Francesca D., and Lavinia Garulli, 'Was will Europa?', Flash Art, no. 237, July–September 2004

Smith, Roberta, 'Anti-Mainstream Museum's Mainstream Show', The New York Times, 4 March 2010

Szymczyk, Adam, 'A Seemingly Innocent Subversion of Reality', Siksi, summer 1997

Szymczyk, Adam, 'The Annotated Althamer', Afterall, May 2002

Szymczyk, Adam, 'A Real Allegory and the Origins of the World', Parkett, no. 82, May 2008

Vallese, Gloria, 'Le Lezione della Tenebre', Arte, September 2007

Wei, Lilly, 'After Nature', Artnews, October 2008

Woliński, Michał, 'Building Activity, Sculpting Communication', Piktogram, no. 5-6, 2006

Woliński, Michał, 'Warsaw: An Alternative Guide for Art Lovers', Mousse, no. 11, November 2007

Wood, Catherine, 'Magic Realism', Parkett, no. 82, May 2008

Żmijewski, Artur, 'Bródnowska nirwana: Rozmowa z Pawłem Althamerem', Czereja, March 1993

CENTRE FOR CONTEMPORARY ART UJAZDOWSKI CASTLE, Warsaw

KRÖLLER-MÜLLER MUSEUM, Otterlo, Netherlands

KUNSTHALLE BASEL, Switzerland

LUDWIG MUSEUM, Cologne

TATE, London

ZACHĘTA NATIONAL GALLERY OF ART, Warsaw

ILLUSTRATED WORKS

COMPARATIVE IMAGES

PHAIDON PRESS LTD.
REGENT'S WHARF
ALL SAINTS STREET
LONDON N1 9PA

PHAIDON PRESS INC.
180 VARICK STREET
NEW YORK, NY 10014

WWW.PHAIDON.COM

First published 2011
© 2011 Phaidon Press Limited
All works of Paweł Althamer
are © Paweł Althamer

ISBN:
978-0-7148-6085-5

A CIP catalogue record of
this book is available from the
British Library.

Designed by Melanie Mues,
Mues Design, London

Printed in Hong Kong

PUBLISHER'S
ACKNOWLEDGEMENTS

Special thanks to Andrzej
Przywara, Joanna Diem and
Aleksandra Ściegienna at
Foksal Gallery Foundation,
Warsaw; Tim Neuger,
Burkhardt Riemschneider,
Emilie Breyer and
Maria Elisa Marchini at
neugerriemschneider, Berlin;
Fondazione Sandretto
Re Rebaudengo, Turin;
Fondazione Nicola Trussardi,
Milan; Claudio Poleschi Arte
Contemporanea, Lucca, Italy;
Tate, London; Kunsthalle
Fridericianum, Kassel,
Germany; Open Art Project,
Warsaw.

Photographers: Agora
Archives, Cecilia Alemani,
Marco De Scalzi, Jacek
Gladykowski, Katarzyna
Kozyra, Archive Grzegorz
Kowalski, Iza Izdebska, Jacek
Markiewicz, Mary McCarthy,
Roman Mensing/artdoc.de,
Grzegorz Olech, Błażej
Pindor, Maria Prosowska, Jan
Smaga, Bartosz Stawiarski,
Ali Subotnik, Rafal Szambelan,
Adam Szymczyk, Jens Ziehe.

Caption descriptions by
Joanna Mytkowska and
Andrzej Przywara in
collaboration with Aleksandra
Ściegienna, Artur Żmijewski,
Michele Robecchi and
Craig Garrett.

ARTIST'S
ACKNOWLEDGEMENTS

Paweł Althamer would like
to thank Michele Robecchi,
Craig Garrett, Aleksandra
Ściegienna, Suzanne Cotter,
Roman Kurzmeyer, Adam
Szymczyk, Marek Sieprawski,
Artur Zapałowski, Foksal
Gallery Foundation, Andrzej
Przywara, Joanna Diem,
neugerriemschneider,
Burkhard Riemschneider,
Tim Neuger.

CONTEMPORARY ARTISTS:

Contemporary Artists is a series of authoritative and extensively illustrated studies of today's most important artists. Each title offers a comprehensive survey of an individual artist's work and a range of art writing contributed by an international spectrum of authors, all leading figures in their fields, from art history and criticism to philosophy, cultural theory and fiction. Each study provides incisive analysis and multiple perspectives on contemporary art and its inspiration. These are essential source books for everyone concerned with art today.

MARINA ABRAMOVIĆ KRISTINE STILES, KLAUS BIESENBACH, CHRISSIE ILES / VITO ACCONCI FRAZER WARD, MARK C. TAYLOR, JENNIFER BLOOMER / AI WEIWEI KAREN SMITH, HANS ULRICH OBRIST, BERNARD FIBICHER / DOUG AITKEN DANIEL BIRNBAUM, AMANDA SHARP, JÖRG HEISER / PAWEŁ ALTHAMER ROMAN KURZMEYER, ADAM SZYMCZYK, SUZANNE COTTER / FRANCIS ALŸS RUSSELL FERGUSON, CUAUHTÉMOC MEDINA, JEAN FISHER / UTA BARTH PAMELA M. LEE, MATTHEW HIGGS, JEREMY GILBERT-ROLFE / CHRISTIAN BOLTANSKI DIDIER SEMIN, TAMAR GARB, DONALD KUSPIT / LOUISE BOURGEOIS ROBERT STORR, PAULO HERKENHOFF (WITH THYRZA GOODEVE), ALLAN SCHWARTZMAN / CAI GUO-QIANG DANA FRIIS-HANSEN, OCTAVIO ZAYA, TAKASHI SERIZAWA / MAURIZIO CATTELAN FRANCESCO BONAMI, NANCY SPECTOR, BARBARA VANDERLINDEN, MASSIMILIANO GIONI / VIJA CELMINS LANE RELYEA, ROBERT GOBER, BRIONY FER / RICHARD DEACON JON THOMPSON, PIER LUIGI TAZZI, PETER SCHJELDAHL, PENELOPE CURTIS / TACITA DEAN JEAN-CHRISTOPHE ROYOUX, MARINA WARNER, GERMAINE GREER / MARK DION LISA GRAZIOSE CORRIN, MIWON KWON, NORMAN BRYSON / PETER DOIG ADRIAN SEARLE, KITTY SCOTT, CATHERINE GRENIER / STAN DOUGLAS SCOTT WATSON, DIANA THATER, CAROL J. CLOVER / MARLENE DUMAS DOMINIC VAN DEN BOOGERD, BARBARA BLOOM, MARIUCCIA CASADIO, ILARIA BONACOSSA / JIMMIE DURHAM LAURA MULVEY, DIRK SNAUWAERT, MARK ALICE DURANT / OLAFUR ELIASSON MADELEINE GRYNSZTEJN, DANIEL BIRNBAUM, MICHAEL SPEAKS / PETER FISCHLI AND DAVID WEISS ROBERT FLECK, BEATE SONTGEN, ARTHUR C. DANTO / TOM FRIEDMAN BRUCE HAINLEY, DENNIS COOPER, ADRIAN SEARLE / ISA GENZKEN ALEX FARQUHARSON, DIEDRICH DIEDERICHSEN, SABINE BREITWIESER / ANTONY GORMLEY JOHN HUTCHINSON, SIR ERNST GOMBRICH, LELA B. NJATIN, W. J. T. MITCHELL DAN GRAHAM BIRGIT PELZER, MARK FRANCIS, BEATRIZ COLOMINA / PAUL GRAHAM ANDREW WILSON, GILLIAN WEARING, CAROL SQUIERS / HANS HAACKE WALTER GRASSKAMP, MOLLY NESBIT, JON BIRD / MONA HATOUM GUY BRETT, MICHAEL ARCHER, CATHERINE DE ZEGHER / THOMAS HIRSCHHORN BENJAMIN H. D. BUCHLOH, ALISON M. GINGERAS, CARLOS BASUALDO / JENNY HOLZER DAVID JOSELIT, JOAN SIMON, RENATA SALECL / RONI HORN LOUISE NERI, LYNNE COOKE, THIERRY DE DUVE / ILYA KABAKOV BORIS GROYS, DAVID A. ROSS, IWONA BLAZWICK / ALEX KATZ CARTER RATCLIFF, ROBERT STORR, IWONA BLAZWICK / ON KAWARA JONATHAN WATKINS, 'TRIBUTE', RENÉ DENIZOT / MIKE KELLEY JOHN C. WELCHMAN, ISABELLE GRAW, ANTHONY VIDLER / MARY KELLY MARGARET IVERSEN, DOUGLAS CRIMP, HOMI K. BHABHA / WILLIAM KENTRIDGE DAN CAMERON, CAROLYN CHRISTOV-BAKARGIEV, J. M. COETZEE / YAYOI KUSAMA LAURA HOPTMAN, AKIRA TATEHATA, UDO KULTERMANN / CHRISTIAN MARCLAY JENNIFER GONZALEZ, KIM GORDON, MATTHEW HIGGS / PAUL MCCARTHY RALPH RUGOFF, KRISTINE STILES, GIACINTO DI PIETRANTONIO / CILDO MEIRELES PAULO HERKENHOFF, GERARDO MOSQUERA, DAN CAMERON / LUCY ORTA ROBERTO PINTO, NICOLAS BOURRIAUD, MAIA DAMIANOVIC / JORGE PARDO CHRISTINE VÉGH, LANE RELYEA, CHRIS KRAUS / RAYMOND PETTIBON ROBERT STORR, DENNIS COOPER, ULRICH LOOCK / RICHARD PRINCE ROSETTA BROOKS, JEFF RIAN, LUC SANTE / PIPILOTTI RIST PEGGY PHELAN, HANS ULRICH OBRIST, ELIZABETH BRONFEN / ANRI SALA MARK GODFREY, HANS ULRICH OBRIST, LIAM GILLICK / DORIS SALCEDO NANCY PRINCENTHAL, CARLOS BASUALDO, ANDREAS HUYSSEN / THOMAS SCHÜTTE JULIAN HEYNEN, JAMES LINGWOOD, ANGELA VETTESE / STEPHEN SHORE MICHAEL FRIED, CHRISTY LANGE, JOEL STERNFELD / ROMAN SIGNER GERHARD MACK, PAULA VAN DEN BOSCH, JEREMY MILLAR / LORNA SIMPSON KELLIE JONES, THELMA GOLDEN, CHRISSIE ILES / NANCY SPERO JON BIRD, JO ANNA ISAAK, SYLVÈRE LOTRINGER JESSICA STOCKHOLDER BARRY SCHWABSKY, LYNNE TILLMAN, LYNNE COOKE / WOLFGANG TILLMANS JAN VERWOERT, PETER HALLEY, MIDORI MATSUI / LUC TUYMANS ULRICH LOOCK, JUAN VICENTE ALIAGA, NANCY SPECTOR, HANS RUDOLF REUST / JEFF WALL THIERRY DE DUVE, ARIELLE PÉLENC, BORIS GROYS, JEAN-FRANÇOIS CHEVRIER, MARK LEWIS / GILLIAN WEARING RUSSELL FERGUSON, DONNA DE SALVO, JOHN SLYCE / LAWRENCE WEINER ALEXANDER ALBERRO AND ALICE ZIMMERMAN, BENJAMIN H. D. BUCHLOH, DAVID BATCHELOR / FRANZ WEST ROBERT FLECK, BICE CURIGER, NEAL BENEZRA / ZHANG HUAN YILMAZ DZIEWOR, ROSELEE GOLDBERG, ROBERT STORR